ROMANTIC
ART THEORIES

August Wiedmann

GRESHAM BOOKS

Gresham Books,
P.O. Box 61,
Henley-on-Thames, RG9 2LQ,
Oxfordshire, England.

British Library Cataloguing in Publication Data

Wiedmann, August
 Romantic art theories
 1. Aesthetics
 I. Title
 700'.1 BH39

 ISBN 0-946095-24-8

Typeset in Times by Elizabeth Wilsey
Reprographics by David Thompson Design Associates Ltd.
Printed and bound by Unwin Brothers Limited

Contents

continued

List of Plates

Introduction

Although studies on Romanticism have been, and still are, proliferating at a frightening pace, little exists that enables the student and interested layman to arrive at a comprehensive and synoptic view of the various ideas of poetry and art promoted by the Romantics. Admittedly, there is M.H. Abrams' excellent and supremely scholarly work *The Mirror and the Lamp*. Indispensable to any serious scholar, it occupies a place of eminence all of its own. Yet its very breadth and dazzling erudition makes assimilation of this work difficult for the uninitiated reader. Moreover, Abrams' text is primarily concerned with Romantic Poetics. Its appeal therefore is confined to the literary critic and historian. The same is true of virtually all the major expositions from René Wellek's pioneering contributions to the highly stimulating speculations of Morse Peckham. As to Johannes Dobai's *Die Kunstliteratur des Klassizismus und der Romantik in England* — a truly monumental exposition numbering nearly sixteen hundred pages — this work is more in the nature of documentation than of synthesis.

The present study strikes out in a new direction by providing a general framework for Romantic aesthetics. It goes beyond most previous explorations by including the testimony of Romantic painting as well. This inclusion is a vital and necessary addition since it reflects the Romantics' own belief in the unity of thought, poetry and art. This unity is usually lost in our "departmentalized" procedures which divide Romantic poetry and painting into clearly separated studies. The loss of perspective imposed by this division is perhaps more keenly felt in art-historical inquiries. Intent on tracing developments of style and the evolution of art, they must

pay close attention to the paintings themselves, which leaves scant time for sustained poetic and philosophical reflections. Predictably this concentration on stylistic changes has brought about a disproportionate pre-occupation with French Romantic art which often has been uncritically accepted as being representative of Romanticism as a whole. For reasons to be explained shortly, such claims are far more justified in terms of English and German Romantic painting. Fortunately, these past two decades have witnessed a vigorous revival and long overdue recognition of both. In this country the revival owes much to such critics as Roger Cardinal and above all William Vaughan whose patient and comprehensive scholarship alerted our understanding to the depth and richness of Romantic art. In view of this re-awakened interest it is important that we come to terms with the larger aesthetic issues involved in Romanticism as a whole.

While the immediate aim of this study is to present a coherent account of the various theories discussed, its larger objective is to comprehend Romantic aesthetics against the diverse philosophical background of the Romantic Age. It is this background in part that gives some Romantic notions of art their distinct flavour and, in turn, provides them with a metaphysical foundation. This must not be understood as though philosophy always preceded and determined the theory and practice of poetry and painting. The latter, as Schelling's apotheosis of artist and art makes abundantly clear, can have a decisive influence on the conceptions and formulations of philosophy itself. Nonetheless, it is an indisputable fact that during the Romantic period artistic reflections were inseparable from a number of metaphysical and epistemological assumptions which have to be understood first before we can begin to make sense of aesthetic beliefs embraced at the time.

Following an introductory chapter, we shall be looking at four major Romantic 'theories' of art — theories in the widest sense of denoting a set of general propositions employed to explain a number of assumptions and phenomena in question. Much attention is paid to the sometimes far-reaching and revolutionary consequences of the different theories examined. As we shall see, some of these consequences lead us straight into the anteroom of contemporary art. Indeed an additional and by no means subsidiary aim of this study is to show how Romanticism paved the way and

laid the foundation for what we erroneously believe to be artistic conceptions unique to our time.

Some of the theories discussed have not always been treated with the respect they undoubtedly deserve. Worse still, one theory — what I call the "holistic theory" — seems to have been overlooked altogether even though it is implied in most discussions; another theory — referred to as the "hierophantic conception of art" — has in turn suffered critical neglect with the result that both theories not only remained basically unfocused but also failed to receive a proper name. This study aims to redress the balance.

The arguments below have in the main been based on the testimony of English and German Romantics. Historically their testimony takes precedence over that of the French, notably in the field of metaphysical, aesthetic and critical inquiries. With the exception of Baudelaire who does appear in these pages even though he belongs to a different age, the writings of French theorists and critics betwen 1795 and 1820 lack the audacity and complexity of thought characteristic of their English and German contemporaries. Mme de Staël's indebtedness to A.W. Schlegel, her eclectic treatment of Romanticism generally, is too well known to require reiteration.

If French painting has likewise been by-passed in the present study it is not for any lack of recognition but for its ambiguous and often tenuous relationship to the core of Romantic ideas. Just how tenuous this relationship was in fact can easily be gleaned from the painter's comparative neglect of nature. Unlike the art of the Germans and the English which is an art predominantly of landscape, there is much less pre-occupation with natural scenery in the paintings of Géricault and Delacroix or in the preceding art of Gros, Girodet and Prud'hon. None of these artists ever painted what William Vaughan calls 'transcendent landscapes'; none, that is, looked upon the grandeur of earth, sea and sky as the gateway to the infinitude of God. Although landscape painting — much of it Italianate or historical — achieved popularity with the Revolution, the greatness of French art right up to the 1830s remains firmly locked within the orbit of a 'heroic' figurative tradition. Even after the art of landscape comes fully into its own with Paul Huet and still more with Théodore Rousseau and the Barbizon painters, the nature portrayed rarely aspired towards those pantheistic heights

characteristic of Romantic art across the Channel and the Rhine.

As to the respective contributions of English and German Romanticism to aesthetics and, beyond that, to art itself, this is not the place to distribute laurels, nor to sharpen patriotic knives. Neither is it the place to emphasise where these two Romantic 'movements' diverge. Ever since René Wellek's exemplary essays in *Confrontations* such divergences have become the subject of numerous discussions which greatly enriched our understanding of the immense diversity manifest in each. Unfortunately, some of these discussions also fostered the belief that the differences separating English and German Romanticism are far more profound than the affinities between them. The following exposition hopes to refute this far from proven supposition. It does not deny the importance of differences, indeed some of them are explicitly acknowledged. However, if it proceeds by way of resemblances it is not merely because they patently exist, but because a closer examination of such resemblances reveals a community of shared thoughts and feelings which touch on the very core of the Romantic outlook.

Concerning style and manner of presentation, an attempt generally has been made to invoke the spirit rather than the dead letter of the Romantic age. That spirit is not served by a pedantic scrutiny but by an imaginative reconstruction which, painting in bold and vivid colours where necessary, strives to bring the period to life. If this procedure offends the sober-minded academic scholar no apology is made. Obviously any synoptic "re-creative" exposition must needs employ a different method from one focusing on more limited analytical enquiries which measure progress by the emmet's inch. If, as has been rightly said, there is much wisdom in the latter, there is virtue no less in the eagle's mile, for it preserves that precious sense which our piece-meal academic industry is on the point of losing altogether: perspective and simplicity of vision.

The study contains twenty-one reproductions of Romantic paintings. Each carries a separate description which compliments and specifies on art-historical grounds the arguments raised in the main text. The reproductions are in black and white not least to persuade the reader to consult the originals themselves. Four Romantic painters are represented: C.D. Friedrich, J.M.W.

Turner, J. Constable and Samuel Palmer. Others like Blake and Philipp Otto Runge could easily have been included. However, the temptation to 'overdress' the study with a multitude of reproductions has been resisted not only because the nature and function of an aesthetic inquiry is essentially different from the customary art-historical procedure, but also because the issue concerning theory and practice in Romantic art is one to be approached with caution. This is especially true of both Blake and Runge, whose paintings require a more painstaking analysis which must take into account these artists' specific religious and philosophical commitments, as well as the influence upon their art by preceding pictorial styles.

To end on a polemical note: whatever the relationship between Romantic theory and practice in the end may have been in the case of every poet and painter, every writer and composer, Romantic speculations on art can stand well on their own. For what is of value in them is not primarily their logical validity as such, or their applicability to matters of artistic concern, but what visions they communicate about the world and the role art is supposed to play within it. The question we should ask is not 'are these theories true or false' but 'do they enrich our understanding or enlarge the scope of our sensibility?' That we can ask such questions in the first place is a truly Romantic contribution.

Acknowledgements

The present study grew out of my *Romantic Roots in Modern Art* (1979). The material retained from the latter has been revised, re-written and generally given a much sharper focus in the interests of the themes discussed.

For permission to reproduce paintings I am indebted to several galleries and museums all properly acknowledged in the text. Photo credits are due to Frau Ursula Edelmann and Herr Uwe Hinkforth for providing a black-and-white reproduction of C.D. Friedrich's 'The Evening Star' at the Frankfurter Goethe-Museum.

Chapter I
Romantic Attitudes

A. The 'Wondrous Whole'

As critics have confessed repeatedly and often rather ruefully, the Romantic spirit is notoriously difficult to pin down. Multiform and plural, its dazzling diversity of expressions seems to foil any attempt to arrive at a conclusive definition of its substance and form. It could hardly be otherwise for Romanticism was not, nor at any time aspired to be, a coherent and self-consistent movement based on a programme of thought or system of ideas. Neither in terms of literature nor art was Romanticism ever a unified style although it did bring about dramatic and far-reaching formal innovations. At its 'beginning' in the early 1790s, Romanticism was but an inner unrest, 'a summons, a revolt that at first did not even find the words to name itself'.[1] Soon after the summons, the revolt generated altogether new ways of thinking and feeling, a decisive change in consciousness which exhibited a number of common though by no means always consistent preoccupations that found diverse expressions in poetry and painting, and beyond that in almost all of man's critical and cultural endeavours. As we shall see it is the presence of these common preoccupations, of these shared features of beliefs, that taken together justify the label 'Romantic' — sometimes, as Hugh Honour rightly points out, 'for lack of a better name'.[2]

Foremost among these shared features was the Romantics' vision of unity and wholeness, a vision prompted by life's increasing fragmentation, its progressive dissolution into discrete parts — social, political, scientific, philosophical and religious. It was precisely this vision of unity and wholeness that in the end

1

sustained and sometimes redeemed the Romantics' eccentricities, their notorious cult of feeling, their rampant subjectivism, their excessive concentration on originality, on everything unique. All of these must be seen in relation to the Romantics' fierce craving for union and fusion, for integration in the living fabric of creation.

This was at the root of Wordsworth's religion of nature, his abiding faith that the 'least of things looked infinite' — that infinity which Blake in turn saw in and through a grain of sand. It was at the root of Shelley's vision of a vast 'everlasting universe', of Byron's conception of Creation in which 'All is concentrated in a life intense, / Where not a beam, nor air, nor leaf is lost'.[3] It was at the root of Coleridge's irresistible craving for oneness. 'My mind feels as if it ached to behold . . . something great and indivisible'. And to behold this indivisible oneness was the supreme destiny of man. 'Tis the sublime of man, / Our noontide Majesty, to know ourselves / Parts and proportions of one wondrous / whole!'.[4]

For reasons social and historical, this wondrous whole cast an even greater spell over the German Romantics. Theirs was a country ravaged by divisions, a country of petty often backward principalities, a people who had never known political, cultural and religious integration. This explained in part Friedrich Schlegel's passionate plea for 'infinite unity' and 'infinite fullness'; Novalis' dream of an 'inner total fusion' with the world; Hoelderlin's vision of union with God via Nature: 'To be one with all, this is the life of the Godhead, this is the heaven of man'.[5] Schleiermacher was no less pantheistically inspired in his urge to possess the entire universe: 'When shall I embrace it in action and in contemplation and achieve an inner union with the All'.[6] Goethe's well-known lines put it still more simply: 'How yearns the solitary soul to melt into the boundless whole'.[7]

The same pantheistic urge moved the 'philosophers of nature': Schelling (in his early system), G.H. Schubert, Oken, Carus, Ritter, Steffens, Baader and Hans Christian Oersted, the discoverer of electromagnetism. Each affirmed the unity of the creation, the 'symphonic music of the All'. Each proclaimed that true philosophy 'is essentially *pansophy*' in the words of Joseph Görres.[8] Although unmistakeably Germanic in its mystical intent and daring para-scientific speculations, this form of *Naturphilosophie* with its fervent affirmation of the 'one life within

us and abroad' was by no means missing from the English scene. Indeed, it was to some extent prefigured in the scientific and religious preoccupations of the elder Darwin and of Joseph Priestley whose influence on the early Wordsworth and the youthful Coleridge was profound. Each one subscribed to what Novalis expressed in plain verse: 'A great life-force everywhere / Blossoms forth and comes to bear / All must link in harmony / Each through the other flourish and fruitful be'.[9]

'All', 'everything', these are the words which recur time and again in Romantic writings — recur rapturously! And this 'all' and 'everything' for the Romantics was infused with a living and procreative spirit which upheld the plenitude of all. Hence Wordsworth's confident assertion: it is 'a spirit that impels / All thinking things, all objects of all thought'.[10] Shelley put it almost identically in his youthful *Queen Mab:* 'Throughout this varied and eternal world / Soul is the only element . . . ', the 'active, living spirit . . . in unity and part'.[11] As Coleridge exclaimed: 'There is one Mind, one omnipresent Mind' whose love diffused 'through all' made one glorious whole.[12] For the Romantics duality in any form was inadmissible. The distinction between mind and matter, 'subject' and 'object' was of limited utilitarian and epistemological significance only. In the last analysis all divisions had to be led back to and absorbed by a common source, an original unity or 'identity' as Schelling put it which must be spiritual throughout. Novalis put it succinctly when he wrote: 'All that is visible rests on an invisible foundation, all that is audible on an inaudible foundation, and all that is tangible on an impalpable foundation'.[13] In short everything derived from and had their being in a benign Universal Spirit.

The Romantics' preoccupation with unity predictably helped to shape their view of society and history. Despite, and sometimes because of, their pronounced individualism their outlook was characterised by a profound feeling for community secular or religious. While affirming, indeed glorying in, the rich diversity of races, nations and peoples, they dreamed of a 'diversity in unity', a whole uniting the many different parts, a community founded on Philadelphian ideals. This was the vision of Blake. Inspired in part by the French Revolution, inspired still more by his own religious quest, Blake turned into the fiery preacher of a New Jerusalem, the

same that the young Coleridge found in Priestley's Unitarianism and in the Gospel of Pantisocracy.

Whatever the specific occasion and regardless of how shortlived the individual's commitment to particular programmes and creeds, communal preoccupations figured prominently in Romantic writing. On the German side, for instance, almost all Romantics called for a community of faith and worship and, with mounting urgency, for a community of state: a politically united and regenerated people. Yet this new-found nationalism was not at all incompatible with cosmopolitan ideals which could conceive of a spiritually organized United Nations. Novalis, like Shelley, went still further by envisaging a 'golden age', a 'world-marriage' joining all beings and all species. 'Men, plants, beasts, stones and stars' will meet 'as one family'. They will 'act and converse as one race'.[14]

Evidently the Romantics' social and utopian conception must be seen in the context of their age so often turbulent and catastrophic, times complex and confusing in their paradoxical shifts and clashes of convictions. Virtually all of the Romantics were in one form or another the 'natural children' of the French Revolution, whose subsequent reign of terror transformed the initial joy and exultation into despair and grim disgust, without however wholly extinguishing the flame of liberty set alight by events in France. Not long after the Romantics marvelled at the meteoric rise of a new Caesar — Napoleon — hailed by Hegel as the 'world-soul' on horseback, the *Zeitgeist* in person. 'No figure', writes William Vaughan, 'revealed the political ambivalences of Romanticism as completely as Napoleon'. A 'product of the liberating forces of the revolution' the defeat of which he helped to bring about, a political and military genius of heroic cast, he was both revered and reviled.[15] When at last this strange extraordinary figure assumed the vain and vulgar trappings of tyranny which enslaved more than half of Europe, the Romantics became patriots and supported the War of Liberation to defeat the Corsican upstart. Sadly, the so-called War of Liberation turned out to be no more than a war of competing imperial powers and reorganising aristocratic dynasties hellbent on restoring privilege and status.

All these events left their marks on the Romantics' social and political preoccupations. Caught between the Revolution and the

Restoration, they could on occasion side now with the one, now with the other. Some, overcome by grief at the futility of all wars and revolutions, would not side with anything political at all. The more historical reality defeated them, the more mystically inclined their communitarian ideals became. Others again knew, or thought they knew, that one great political revolution was bound to defeat itself. It merely called forth terror and counter-terror. The thing needed was not just one but a series of great revolutions — social, religious, philosophical and artistic — to bring about the spiritual purification and unification of men. Such millennial dreams, as we shall see, greatly occupied the Romantics.

B. Enchantment's Veil

Seeking to heal Man's alienation from the living spirit of creation made the Romantics fierce opponents of any system that explained the universe in terms of quantities and numbers or by way of mere sense impressions. Idealists to the extreme, they denied the existence of any reality seemingly independent of the spirit.

Almost to a man the Romantics rejected French materialism and English empiricism, including the blind determinism of Newtonian science which frequently provoked profound horror and disgust. Blake's aversion to the satanic 'Waterwheels of Newton' and to the mindless 'Loom of Locke' hardly requires much reiteration; nor does Wordsworth's condemnation of 'scientific man' who, in dissecting nature, savaged the 'beauteous forms of things'.[16] E.T.A. Hoffman drew a still more devastating portrait of the analysing, anatomizing and botanizing mind in his sardonic tale 'Heimatochare' and in *Meister Floh*. Kleist added a touch of humour when he accused Newton of seeing no more than a curved line in a girl's beautiful bosom while her glowing heart interested him only for its 'cubic content'.[17] Mechanistic science, charged Novalis, unsouled and desacralized all things on sight leaving behind a barren godless world. 'Lonely and lifely nature lay prone, fettered with an iron chain, strict measure and the arid number prevailed'.[18] As to French materialism and in particular Holbach's notorious *System of Nature,* the Romantics' reaction to it is best summed up in the sombre words of Goethe: 'It appeared to us so

dark, so Cimmerian, so deathlike, that we found it difficult to endure its presence.[19]

For most Romantics mechanism and materialism presented a diabolical distortion of reality in their deliberate reduction of phenomena to laws and measureable quantities. The Romantics' passionate protest was on behalf of a *qualitative* universe, a world replete, that is, with sounds, scents, colours, textures and beyond that, with an infinite variety of physiognomic properties, each and all the sensuous and affective imprint of a living spirit. Denying the objective reality of these qualities, mechanism and materialism denied the reality of soul and spirit. What they offered instead was a truly soulless, senseless universe, an 'atheistical half-night' through which man wandered aimlessly, a stranger to creation. As Coleridge was to claim repeatedly, 'Mechanico-corpuscular Philosophy', while of evident use as a scientific working model, replaced, when pressed too far, the living world by a 'lifeless Machine whirled about by the dust of its own Grinding . . .'.[20] Novalis provided the more striking, the more memorable imagery in his attack on the new manner of thinking which culminated in Newtonian science and in secular philosophies. This form of irreligious thought

> reduced the infinite creative music of the universe to the monotonous clatter of a monstrous mill which, driven by the stream of chance and floating thereon, was supposed to be a mill in the abstract, without Builder or Miller, in fact an actual *perpetuum mobile,* a mill that milled of itself.[21]

To be sure, some Romantics including Coleridge, Wordsworth and Novalis professed no hostility to Newtonian science itself. Their quarrel was with its boundless metaphysical presumptions, its wholly unjustified arrogant extension to areas of reality neither mechanistic nor materialistic. Other Romantics however viewed the very presence of this science with the grimmest premonitions. Science, they maintained — anticipating Max Weber — 'disenchanted' the world by divesting things of their pristine magic and spendour. In Keats' much-quoted phrase, science 'will clip an Angel's wings, / Conquer all mysteries by rule and line',[22] by measurement and number leaving behind a cold and senseless world of 'eternal matter in eternal motion' ruled by blind,

inscrutable necessities.

What, some Romantics agonized, will be the fate of literature and art in this ill-fated, disenchanted world? What place, if any, remained for the poet and painter once all things have been 'explained' in terms of their physical causes and components, their measurements and numbers? In short

When Science from Creation's face
Enchantment's veil withdraws,
What lovely vision yield their place
To cold material laws?[23]

Thus Thomas Campbell.

It was an extreme view perhaps but not at all unrepresentative, for most Romantics at one time or another pointed anxiously to the immense and seemingly unbridgeable distance separating the poets' and painters' holistic vision of the world and the scientists' dissecting gaze which sliced all things into lifeless disconnected parts, a cold unfeeling gaze under which nature withered and perished. Hence Wordsworth's hallowed lines of the 'meddling intellect' that always kills in order to dissect, his condemnation of science and reason as 'that false secondary power' by means of which we 'multiply distinctions' and then insist that these 'puny boundaries' drawn up by the scientific mind correspond with the ultimate reality of things.[24] That reality was revealed only to the innocent eye of the artist. Undeceived by the scientists' hollow claims it penetrated to the very heart of things. As Wordsworth, referring to himself, put it: 'To thee, unblinded by these formal arts, / The unity of all hath been revealed'.[25]

Some Romantics hoped to mend the rift by calling for a 'higher' science capable of synthesising what has been patiently obtained through analysis and observation, a superior science infused by a poetic spirit, since only a spirit such as this could shape observed particulars into a living whole. 'The sciences', Novalis urged, 'must all be made poetic' and once 'poeticized' became part of a still more comprehensive science which incorporated all forms of knowledge, including poetry and painting, philosophy and religion.[26] Coleridge's projected 'universal science' was quite in line with such lofty-minded aspirations, and so was Shelley's unfounded faith in the poetic root of all genuine science and

knowledge. Reminiscent of Novalis he claimed that poetry

> is at once the centre and circumference of knowledge, it is that which comprehends all science, and that to which all science must be referred. It is at the same time the root and blossom of all other systems of thought.[27]

Even Wordsworth dreamed of a time when the poet would lend his 'divine spirit . . . to aid the transfiguration' of the scientific mind. Alas, it has remained untransfigured.

If Newton incurred the wrath of the Romantics, some sciences, falling outside the scope of a mechanistic mode of explanation, found their rapturous approval, none more so than the sciences of Electricity, Galvanism and Magnetism. All three were meat and drink to minds pantheistically and animistically inclined. Their general effect on the Romantic imagination was truly profound — 'galvanizing' and 'electrifying' as well as 'mesmerizing' in tribute to Anton Mesmer and his disciples who seemingly harnessed the forces of magnetism to miraculously cure man's mental and physical afflictions. For the Romantics the very success of these sciences was glorious proof at last that matter as such was not the ultimate reality. Something existed within and between matter, something far more original and fundamental, a dynamic interplay of forces and polarities, a ceaseless 'productive activity' as Schelling loved to call it, which held the whole universe together, an activity that issued from the Absolute itself.

This vision of a 'productive activity' sustaining all decisively changed the Romantics' outlook on the world. It brought about a radical and irreversible shift, a shift away from everything static and generic towards things dynamic and genetic, a shift, in short, which replaced the limited notions of atomism and mechanism with the more creative and flexible models of organicism and universal dynamism. The Romantics ushered in man's preoccupation with change rather than with permanence, with process rather than with products, with force and flux rather than with finished forms and seemingly unchanging timeless substances. There is no Being, they proclaimed, only Becoming.

Inevitably this dynamic-developmental understanding of the world changed the Romantics' attitude to literature and art. Each genuine work, they maintained, must proceed from and hint at the

primordial energy active in everything. Henceforth every poem and painting, indeed every work of the human spirit, had to bear witness to the laws of flux and transformation flowing from the heart of Creation itself. This fascination with eternal flux and transformation expressed itself in the artists' attraction to nature's fierce primeval forces as manifest in raging storms, gigantic seas or lava-hurling mountains. It also expressed itself in the painters' exclusive concentration on whirling, shifting clouds, for clouds in particular were seen as repositories of electricity and, beyond that, as manifestations of the 'energy divine'. Romantic literature and art are inseparable from this passion for energy and force, a passion which profoundly affected their respective matter and form, their substance and style. Turner's later paintings are supreme examples of this tendency. All testify to the transformation of substance into process, of solid forms and tangible objects into dynamic fields of forces. In poetry, Shelley's verse provides numerous poetic parallels of a similar de-substantializing process obeying the law of metamorphosis, of transformation, of 'liquification'.

Historically, the Romantic's concern with metamorphosis and transformation presaged and prepared the way for the development of early modern art, although there the emphasis became more single-minded. Similar to the Romantics, and in the wake likewise of post-Newtonian science as represented by subatomic physics and new developments in biology and chemistry, the early Modernists subscribed to an 'energy-mysticism' which pushed the frontiers of science out towards the mythical and the divine. And this intoxication with energy aimed for a form of art no longer substance-inspired but process-minded, for an art, in short, devoted to the expression not of things but of their dynamic properties and relationships. Unlike the Romantics however, who for the most part still made use of nature's outward shape to express her inner force and energy, the Modernists strove to embody this energy more directly through the dynamics inherent in non-objective forms and colours.

C. Towards the Non-rational and Transrational

The Romantics' attack on the meddling mechanical intellect frequently mirrored their misgivings about reason or the

intellectual faculty itself. Reason, like science, tended to divide, and in so doing, to destroy the living whole, impose its narrow will upon Man's glorious passions and feelings. Worse still, this seemingly godlike faculty in Man curtly dismissed the truth of the imagination, of the heart and of the senses, as much inferior to the truth it claimed for itself.

On the surface, and impelled by visions of wholeness, the Romantics strove to reconcile the rational with the tender feelings of Man's heart. Reason, they maintained, must be animated by imagination, imagination find place for rationality. The senses and the soul at their most profound called for, indeed demanded the closest of co-operation with the deepest thoughtfulness. Yet all these and similar ritual pieties professed on behalf of Man's undivided wholeness concealed but the Romantics' unresolved relationship to reason; their tense, ambiguous and often outright negative attitude towards the rational. It was clearly negative in Novalis' notion of a 'petrified and petrifying Reason' or in his conception of thought as being 'only feeling's dream, feeling that has expired, a pallid and feeble life'.[28] It was still more negative in Heinrich von Kleist's despair over a dissecting rationality which distorted and ultimately paralyzed everything spontaneous and vital. — 'O Reason, miserable Reason'.[29]

While the Romantics recoiled from the dryness and divisiveness of reason, they often fell back upon a mystically inclined rationality in league, it seemed, with the transrational and transcendental. Thus Novalis and his close circle of fellow Romantics hoped to blend philosophy and poetry into an all-comprehensive 'transcendental poesy'; an ambition which Friedrich Schlegel expressed in his high-sounding prose: 'The whole history of modern poetry is a continuous commentary on a short text of philosophy: all art should become science, and all science art: poetry and philosophy should be united'.[30]

Although the Germans experienced the conflict between the rational and the non-rational more intensely, a similar ambivalence towards reason, and its offspring, knowledge, was current among English Romantics. We meet it in Wordsworth's praise of some 'vernal wood' that taught him far more of man than all the sages could,[31] and in Keats' sigh for 'a life of Sensations rather than of Thoughts'.[32] Conversely, however, both Coleridge and Shelley

firmly believed that 'no man was ever yet a great poet without being at the same time a profound philosopher'.[33] It would be easy to multiply examples.

The Romantics could not or would not resolve the conflict between the rational and the non-rational. While painful and destructive this conflict may have been at times in specific individuals, they thrived on it. This made for a strangely compelling and strangely modern view — minds playing with the intellect, employing rationality to weave ever more fantastic patterns, ever more abstract and ethereal configurations while at the same time being deeply concerned to the point of despair over reason's seemingly debilitating functions, its dreaded enervation of man which predisposed the Romantics towards the irrational. Seen thus and anticipating Nietzsche, Romanticism was the creative tension between a uniquely self-conscious intellect and an equally self-conscious anti-intellectualism which by its very nature precluded the pursuit of the thoughtlessly irrational. In any case there are degrees of irrationality. In Romanticism it had sophistication, refinement and 'irony' written all over it. We might indeed call it an 'ironic' irrationalism since it always remained mobile, experimental and self-reflective.

Nonetheless, the anti-intellectual inclinations of the Romantics, their persistent fascination with the non-rational and irrational aspects of existence was real enough, nor has it lost its relevance. This fascination was glaringly manifest in the Romantics' exaltation over life as a power richer, greater, deeper and more rewarding than the bitter nourishment of reason. Life, the Romantics craved and with it *Erlebnis*, a term that now significantly comes into its own, notably in the writings of Tieck. *Erlebnis* meant life experienced deeply and intensely, unencumbered by the sober and sobering mediations of rational reflections, life as immediately and innocently lived by the senses, the passions and the feelings. The Romantics had no trouble at all identifying with Mephisto's curt reply to one of Faust's inquiring students: 'All theory, my friend, is grey, / But green is life's glad golden tree'. Even Schelling hinted at this thirst for immediate experience when in one of his few poems he rhapsodized: 'Life should forget itself in living'. (Das Leben soll im Leben sich vergessen).[34] This surely was behind Keats' cry for a life of sensation which contested the

value of consecutive reasoning, a reasoning which Blake impatiently disowned when he preached the delights of energy and the 'wisdom of excess'. In their own ways both Blake and Keats expressed the Romantics' fierce desire to recapture the 'fullness' of life, the power of instinct and impulse uncontaminated by pale reason which made for fetters and restraints, a hindrance, that to Blake at least, was wholly wicked.

This tendency to plunge headlong into the whirling currents of life to the point of courting sickness, even insanity and death for whatever fruit each had to offer, this unremitting pursuit of intensity and ecstasy which once briefly obtained, producing, not unexpectedly, their own distinct hangovers, I have called elsewhere Romantic vitalism,[35] a vitalism which was but the active and 'sensational' part of the Romantics' emotional response to life, their unwavering belief that the way to truth and wholeness led straight through 'the holiness of the heart's affections'. As we shall see more explicitly in chapters III and IV, this emotional response was no simple 'cult of feeling' even though the achievement of simplicity was one of its cherished aims. It was a metaphysically justified emotionality which invested the heart's affections with an unheard of transcendental significance foreign to a differentiating reason. A.W. Schlegel expressed it aptly: 'Whereas reason can only comprise each object separately, feeling can perceive all in all at one and the same time',[36] feeling purged, of course of gross indecencies, feeling consonant with nature and the deepest workings of the Creation.

This metaphysical cult of feeling frequently revealed a pronounced primitivistic inclination which could look upon a cold and calculating reason as something devitalized and contrary to nature. It was implied in Wordsworth's rather self-conscious cultural primitivism which insisted that man must disown 'false refinements' and 'artificial desires', false habits of thinking and feeling, in favour of humble and rustic life 'because in that condition of life our elementary feelings coexist in a state of greater simplicity', a simplicity at one with nature.[37]

Wordsworth's cultural primitivism, with its implicit Rousseauist rejection of intellectual and mechanical civilization on behalf of nature, was a creed enthusiastically proclaimed in Germany. The German Romantics pressed again and again for more

'spontaneous' and 'natural' forms of existence delivered from the 'curse' of reason. Their return to nature often voiced a longing to be completely absorbed by her. It was the old primitivistic dream of merging with plants and trees, of transcending the enervating effects of rationality by descending into a *sub*rational vegetative unity which obliterated all anxieties of separation, all feelings of exclusion. The writings of the Germans do indeed suggest that it was man's voracious quest for knowledge, his 'unnatural' acquisitive intelligence and, beyond that, his growing self-consciousness and increasing capacity for reflection that drove a fateful wedge between himself and nature, and between his mind and feeling. Karl Gustav Carus conveyed it neatly: 'The higher intelligence develops, the brighter the torch of science shines, the more the sphere of the miraculous and the magical contracts'.[38]

This brings us back again to the Romantics' dread of a disenchanted world laid waste by a rational-scientific culture destructive of everything numinous and 'cultic', their horror before an imminent Wasteland haunted only by a cogitating consciousness visibly trailing through a void, through a reality deprived of all meaning.

It is easy enough to accuse the Romantics here of exaggeration, but this misses the point. It misconstrues their basic response to the failure of the Enlightenment, the failure of its rationality which dogmatically denied the claims, sometimes even the reality itself, of the non-rational by way of instincts, passions and feelings or in the form of man's imagination which it airily dismissed as the source of all errors and illusions. Extreme counter measures were required and by going to extremes the Romantics rescued the seriousness and significance of the non-rational.

Their rescue mission simultaneously sought to retrieve the transrational aspects of the world, its inherent often awesome mystery. There is perhaps no other word in Romantic writing which appeared as frequently as the word 'mystery' or 'mysterious', not to mention some of their derivatives: 'enigmatic', 'miraculous', 'inscrutable', 'secretive' or 'wonderful'. The Romantics were wide awake to the mysteries embedded in existence. They looked at the world in Adamic wonder alert to the 'hidden song' dwelling in all things, and waiting for the magic sound to rouse them. They shrank from the narrowness and

negativity of a seemingly 'enlightened' reason which in its arrogance failed to recognize its own limits. For Enlightenment rationality there were no mysteries immune from examination and explanation, no fetters to man's Knowledge. The tragedy of this rationality, according to the Romantics, was its sharply focused brightness which plunged all things around it into deep shadows, shadows it then deemed insignificant or non-existent. Hence the Romantics' censure of Lessing for 'seeing too clearly', for drawing prosaic distinctions destructive of the whole,[39] their tireless insistence that an inscrutable profound mystery was at the heart of all things, at the heart as well of all genuine literature and art.

Poets and painters rallied in their choice of scenes and subjects charged with the magic of the mysterious: the night, moonlight, caves, mines, mists and the majesty of mountains. And the mystery without mirrored the mystery working within Man himself — in his dreams, visions, fantasies and hallucinations, in his states of semi-conscious reverie, induced at times by artificial stimulation.

The Romantics went to any length to break down our habitual perceptions, to reinstate man's sense of awe and wonder in the hope of safeguarding the sanctuary of mystery from the disenchanting scrutiny of rationality, from its 'irritable reaching after fact and reason'. The last words are Keats' which he used to describe the obstacle to 'negative capability' — the willing acceptance of uncertainties. Keats formulated this principle not as an end in itself, but as a priestly injunction to heed the 'Penetralium of Mystery'.[40] None heeded it more than Novalis who perceived the presence of mystery in virtually everything. Hence his demand that the whole of life should be transformed into something inherently magical, a transformation brought about by 'romanticizing' all of reality. The world, he wrote, 'must be romanticized by giving a lofty meaning to the commonplace, a mysterious appearance to the ordinary, the dignity of the unknown to what is known, the semblance of infinity to the finite'.[41]

Predictably this state of mind professed close kinship with the tradition of the mystics ranging from Neoplatonism to Master Eckhart and Paracelsus, from Tauler, Suso, Hemsterhuis and Oetinger to Swedenborg and to the much-loved charismatic Jacob Boehme, the humble cobbler of Görlitz. Beyond that the

Romantics were well acquainted with things gnostic and spiritualistic, things cabalistic, alchemistic, theosophical and quietistic. To reprimand them for dabbling in the occult or in the pseudo-sciences is to pass judgement at the same time on the false clarity of the Enlightenment which impoverished the human spirit. At its deepest — and we often catch a glimpse of it in Blake, Coleridge and Wordsworth or in the speculations of Novalis, Schelling, Baader and G.H. Schubert — Romanticism forged its own *gnosis,* its own illuminations and revelations of life's great mysteries.

D. The Twilight Realms of Consciousness

Not surprisingly, it was just this immense sensitivity to the non-rational and transrational that made the Romantics uncannily receptive to the claims and promptings of the unconscious. When Freud declared that it was not he but the poets who discovered the unconscious, he should have mentioned the works of the Romantics, for to them belongs the credit of having recognized its profound significance in the affairs of man. In their own fashion the Romantics were indeed the first to explore and chart the mind's 'abyss', the first to declare that the key to conscious life must be found in the concealed corridors of the unconscious. Their explorations of the latter, their analysis of myths and dreams, of hypnotism, somnambulism, animal magnetism and different forms of mental illness, advanced ideas which were to achieve great prominence in modern psychotherapy and psychoanalysis. According to Ellenberger, whose wealth of supporting evidence is truly overwhelming, 'there is hardly a single concept of Freud or Jung' which was not 'anticipated' by Romantic *Naturphilosophie* and by Romantic medicine,[42] both fields being jointly represented by such men as G.H. Schubert, Carus, Troxler (a disciple of Schelling), and Johann Christian Reil.

Thus G.H. Schubert's division of man into body, soul and spirit, for instance, points forward to Freud's tripartite conception of the id, the ego and the superego. Similarly G.H. Schubert's notions of 'egotism' and *Todessehnsucht,* that is longing for death, can be found in Freud's 'narcissism' and 'death instinct'. One of

Carus' many contributions was his insistence on a totally unknowable layer of the unconscious and his belief that we share a kind of collective unconscious through which we relate to other men. He also stressed the dynamic nature of the unconscious which is supposed to possess its own 'healing' wisdom.[43]

Other Romantics made related contributions not least Justinus Kerner through his *Klecksographien* which influenced Rorschach. Of more lasting interest, this physician-poet treated and recorded a sensational case of 'possession', that of Friedericke Hauffe the revered 'Seeress of Prevorst'.[44]

The Romantics' notion of the unconscious differed from ours, of course, in many important respects. We approach it 'scientifically', that is with an eye on verification; they wove around it a sometimes impenetrable veil of unsubstantiated metaphysical and religious speculations. While we tend to think of the unconscious as a reservoir of the repressed which can erupt at times into a seething cauldron of competing drives and appetites — the legacy of Freud — the Romantics looked upon it as an inexhaustible creative darkness which could be tapped for its redemptive energies. The unconscious in their view was the connective link with our innermost self and the bridge to the innermost soul of the world. Out of its mysterious depths arose 'the feeling for the All' which originated in man's experience before the Fall when he communed with the totality of nature. In this as well as in their speculations on myths and symbols begun by Schelling and continued by Creuzer and Görres, the Romantics came closer to Jung.

Whatever else the Romantics may have discovered or read into the unconscious, their high regard for it decisively changed the whole psychology of literature and art. Henceforth the truly creative work was seen to rise from the depths of the unconscious and while reason had a part to play in the creative process it was a subservient part subject to unconscious promptings. As William Hazlitt put it: 'The definition of genius is that it acts unconsciously'. It was the unconscious, in Coleridge's categorical assertion, which comprised 'the genius in the man of genius'.[45] This and this alone, proclaimed Jean Paul, was 'the most powerful thing in the poet', one which blew 'the good and evil spirit into his work'.[46] Jean Paul's rationalistic inhibitions and acute sense of material reality stopped short of yielding completely to the darker

forces from below. Those we sense much more in his contemporary E.T.A. Hoffmann, the novelist of the uncanny, the formidable spinner of tales which fascinated Freud.

The Romantics' contribution to the psychology of literature and art, and, beyond that, to man's entire self-perception was profound, impossible to overstate and impossible to calculate since much of it lives on within us as a debt unrecognized. Their unreserved acceptance of the unconscious, their often daring surrender to it in defiance of each and every reason opened wide the gates to hitherto unsuspected areas of experience, to regions of reality at once attractive and repulsive, beckoning and frightening. We may reproach them for plunging foolhardily into the mind's abyss, of wandering aimlessly in its sunless caverns without securing a life-line with the surface, but such risks face every explorer working on and beyond the frontiers of knowledge. In any case the Romantics knew well enough the hazards of the journey, the dangers of descent, the demons lurking on the 'nightside' of nature as G.H. Schubert called it, demons that lured man into nightmare's alley. Some fell foul of it and became its victim, but in this, as in so many other respects, the Romantics were simply the first Moderns, the bearers of a consciousness, which no longer can turn back but must accept and brave the perils of the deep.

Chapter II
The Holistic Conception of Art

A. Art and the Whole

As we have seen, a quest for the Whole was at the root of the Romantic movement. It determined its hostility to science, mind, mechanism, materialism and its embrace of feeling, mystery and mysticism. What remains to be shown now is the supreme importance of this quest in relation to poetry and art. The testimony of English and German Romanticism here tells its own convincing story.

Thus to Philipp Otto Runge the concept of the Whole was the mainspring of artistic creation. 'Does a work of art not originate the moment I perceive a connection with the Whole?' This perception of the universe in its totality, he insisted, 'drives us on and urges us to communicate'.[1] A.W. Schlegel was still more emphatic. The artists' ability to relate to the Whole, his power to intuit the oneness of all, decided the greatness of his creative gifts. 'The fullness, the totality with which the universe is reflected in the human spirit . . . determines the degree of his artistic genius and puts him in a position to form a world within the world'.[2] And since the work of art proceeded from an awareness of totality it necessarily exhibited an imprint of totality. Hence A.W. Schlegel's definitions of the work as a 'miniature imprint' of the great Whole.[3] Schelling, using a philosophical approach, likewise demanded that the object of art was the universe in its unity and totality. The artist's task was to comprehend and represent 'the idea of the Whole'. Coleridge was merely echoing Schelling when he wrote: 'The object of art is to give the whole *ad hominem*'.[4]

Friedrich Schlegel again appealed to the notions of unity and an

all-encompassing oneness in his notorious definition of Romantic poetry as a 'universal-progressive poetry'. It was *universal* according to Schlegel, not in the restrictive sense of seeking to conform to norms and universitality of appeal, but in the far wider sense of striving to embody within itself all the actual and possible modes of existence. Romantic poetry at the same time was *progressive*, in that it aimed at expressing the expansion, the growth and process of life understood as a ceaseless becoming.[5] In Romantic poetry, wrote his whole-intoxicated brother, '*all* contraries: nature and art ... spirituality and sensuality, terrestrial and celestial, life and death are ... blended together in the most intimate combination'.[6]

With the possible exception of Michael Cooke's *Acts of Inclusion* (1979) no critic, strangely enough, as yet provided a coherent framework for such conceptions. Worse still, notions of this kind even failed to receive a proper name and this despite the fact that the name and the theory it implies can be readily inferred from the context. Thus one can, indeed one must, refer to the above as 'holism', and to the argued assumptions connected with it, as the 'holistic theory of art' — holistic since an awareness of the Whole, a vision of totality and unity, was declared to be the object as well as the indispensable condition for the production of genuine art. And this Whole supposed to be constitutive of art was conceived by some Romantics in the widest possible terms. As Schlegel's just cited passage indicates, it involved the union of the temporal and the eternal, of the sensual and the spiritual, of mind and matter, of the self and things. It could embrace Pantheism as well as Pan*en*theism and, beyond that, the different streaks of Neoplatonism and Transcendentalism. In short, the Whole conceived covered any form of Monism based on idealist foundations.

In any event, this holistic conception cuts deep into the theory and practice of Romantic art. It was implicit in Coleridge's original and still groping discussion concerning the powers of the imagination in relation to the function of the senses. The latter, according to Coleridge, contemplated 'nothing but *parts* — and all *parts* are necessarily little', whereas the former bestowed 'to the mind a love of the "Great" and the "Whole"'.[7] This distinction clearly anticipated Coleridge's more celebrated differentiation

between fancy and imagination in *Biographia Literaria*. The fancy, we are told, is condemned to play with 'fixities and definites'. It receives 'all its materials ready made from the law of association' in opposition to the recreative power of the imagination which blends, fuses and unifies. 'This power', writes Coleridge reminiscent of Schlegel, 'reveals itself in the . . . reconciliation of . . . discordant qualities: of sameness, with difference; of the general, with the concrete; the idea, with the image; the individual, with the representative . . .'.[8] Wordsworth similarly stressed the synthesizing power of the 'Young Imagination'. Like Coleridge, he could look upon the senses — sometimes called the 'bodily eye' — as being concerned only with differences, unlike the 'inward eye' of the imagination which, looking at things, looked *through* them to their underlying oneness. Elsewhere Wordsworth referred to the poet's 'under-sense' of greatness which made him see all parts 'As parts, but with a feeling of the whole'.[9]

Nearly every Romantic poet has left testimony to that effect. While affirming the potency and vitality of the senses each one stressed the necessity of purging perception of its material attachment to the finite. In Blake's matchless phrase: 'If the doors of perception were cleansed everything would appear to man as it is, infinite'.[10] Even Byron who poked fun at the Romantic Imagination could yet insist: 'Thou seest not all'. Our corporal vision 'Is but of gradual grasp'. Man must outgrow the 'littleness' of sight until the soul enlarged perceived the encompassing oneness.[11]

Romantic poetry implicitly proceeded from such precepts. A consuming quest for wholeness pervaded all its efforts. The holism pursued was present not only in the poet's instinctive preference for words like 'all' and 'everything', or in the frequent use of phrases suggestive of the cosmic. Nor was it even present primarily in verses composed to consecrate oneness. Such verses as Coleridge's early poetry shows, could at times be rather self-conscious and rhetorically Miltonic. The holism pursued in Romantic poetry was present first and foremost in the poet's *un*selfconscious blurring of boundaries, in his elevation and transformation of the concrete objects of sense into something more expansive. Wordsworth's poetry here furnished the impulse and provided the direction for a poetic sensibility intent to push all

particularized and localized existence towards a felt or intuited wholeness.

> Dreamlike the blending . . . of the whole
> Harmonious landscape; all along the shore
> The boundary lost — the line invisible
> That parts the image from reality.

Or in a more dramatic vein:

> All things . . . there
> Breathed immortality, revolving life,
> And greatness still revolving, infinite.
> There littleness was not, the least of things
> Seemed infinite.[12]

It is in passages of this kind — and they are much too numerous to cite — that we witness the presence of a synoptic vision, the power of a holistic imagination which is determined to redeem all things from the curse of brute existence, from the ills of sheer contingency that surrounds the 'there' of time, place and circumstance. To this vision the images of sense and the mind that contemplates them, join in a celebration of the One Life pervading all.

The Romantic poets were the militant opponents of anything finite and particular which proudly persisted in a spirit of isolation. Such persistence made for littleness and littleness diminished the grandeur inherent even in the meanest object. Under littleness the Romantics included the dogma of 'singleness', the belief that each thing is completely self-contained and unrelated to anything else. As Wordsworth argued in his criticism of Macpherson's *Ossian*: nature, although making everything distinct, at the same time abhors 'absolute independent singleness'.[13] In Wordsworth's case this aversion to 'absolute singleness' expressed itself even grammatically in his frequent omission of punctuation. Punctuation erects barriers; it creates semantic boundaries inimical to intimations of the Whole.

Thematically, the spirit of the whole was repeatedly evoked through the spirits of air, earth, fire and water. Indebted to Wordsworth's early pantheism, the English poets wove their holistic visions around these ancient elements and their primeval

associations. Shelley's Alastor hailed them as his 'beloved brotherhood', a brotherhood that extended to each element's diverse manifestations: to *air* as endless sky and iridescent light, as luminous cloud and warring winds; to *earth* as solitary plain and imperial mountains; to *water* as illimitable seas, as vaporous spray and cascading rivers and fountains. And when Shelley later came to pursue a more Platonized ideal of oneness, he turned again and again to images of fire to convey his transcendental visions.

Byron's belief in the 'beloved brotherhood' of elements was in parts even more rhapsodic for this brotherhood included Man. 'Are not the mountains, waves and skies a part / Of me and of my Soul, as I of them?'[14] Fittingly *Childe Harold's Pilgrimage* reached its final destination in the sight of a heaving majestic ocean. 'Roll on, thou deep and dark blue / Ocean-roll! ... Dark-heaving — boundless, endless and / sublime ...'[15]

Keats gave to these ancient elements a 'touch ethereal' to which he added the notions of organic process and of time. What Shelley called the 'splendours of the firmament of time' culminated for Keats in the intensity of an 'eternal present' pregnant with the ripeness of the past. '*Feel* we these *things*? — that moment have we stept / Into a sort of oneness ...'[16] Of course each poet summoned the spirits of the elements in keeping with his own conceptions, in keeping with his own set of symbols and meanings. Yet, diverse and changing as these symbols and meanings may have been, all breathed that elevated sense

> Of something far more deeply interfused,
> Whose dwelling is the light of setting suns,
> And the round ocean and the living air,
> And the blue sky, and in the mind of man,

which Wordsworth most intensely felt at Tintern Abbey.[17]

In German Romantic poetry the holistic inclination was just as profound. More than any other it was this inclination which coloured its richly diverse and sometimes ambivalent endeavours. Like their English cousins though far more softly spoken, the German poets concentrated the whole of nature into some of her particulars — more often than not into the enchanted hills and meadows, the haunted streams and woods of their native homeland which turns into a magic mirror of the Great Whole. This poetry

loved the all-embracing night and twilight, the mysterious dark forests, the ever deepening sunsets which deadens the distinctions between objects thereby revealing their unity. Profoundly lyrical, it sings of wholeness, of the song that sleeps in all things; but just as often it laments the loss of unity, the pain of not belonging as we shall presently see.

On a more fundamental level, the holistic inclination implicit in this poetry was manifest at times in its very vagueness and indirectness. Such qualities are often turned against it and deservedly so sometimes in the case of Tieck, Chamisso, Arnim and Brentano and in the case of such lesser lights and later Romantics as Fouqué, Lenau and von Loeben. Yet at its very best, the 'vapourousness' of Romantic poetry, its haziness and indirectness becomes a rich allusiveness, a suggestive ambiguity which is the result of a holistic vision that by its very nature eclipses the hard contours of reality. It is never a sharply focused vision but one which effaces the borderline of things.

While providing the impulse and object for poetic production, this holistic outlook in turn yielded criteria of criticism which the Romantics used to disparage forms of poetry seemingly devoid of any larger intuitions. The sternest critic by far in this respect was Coleridge who condemned Erasmus Darwin's poetry because it presented no more than a 'succession of landscapes' that distracted the eye and made 'the great little'.[18] Landor came in for similar criticisms. Not even some of Wordsworth's lines escaped Coleridge's strictures, the strictures being directed against the Lake poet's alleged 'laborious minuteness and fidelity in the representation of objects'.[19]

B. Painting and the Synoptic Sensibility

A holistic vision was not confined to Romantic poetry. It pervaded Romantic painting as well. The quest for wholeness here was a quest for immensity and vastness — for an enveloping 'self-absorbing' vastness. This vastness comes to the fore in Caspar David Friedrich's paintings portraying an 'infinite landscape'. It prominently emerges in Turner's mature pictures with their gyrating aerial perspectives. It meets the eye no less in those later

Constables that thematically and expressively transcend the scenic and the picturesque 'towards a grand infinity'. (*Plates* 1-5)

What was Samuel Palmer's dream, a Turneresque dream no doubt, but one he strangely failed to realize on canvas?

> To get vast space, what a world of power does aerial perspective open! From the dock-leaf at our feet, far, far away to the isles of the ocean. And thence — far thence, into the abyss of boundless light.[20]

For Turner this light was frankly pantheistic and we hardly require the confirmation of his alleged Last Words: 'the Sun is God'. For Friedrich it was the light beyond all land and seas, the radiance of a divinity breaking in upon a waiting world from a source behind creation. And Constable? Are we to believe that his luminous skies were the result simply of 'scientific' observations coloured by the painter's moods? This pedestrian and wholly one-sided account conveniently ignores that visionary aspect of an artist to whom nature conveyed the Biblical revelation: 'I am the life and the resurrection'. To be sure, unlike Turner, Constable never invented and 'staged' a landscape. Nor did he indulge in Turner's dramatic histrionics. He looked at nature observantly, but also lovingly and with imaginative perception which could transform the local and parochial into images of the vast and boundless. (*Plate* 6)

Admittedly, the vast makes its appearance in art prior to Romantic painting. Claude was clearly captivated by its majesty and so, in a manner less elegaic, was Ruisdael and, among English painters, Richard Wilson, Joseph Wright, Alexander Cozens and others. Yet the vast for all these painters never reached the visionary grandeur nor the quasi-religious and pantheistic meaning it achieved in the compositions of Friedrich, Turner, Constable and the young Thomas Girtin, to mention another Romantic painter who must be included in this context. Towards the end of his short life Girtin increasingly turned away from the picturesque of thatched cottages and rural subjects to painting endless stretches of solitary mountains and austere deserted bays and beaches — pictures all of a pregnant vacancy which convey the Wordsworthian sense 'of something far more deeply interfused'.

To lump the art of these painters under the barren heading of 'landscapes' is an unfortunate classification which does scant

justice to the artists' aspirations and creations. 'Skyscapes' might be a more suitable description especially in view of the untiring application each painter brought to what Constable called 'skying'. One is even tempted to call such paintings 'wholescapes' but the title has a somewhat wayward unconvincing ring. Perhaps the name matters little so long as we appreciate this form of art as intimations of the boundless, or as expressions of the 'Sublime' to resurrect a term then very much in vogue.

It is still a useful term as Andrew Wilton's discriminating study clearly shows. Indeed the notion of the Sublime leads us straight into the heart of wholeness and to an understanding of Romantic art. Following in the footsteps of eighteenth century aesthetics, the Sublime was invariably associated with the immeasurably great or the immeasurably vast. Coleridge, in line with Burke, Addison and others, defined it simply as 'unity' apprehended in the form of an 'endless allness'.[21] Kant, utilising and systemizing the fertile conjectures of his English predecessors, provided additional distinctions that can be directly applied to Romantic art. Beginning with a general definition of the Sublime as 'that which is absolutely great', he then proceeded to distinguish its two-fold aspects — what Kant somewhat drily though rather accurately, called the *mathematically* and the *dynamically* Sublime. The former involves the notions of magnitude, of infinity and totality; the latter the ideas of awesome splendour, of fearful might and omnipotence.[22] Romantic painting — and the same is true of Romantic poetry — often combined both species of the Sublime: immeasurable magnitude with immense force or might. For the Romantic artist generally, the conception of wholeness was indeed inseparable from the conception of mightiness. It was the *mighty* Whole that was the object of their aspirations. Hence the Romantics' attraction to nature's fierce primeval powers previously mentioned, their fascination with force in any form: as soaring mountains and erupting volcanoes, as stormy seas and unfettered clouds piled up to the vault of heaven. Turner obviously delighted in painting scenes of this kind. Constable in turn was drawn to painting thunderstorms and Friedrich could depict alpine glaciers and ships crushed to death under the weight of Polar ice. (*Plates* 7 & 8)

It is possible, of course, to place these painters on the scale of the Kantian Sublime. Thus Friedrich evidently leaned towards the

more quiescent mathematical Sublime, while Turner and to a lesser extent Constable, were attracted to the dynamically Sublime. In either case, however, the Sublime on canvas was cast in the image of immensity — an immensity which compelled the mind to think of God.

For all their internalization of the Sublime, their acceptance of it as 'an Image reflected from the inward Greatness of the Soul'[23] the Romantics' pantheistic inclinations held fast to an older anti-Enlightenment notion of sublimity which associated the might and magnitude of nature with the incomprehensible omnipotence and majesty of God. This stupendous nature expressive of divinity was and remained the touchstone of the Sublime, a nature which roused the soul's sensation of submission and obedience as well as of awe, reverence and wonder.[24]

In passing, Kant made an additional observation, an important and prophetic one at that. Following a hint from Burke, he argued that the 'formless' may be suggestive of the vast and boundless. Translated into art, it implied that images devoid of clearly circumscribed form, or lacking in minute articulation, can evoke the ideas of limitlessness and totality.

Kant's observation anticipated the direction Romantic art was to in fact take. It signalled a development which progressively moved away from depicting sharply defined objects towards representations of less definable phenomena like seas, skies, clouds, mists and vapours, all of which carried the stamp of the Sublime. This development reached its peak in Turner who focused on the seemingly 'undefined' in search of sublime effects. Turner's 'indistinctness' which he condemned as a fault comes across not so much as vagueness but as an enveloping vastness.[25] What remains indistinct in this vastness is 'absolute singleness', that is, the clearly isolated and precisely drawn object, for this would have created a feeling opposite to greatness. As Longinus observed long ago in his tract on the Sublime: 'precision in every detail' may come 'perilously near to littleness'.

While Romantic art generally gravitated towards the vast and boundless, the idea of the Whole productive of such painting could also express itself in different form: in imaginative visualizations of nature's fecundity and overflowing fullness. This identification of wholeness with a procreative fullness found its most striking

embodiment in the art of Samuel Palmer. Distinct traces of it are likewise found in Philipp Otto Runge's pictures which make use of foliage patterns and freely drawn arabesques. Both denote luxuriant growth or vegetal abandon — reminders of the unceasing creative source of life. However, it is clearly in Palmer that the identification of wholeness with a pregnant fullness is expressed most intensely and directly. Palmer may have dreamt of painting 'vast space' and the 'abyss of boundless light' but his most accomplished compositions immediately before and during the Shoreham period celebrate the magic plenitude of Creation. (*Plates* 9 & 10) Fields are thick and ripe with corn, the earth burgeons with growing things, the recurrent globular trees — these ancient symbols of cosmic life and oneness — burst with leaves, fruits and blossoms.[26] To borrow Keats' phrase, everything in these pictures 'is filled with ripeness to the core' filled indeed with the fineness of excess which Palmer so much admired in his self-appointed mentor Blake. This persistent imagery — sometimes sexual imagery — of nature's exuberant abundance is undoubtedly the most obvious single characteristic of Palmer's art associated with Shoreham — his beloved 'valley of vision' through which he sensed at once the wholeness and the holiness of all.

Inevitably the holism rampant among Romantics was to be turned upon the various arts themselves. Where Lessing and other eighteenth century critics passionately defended the 'purity' and *independence* of each art in relation to all the others, the Romantics just as passionately pleaded for their mutual interdependence. Some entertained ideas far more ambitious. Consumed by visions of oneness, they urged the synthesis of all the arts, the joining together of poetry, painting, music and the plastic media into one composite creation, a 'total work of art' (Gesamtkunstwerk). This total work of art would mobilize Man's different senses and thus induce a state of synaesthetic bliss in which the human soul communed with the divine. The arts, insisted A.W. Schlegel, should all be drawn together and take on the sensory effects of one another. Then 'statues perhaps may quicken into pictures ... pictures become poems, poems music'.[27] Brentano attempted some such marriage of media in his novel *Godwi* which encourages the reader to discern through 'the wonderful confusion' of colour, tone and form the functional interrelationship and interdependence of all

the arts.[28] Moved by similar aims Philipp Otto Runge embarked on his compositions entitled 'Seasons of the Day' which he sought to combine with other forms of art. The whole was supposed to be 'an abstract painterly fantastic-musical poem with choirs, a composition for all the arts collectively, for which architecture should raise a unique building'.[29]

If the unity of the arts remained but a dream, the desire to combine different senses within the confines of one art became a common practice and nowhere more conspicuously so than in the poetry of the Romantics. Synaesthesia, the arousal and blending of several sense-impressions into a unified and intensified experience, marked the endeavours of both English and German Romantics. Among the latter, Ludwig Tieck and E.T.A. Hoffmann who in turn could draw on Herder's speculations on the subject, were some of the principal exponents of poetry appealing to the 'community of the senses'. However it was in Shelley and Brentano that this ideal found one of its most compelling expressions. Their poetry, more than any other, embodied the Romantics' dream of seeking for salvation in and through an expanding sensorium that plunged the whole world into an 'ethereal existence'.

Shelley's 'bubbling' stream of words and Brentano's gently undulating rhymes and rhythms stood above all for the poet's attempt to harmonize the spheres of sight and sound which Coleridge explicitly demanded. 'The poet', he wrote, 'must . . . understand and command what Bacon calls the *vestigia communia* of the senses, the latency of all in each, and more especially . . . the excitement of vision by sound and the exponent of sound'.[30] The exponent of sound was none other, of course, than music and we shall see in the following chapter how this much admired art deeply affected the theory and practice of poetry and painting.

Romantic synaesthesia — a clear concommitant of a holistic aesthetic — was to prepare the ground for Baudelaire's 'Correspondences' based on that 'tenebrous and profound unity', where scents, sounds, forms, colours and feelings correspond to one another and to the totality of things. Romantic synaesthesia again points forward to Wagner's music-drama, to Scriabin's colour-music and to Kandinsky's experiments with different arts. Its greatest triumph, however, and this already during the lifetime of most Romantics, was something more intimate and individual,

something more endearing and enduring: the *Lied*, a composite form of art which in the 'songs' of Schubert and Schumann, of Brahms and Mahler achieved a perfect union of poetry and music.

The Romantics made still other claims for art which reflected their holistic outlook. Thus to Coleridge the best of poets produced in Man a sense of harmony, a feeling of being at one with himself. The Germans, more expansively, stressed the unifying and spiritualizing power of art in relation to society as a whole. 'Through the artist', declared Friedrich Schlegel, 'mankind becomes *one* individual' and the world *one* world.[31] To such claims must be added still greater expectations which looked to art as the medium communicating the highest truth. As we shall see in detail later, the Romantics accorded to art a metaphysical significance all its own. Art was supposed to be the unique and irreplaceable connecting link between the human and the divine. It was supposed to disclose a noumenal realm that revealed the very mysteries of cosmic life. In the aesthetic experience, in creating and beholding art, man, it seemed, communed with the world soul and participated in Being.

C. The Power of Love and Longing

Thus far we have described the holistic quest in art in terms primarily of its object. For a wider and more comprehensive view we must turn to the emotions fundamental to this quest, emotions that sustained its force and fire and, in the end, generated a tragic sense of disappointment and of loss — 'the forms of ruin' in Thomas McFarland's apt phrase — which we associate with Romantic poetry and painting.

What sustained the quest for wholeness was an exalted view of love. Love, according to the Romantics, transcended strictly human feelings. It was a cosmic force, a spiritual power that spread its potencies throughout the universe of living things. Infinite and omnipresent, this love, to Coleridge, upheld the 'plenitude of All', illuminated 'manhood's maze', redeemed all mortal toils and tribulations.[32] A kindred, though far more assertive love, appeared to Wordsworth's visionary eye contemplating

nature: 'By love subsists / All lasting grandeur, by pervasive love; / That gone, we are as dust' as dust as all the world would be without its animating vital presence.[33] 'With love', wrote Shelley, 'all things together grow'. It made all creatures one and fully equal. Even 'The spirit of the worm beneath the sod / In love and worship blends itself with God' — in this case a quasi Neoplatonic God.[34]

The Germans similarly revered a form of love that surged beyond the human to the cosmic and its home in the divine from which it streamed forth again into visible creation to become, in Tieck's words, *Die Liebe die der Schöpfung All durchklingt*.[35] (The love resounding throughout the cosmos). Love, they insisted again and again, was the end of history and the final goal of humanity. For Franz von Baader summing up Romantic attitudes, love was the unifying principle in the universe. Manifest in nature as cohesion, affinity and attraction, it held all things together. Without love there would be 'no wholeness'. There would not even be a world.[36]

In its human forms the love embraced by the Germans was by no means a matter only of gentle sighs and faints. For all its lyrical and sometimes sickly sentimental evocations this love contained a pronounced Dionysian component which made for an intense and passionate celebration of life. At once sensuous and spiritual, erotic and abstract, the love pursued frequently looked to sexual union as 'the most compelling symbol of the all-devouring immense passion for oneness' — an androgynously conceived oneness.[37] This made love between man and woman an 'applied religion' according to Novalis. And it is in Novalis that Romantic love achieved one of its finest and most poignant expressions in the strange form of a 'nocturnal' Christianity which embraced the night as the 'womb of revelation', the sacred, ineffable, mysterious night' that culminated in the soul's sensuously experienced *unio mystica*. Novalis' *Hymns to the Night* combined profound psychological, even physical needs with the deepest wells of religious wisdom which addressed the divine as Father, Mother and Lover at once, an androgynous God-language not unknown to the devotional literature of the Middle Ages. On 'balance', the scale in Novalis slightly tilted towards a maternal conception of divinity. In any event, it is a poetic miracle how Novalis succeeded in feminizing a predominantly patriarchal Christian god. For sheer daring and pure archetypal intuition there is simply nothing in the whole of German

literature to compare with the last two lines of his final hymn: *Ein Traum bricht unsere Banden los, / Und senkt uns in des Vaters Schoss.* (Dream bursts our bonds / And we sink down into the womb of the Father.)[38]

The twin of this as of any other form of Romantic love was, of course, the much-sung *Sehnsucht* — longing. Love engendered longing, the irrepressible desire to be united with the world. Shelley characteristically appealed to the 'lodestar' of his longing which led to the Infinite, the One. Wordsworth, by his own admission, obeyed a 'yearning towards some philosophic Song of Truth' resounding with the 'unity Sublime'.[39] This language of longing pervaded all Romantic thought. It moulded the very substance of poetry and art. 'Whereas the poetry of the ancients expressed possession, ours is the poetry of longing'.[40] For once A.W. Schlegel's definition derived from fact. Romantic poetry is pre-eminently a poetry of longing. Page after pensive page, the poet sings not of possession but merely of 'longings sublime and aspirations high'. Nor could he aspire to anything 'higher' and reach for a presence more abiding, for the distance between the soul's desire and its object was truly infinite, as infinite as was the goal of all such longing. Hence the attempt to absolutize longing, the effort to 'infinitize' desire itself. Thus to Friedrich Schlegel longing did not so much imply absence of possession, and therefore lack of fulfilment, but paradoxically, a state of Being denoting quiet and repose. 'Only in longing do we find peace'.[41] Whatever else Schlegel may have meant, his statement clearly implied that man's yearnings will not be crowned by any lasting consummation. Together with the desire for the Infinite, the boundless Whole, we must recognize the impossibility of obtaining them.

Nonetheless the yearning for fulfilment, the 'ache' in Coleridge's words 'to behold and know ... something *one and indivisible*' was a consuming passion which drove the Romantics to search for their imagined homeland everywhere: deep within the human mind as well as in the most far-flung corners of their world. Roving souls, shifting from townhouse to cottage and country and from there to still more distant shores and places, they were always in motion egged on by an incurable longing. 'Within me', confessed Karoline von Günderode, 'was an aimless longing, and I kept on

seeking, and what I found was never what I had thought; and in my longings I wandered through the infinite'.[42] Like Wordsworth, each Romantic could truly say: 'I, too, have been a wanderer' of 'unvisited places' pining for a presence which the noisy rootless world disowns — the same world which later in the century, and increasingly in our own, drove countless artists into voluntary exile in search of new beginnings.

This restless mobility translated itself into Romantic poetry and painting. The painter instinctively turned to images of nature communicating a sense of ceaseless motion: to massing clouds and wind-swept shores, to surging seas and violent storms, to departing and arriving ships — the latter being perhaps the most obvious symbols of Romantic restlessness and longing. (*Plate* 11) Even where Romantic art conveys a feeling of utter stillness as in the painting of Friedrich, the stillness is charged with a profound tension which speaks of the soul's boundless yearning to traverse the vastness of the All to reach its final destination.

The same restlessness found an even more immediate expression in the poets' personifications: in Wordsworth's female vagrants, searching solitaries and itinerant pedlars; in Shelley's mythologized *Prometheus* and Keats' *Endymion*; in Byron's *Childe Harold's Pilgrimage*. It was just as pronounced in Tieck's *Franz Sternbald* and *William Lovell* and in Novalis' *Heinrich von Ofterdingen*. Restlessly exploring the earth — and in the case of Keats, Shelley and Novalis, even the vast spaces and the temporal limits of the universe — these Romantic voyagers spurned any invitation to secure anchor and rest. No sooner have they arrived at an island beckoning peace and they sailed forth again towards still further distant and receding horizons. Shelley's 'my soul is an enchanted boat' which floats forever round and round 'Into a sea profound, of ever-spreading sound . . .' was but a most lyrical and tender-minded expression of desire unappeased.[43]

Not surprisingly, the Romantics have frequently been charged with yearning 'for what is not', with chasing invisible unobtainable splendours. Theirs, it is often said, was a journey without a goal, a love and longing without a real object.[44]

There is some truth in this. Indeed the same conclusion could be arrived at if, instead of from longing, one proceeds from the Romantic infinite itself. This infinite or boundless Whole defied all

human understanding. It was forever eluding the Romantics. When Wordsworth wrote and wrote quite well that 'Our destiny, our being's heart and home, / Is with infinitude, and only there',[45] the infinite, unfortunately, being everywhere was at the same time nowhere. Just because it could be identified with virtually anything, it was for this reason nothing. Hence nothing in the end could assuage desire, nothing bring fulfilment and repose. As *Childe Harold* put it '... there are wanderers o'er Eternity / Whose bark drives on and on, and anchor'd / ne'er shall be'.[46]

Valid as this explanation may be, in the last analysis it is much too one-sided, for Romantic longing, like Romantic love, contained an active and a passive component, a positive and a negative dimension. In its passive manifestation it could indeed express itself as a self-indulgent drifting into nowhere, an escapist seductive pull away from the prosaic concerns of everyday existence. Tieck, Wackenroder and Brentano or, for that matter, Keats and Shelley provide numerous poetic and fictional examples of a mentality which nowhere came to rest on what Jean Paul tellingly called 'the hard bunkbed in the guardhouse of life'. (die harte Pritsche in der Wachtstube des Lebens.)[47] It was clearly not the home of Godwi, Franz Sternbald or Joseph Berglinger.

In its active and positive forms, however, Romantic longing always retained a sense of purpose and direction, 'a positive awareness', in Alan Menhennet's well-chosen words, 'of a real object and even some degree of participation in it'.[48] While wholeheartedly following the call of longing, the self here never completely renounced control or entirely succumbed to it. This form of longing ran parallel to and was reinforced by the Romantics' acceptance of reality as movement, their belief that life, borrowing Arnold's words, was not 'a having and a resting, but a growing and becoming'. Nor again as we shall see shortly was this form of active longing incompatible with an embrace of death as the consummation of desire, 'the day of birth' in Novalis' phrase, which initiated man's transformation.

In the end the solution to the vexing problem of what is positive and negative in Romantic longing can be found only by considering the relative stability or instability of the personality concerned or, putting the matter another way, by carefully analyzing where in each given case the accent of yearning lies: on

participation in the object or state desired, on consummation of the search and on a new integration of the self, or on release, oblivion, escape, on what Hoelderlin, who came to resist this powerful temptation, called the 'wunderbare Sehnen dem Abgrund zu'[49] — the wondrous yearning toward the abyss which is hauntingly evoked in E.T.A. Hoffmann's Elis Fröbom, the ill-fated miner of Falun.[50] The challenge of interpreting Romantic yearning begins precisely with figures like Elis, where we meet a split personality or a duality of motives: a longing which could find consummation in earthly love and a powerful unconscious drive towards annihilation in the petrifying depths of nature — an instance of the *Todessehnsucht* described by G.H. Schubert.

D. The Pain of Longing

Yet even at its best Romantic yearning was fraught with ambiguities and inherent perils. Thus Goethe wrote of Runge's cosmic aspiration that 'it wants to embrace everything and in doing so becomes lost in the elemental'.[51] However this could be dismissed as the not unexpected sour grapes from Weimar. More painful was the experience of homelessness which is the inevitable consequence of deep longing. Related predicaments followed given the absoluteness of the Romantics' quest. Thus intent on 'total fusion' they often stretched themselves too far and suffered the fate of 'total isolation'. Romantic holism was prone to such misfortunes. Its reverse was an unmitigated pessimism and cosmic disquiet. The poets' and painters' prodigious straining to embrace everything often left the heart painfully empty, conscious only of its loneliness and despair. Hence the frequent confessions of soaring hopes dashed to naught on the barren rocks of desolation: 'As high as we have mounted in delight / In our dejection do we sink as low'.[52] Thus their song of love and longing was at the same time a lament over man's isolation and exclusion from the Whole. Inevitably, a sense of pensiveness and pathos crept into their conception of the world, what Schleiermacher called the pervasive mood of 'holy sadness'. 'What do you call that feeling of an unsatisfied longing which is directed towards a great object, and which you are conscious is infinite?' — None other than *heilige Wehmut*![53]

Among painters, such moods were hauntingly evoked by Caspar David Friedrich. His pensiveness could indeed sink at times towards the sternly melancholic. Now and then it arises from the confrontation of man's fragile finitude with an overpowering 'infinite allness'. It evidently does so in his awesome 'Monk by the Sea'. Friedrich's desolate landscapes with their eerie lights, his mountains enshrouded in roving mists, his snow-bound graveyards and fog-surrounded ships, express a solitude at once sublime and chilling. A profound silence emanates from such paintings, a silence born of pious hopes and a sense of weariness and desolation. (*Plates* 1, 12, 13 & 21)

On the surface, Turner's art seems far removed from Friedrich's pained and pensive contemplations. Composed of light and blazing hues, it appears to express the opposite of sombre moods. Yet as Turner repeatedly revealed, this light can burn with a fierce destructive heat that reduces all human hopes and aspirations to smouldering cinder and ashes. Turner's pessimism, his belief that man is the helpless plaything of mighty titanic forces, pervades many of his paintings. They speak of 'hopes delusive smiles', of what he called 'The Fallacies of Hope'. (*Plate* 14) — Nor was Constable immune from such pessimistic moods. Indeed — and like Turner — he suffered from prolonged fits of depression when he complained of being a 'prey to anxiety', of having to live 'by shadows'.[54] The shadows do appear in his pictures. While he excelled in painting the morning-freshness on country fields and meadows, he could also paint remote and barren landscapes over which hangs a brooding darkness and an air of desolation. (*Plate* 15)

Palmer in turn was arguably the far more tragic figure for it seems that in the wake of increasing disappointments and the struggle for existence his creative powers waned. Judging by his own testimony, the dale of Shoreham — initially a joyful, veritable Garden of Eden — turned into a 'den of . . . agonies'. The once blessed visions of nature's procreative fullness grew gradually darker and dimmer. His paintings after Shoreham began to lapse into a prosaic pastoral convention which lacked the exuberance and vitality of Palmer's preceding compositions. 'Our Ossian Sublimities are ended . . . poetic vapours have subsided and the sad realities of life blot the field of visions'.[55]

Romantic poetry was haunted by similar feelings. Of course not all of them were occasioned by cosmic despair. Lack of recognition and the daily drudgery of living saw to that. Nonetheless, among some poets the soul's failure to achieve total fusion with something 'one and indivisible' was experienced with peculiar intensity. Suspended between the finite and the infinite, the partial and the Whole, they turned into tragic bearers of longings unfulfilled. It predisposed some towards nihilism, or to what Morse Peckham aptly called Negative Romanticism which signified the complete loss of meaning and value.[56] Associated primarily with the Byronic hero, this nihilism or Negative Romanticism was to some extent anticipated by Hoelderlin's *Hyperion*, Ludwig Tieck's *William Lovell* and still more emphatically — though with rather grim and grisly overtones — by Bonaventura's *Nachtwachen* (Nightwatches) in which Nothingness has truly the last word.

If Bonaventura's unrelieved chilling nihilism occupied an extreme position, the notorious and altogether misunderstood *Weltschmerz* of the Germans was, on the whole, a more pervasive and poignant expression of yearnings unappeased. Novalis' pensive observation was a variant of it: 'Everywhere we seek the infinite, and always find only finite things'.[57] If true, then one could but pine for a peace which the world does not give, a peace which drove Shelley, pursuing his own spiritual beauty, beyond this sublunar sphere of shadows.

> I loved — oh, no. I mean not one of ye,
> Or any earthly one, though ye are dear
> As human heart to human heart may be; —
> I loved, I know not what — but this low sphere
> And all that it contains, contains not thee . . .[58]

In Neoplatonic terms, this represents the soul's still unconsummated union with the Divine from the imagined vantage point of which the whole of material Creation is experienced as a 'vale of tears', sadly lacking in ideal beauty and perfection.

Wordsworth proved no exception to such feelings of intense disquiet. Although no Neoplatonist himself and ostensibly championing the claims of the concrete, he could write with melancholic sadness: 'The world is too much with us'. Rather be a pious pagan at home with nature and in possession therefore of the

Whole, than lead a 'life forlorn', unredeemed by the presence of the Holy.[59] This was no momentary lapse into conventional nostalgia: Wordsworth expressed such sentiments in verses far more compelling, one of which even hinted at the notion of a 'suffering God' beloved by the Germans. 'Suffering is permanent, obscure and dark, / And shares the nature of infinity'.[60]

Wordsworth's poetry indeed suggests that man's fate is not dissimilar to his solitary Margaret who, travelling far and wide, discovered the futility of all searching. 'About the fields I wander / knowing this Only, that what I seek I cannot find'.[61] Or again, we are like Emily of Bolton: pilgrims of a penitential solitude subjected to a 'holy' and 'stern melancholy'.[62] This sombre mood gave way at times to perplexing premonitions, to something approaching metaphysical disquiet that broke out into incomparable lines such as these:

> o'er my thoughts
> There hung a darkness, call it solitude
> Or blank desertion. No familiar shapes
> Remained, no pleasant images of trees,
> Of sea or sky, no colours of green fields;
> But huge and mighty forms, that do not live
> Like living men, moved slowly through the mind
> By day, and were a trouble to my dreams.[63]

What were these mighty forms? Forms of sheer dread or premonitions of dark powers overwhelming man? We are not told.

It could well be argued that the most profound passages in Wordsworth's poetry, and in Romantic poetry generally, are not to be found in the familiar homilies on daffodils and celandines, nor even in the raptures of an apprehended oneness, but in verses and lines that convey the homelessness of the human spirit and the silence of 'absent things', the silence to which Keats' 'Darkling I listened' surrendered with heavy 'leaden-eyed despair'.

Wordsworth kept his composure and tranquility. Moments of surging joys and vouchsafed visions redeemed uneasy premonitions and intermittent feelings of disquiet. Others fared less well, least of all Coleridge, this inherently tragic figure whose desperate search for wholeness left his life, his thought, his art in virtual ruins. Already as a youth Coleridge felt the 'Dim-visaged

shapes of dread'. He suffered from a temper 'sore with tenderness / When aches the void within'.[64] It never left him! The higher his imagination soared, the more exulted his vision of an all-encompassing oneness, the deeper his fear of being exiled to a 'lone-some tent', of being cast into the 'Limbo of a wall'd round' self that crushed the soul into a thing of stoniness and silence.[65] Alienated from the spirit of hope, addicted to opium and suffering the miseries and self-loathing consequent upon addiction, Coleridge could succumb to the grimmest forms of despair: 'A grief without a pang, void, dark, and / drear, A stifled, drowsy, unimpassioned grief / . . . And still I gaze — and with how blank / an eye!'[66]

Throughout Coleridge's major poems and Notebooks, there runs this under-current of profound disquiet and troubled restlessness, a restlessness which in turn was clearly mirrored in his philosophic journey. From Unitarianism and Necessitarian beliefs, from being a follower successively of Godwin, Darwin, Priestley, Hartley and Spinoza he rushed from these different forms of Pantheism to the various types of Idealism: to Kant, Fichte, Schelling, to the mystical creed of Boehme and back into a Trinitarian Christian faith. His was indeed a shipwrecked life and a shipwrecked knowledge, as Professor McFarlane has persuasively and movingly shown.[67] For this reason Coleridge's 'tragic existence' may well touch us on a deeper level than a more 'completed' life might have done since it holds up a mirror to our own inevitable foundering.

E. The Promise of Death

What of other Romantics? How did they cope with a longing that was essentially an incurable affliction? Not surprisingly, some sought to alleviate the pain of longing by recklessly plunging into the maelstrom of existence, by pursuing the 'life intense' previously discussed. Even less surprisingly, and quite in keeping with such pursuits, the Romantics simultaneously courted death as a means to escape cosmic isolation and achieve 'eternal wholeness'. Hence all these numerous invocations to the powers of dissolution, pictures and songs that celebrate man's return to a

primeval home beyond corporeal existence. This glorification of death was characteristic of the Germans, notably of Novalis and of Caspar David Friedrich. Novalis' *Hymns to the Night* and *Spiritual Songs* are supreme examples of desires which this 'dull and clodded earth' denies. To quote but one stanza of Novalis' final hymn to the night entitled 'Yearning for Death':

> Gelobt sei uns die ew'ge Nacht,
> Gelobt der ew'ge Schlummer.
> Wohl hat der Tag uns warm gemacht
> Und welk der lange Kummer.
> Die Lust zur Fremde ging uns aus,
> Zum Vater wollen wir nach Haus.[68]

(Praised be the everlasting Night, / Praised be eternal slumber! / Day's warmth has animated us, / And withered by sorrows without number. / For alien lands we no more yearn, / To our Father's house we would return.)[69]

Contrary to some critical responses, Novalis' culminating hymn does not preach the nirvana of extinction, the bliss of oblivion. If it praises night and sleep as the symbols of eternity, it is not least because the holiest of things have been hidden there, kept out of sight from the unholy gaze of day — the glaring light of the Enlightenment which as the fifth hymn suggests has little use for man's deepest other-worldly yearnings. Beyond that the final poem and the whole cycle of hymns celebrate the Night as the Queen of the world, the Mother of Love, the reign of the eternal feminine with sleep signifying the force of erotic-spiritual union which turns into religious communion. Nowhere does Novalis picture the 'womb of night' as the final tomb. Night is the well-spring of creation, the 'mighty womb of revelation' which brings forth a new birth, a new life after death.

There is nothing weary and resigned about Novalis' final hymn affirming death. As one of his sternest and most perceptive critics has remarked, this poem of death and sleep possesses an immense vitality; 'the rhythm of every stanza is informed by an ardent energy' — a positive thrust which triumphs over the negative.[70] Nor again was this positive thrust towards fulfilment in death proclaimed at the expense of the demands of the day, of the duties each man must perform. 'Gladly will I stir my industrious hands,

look about everywhere thou hast need of me'.[71] For all his otherworldly longings Novalis, paraphrasing Nietzsche, never betrayed the earth. His idealism was always balanced by an admirable sense of realism, be it in the pursuit of profession or in the pursuit of human relationships.

A still more sober-minded realism coupled with an unbending, uncompromising sense of duty complemented Caspar David Friedrich's otherworldly aspirations. Unlike Novalis' *Todessehnsucht* which combined the sensual and the spiritual, Friedrich's ascetic Protestant piety precluded anything voluptuous and erotic. His pensive sometimes obsessive preoccupation with Man's mortality and salvation found expression in melancholic paintings of graves, funerals and ruins. He voiced his longings once in a self-made verse addressed to his carping critics: 'Why, the question is frequently put to me, / Do you so often choose as the subject for painting / death, transcience, and the grave?' And he replied: 'In order to live one day eternally, / One must subject oneself to death repeatedly'.[72] At the age of thirty, Friedrich even portrayed his own funeral as a foretaste of eternity. However it is not in such graveyard scenes, or in the later pictures of coffins on which are perched huge owls, that Friedrich's art convinces most or makes its greatest impact. His belief in the soul's journey towards its final destination is far more hauntingly evoked in pictures of ships floating down rivers or sailing out into an endless sea beyond which lie the shores of everlasting peace. (*Plate* 16) His close friend and admirer, the Romantic philosopher of nature, G.H. von Schubert has pointed to the meaning behind these and other paintings.

> At last the mind understands that the abode of that longing which has guided us so far is not here on earth. Speed on then, river, down your way! Where your waves flow into the infinite sea on a far distant shore we have heard of a last place of rest. There indeed the inner fire shall cool, the deep wound shall heal.[73]

This preoccupation with death was not at all confined to the Germans as many modern critics would like us to believe. English Romantic art makes its own distinct appeals to the powers of transcience, and such appeals are present even where the eye least expects them — in Turner's painting.

Turner a painter of death and 'blissful dissolution'? Yes, indeed, and the evidence for this seemingly strange assertion is found not only in compositions revealing an explicit apocalyptic intent, compositions, that is, which deliberately invoke the angel of death and destruction. Nor again is it found only in pictures like 'Burial at Sea', or 'Hero and Leander' which tells the story of a tragic love and of suicide in the sea. It is found, above all, in Turner's irresistible fascination with the vortex which draws everything towards its gaping centre. What is this fascination with the recurrent vortex in his paintings if not a fateful attraction to the void, to the 'abyss of boundless light' which swallows all distinctions? (*Plate* 17)

Turner was an obsessive painter. He instinctively painted *into* the sun and *into* the sea. The latter was his first obsession. He could not help being drawn to 'the power, majesty, and *deathfulness* of the open, deep, illimitable sea' as Ruskin aptly phrased it.[74] And he rendered its deadly aspect in the form of violent whirlpools. Nor — his second obsession — could Turner help being drawn to the consuming power of light and flame painted as whirling masses of fire. No artist could have painted water and fire with such persistence and in this 'vortexing' fashion unless he was secretly attracted to the 'deathfulness' of these elements. On a deeper level, the underlying theme of many of his pictures centres on death by water and by fire which corresponds with the soul's ancient longing to merge with a primeval undifferentiated wholeness. Seen from this vantage point Hazlitt's famous remark concerning Turner can be interpreted in quite a different light. There is a sense in which Turner's art is indeed 'without form and void' — it is the void of non-being. Alternatively, Turner does 'delight to go back to the first chaos of the world' — to that original state of Creation in which no thing as yet knows of the solitude of separate and transcient existence.[75]

Owing to their medium, the English poets could express the longing for death far more directly. They all did, from Wordsworth's 'sad delight' at the grave of Burns to Shelley's longed-for moment when 'the pure spirit' shall flow back to 'the burning fountain whence it came'; from Byron's invocation of that 'dread power' which 'walks in the shadow of the midnight hour', to Keats' celebration of the same hour in his memorable Ode.[76]

Where Keats was merely 'half in love with easeful Death', Heinrich von Kleist and Karoline von Günderode died by their own hands. Strangely enough, a premature death seems to have been the fate of other Romantics and to the names of Kleist and Günderode one must add those of Runge and Novalis, of Wackenroder, Keats, Shelley and Byron. Of a few at least it could be said that their life exemplified a destiny diagnosed by a kindred modern spirit: 'A yearning knocks at the door of the world of which we must all die'.[77]

Of course, not all Romantics courted death with the same intensity nor looked upon it as the sole avenue to spiritual salvation. Some, disenchanted with a receding far-off Infinite, soon channelled their inordinate longings into established forms of religion. Thus Friedrich Schlegel and Brentano sought safety in the comforting arms of Mother Church. Wordsworth and Coleridge found refuge in an orthodox Anglican Faith. Others similarly returned to systems of beliefs more time-hallowed, more hopeful and reassuring than their previous pursuit of unobtainable splendours. Coleridge's *cri de coeur* in one of his later poems summed up the Romantics' spiritual dilemma: 'Hope without an object cannot live'.[78] Perhaps it can't. Unfortunately, the object embraced did also include some rather outworn political and social ideals which somewhat stained the original purity and revolutionary impetus of the Romantic spirit. But by then its creative fire was already cooling off. It is a sad yet incontestable fact that once the Romantics became conservative in politics and orthodox in religion, that once they joined those 'solemnm institutions', in Wordsworth's telling lines 'to guard against the shocks, / The fluctuation and decay of things',[79] their original genius declined or turned to completely different things if it was not subject, that is, to prolonged periods of stagnation or depression as in the case of Coleridge.

In any event, for all those who 'survived' into a prosaic, positivistic age, the holistic quest had ceased and they could uneasily ponder the question Keats took to his grave:

> Was it a vision, or a waking dream?
> Fled is that music: Do I wake or sleep?[80]

Chapter III
The Expressive Theory of Art

A. 'The Language of the Heart'

'The true principle of Romantic art', announced Hegel in his *Lectures on Aesthetics*, 'is absolute inwardness'.[1] Few would have disagreed with Hegel at the time, not even those disinclined to accept his dialectical deliberations for what he affirmed was clearly visible in Romantic poetry and painting, and, above all, in Romantic music. Repelled by an age concerned almost entirely with externals and their utilitarian significance, the Romantic artist invariably turned in upon himself. Yet this turning inward was more than just a reaction to the dominant rationalistic and scientific temper of the age. It was simultaneously a genuine awakening to the voice of the heart, to the claims of human passions and feelings which were now declared to be the very life of art. With Romanticism begins what has prevailed virtually unopposed ever since: an expressive aesthetic which maintained that the first and foremost function of art is to express and to communicate emotion.

While some of this expressive point of view was prefigured in the eighteenth century, notably in Rousseau and the restless rebels of *Sturm und Drang*, the Romantics' affirmation of emotion as the mainspring of art was more radical and revolutionary as well as more metaphysically inclined, as we shall see. No major poet before Wordsworth would have thought of, let alone dared, to define poetry as 'the spontaneous overflow of powerful feelings' nor would any major painter prior to Constable have annnounced that 'painting is with me but another word for feeling'.[2] Neither was alone in extolling what Constable called the 'language of the heart' which is the only one that is universal.[3] Thus Keats was of

nothing so certain as the 'holiness of the Heart's affections' and when he praised intensity as the criterion of excellence in poetry it was in praise of life *felt* in all its immediacy and fullness.[4] Shelley's emphasis on emotion as the life and substance of art was just as pronounced. Even Byron, so often the mocking exception to Romantic expectations, thought of poetry as 'the expression of *excited passion*' often self-indulgent and Janus-faced passions as Andrew Rutherford pointed out long ago.[5]

Of course this exclusive affirmation of passions and feelings should not obscure the implicit recognition of conscious deliberations during the creative process. The Romantics knew well enough that great poetry is rarely, if ever, the spontaneous overflow of powerful feeling nor, in Keats' organic metaphor, does it come 'as naturally as the leaves to a tree'. The rule of poetic composition is not *Kubla Khan* but *Christabel* over which Coleridge laboured endlessly. In other words feelings are almost always allied to reason and reflection, 'emotions', in Wordsworth's well-known phrase, 'recollected in tranquility', in a state of *Besonnenheit* to use a favourite term of the Germans. Tranquility and *Besonnenheit* implied premeditation, consciousness of aims and with it the ability to control the flow of feeling. Nonetheless, the expression of feeling was and remained the Romantics' chief concern.

Indeed the German Romantics placed an even greater premium on emotion as the mainspring of art and none more so than the youthful Tieck and Wackenroder in their joint publications.[6] Of the two, Wackenroder was the more pious and persuasive figure, the true prophet of a new sensibility which canonized art as the divinely sanctioned vehicle of emotional revelation, the mirror of the human soul as it yearned for God. Wackenroder's 'religion of feeling' was almost always a feeling for religion, one which soon after achieved great prominence in the pantheistic reveries of Schleiermacher.

Similar to Wordsworth's definition of poetry Wackenroder as well as Tieck favoured images of fluidity to describe the creation, the nature and the enjoyment of art. The very title of Wackenroder's famous tract *Herzensergiessungen eines Kunstliebenden Klosterbruders* (Outpourings of an Art-Loving Friar) points to what the whole book proclaims: true art issues

from the heart's overflowing fountain which has its source in God. All these recurrent images of fluidity which appear not only in Tieck and Wackenroder but throughout Romanticism suggest an inner life in constant transformation, in ceaseless motion, an inner life which is pictured now as a gently bubbling brook, now as a deep and darkly flowing stream, now as a fearsome torrent of irrepressible passions and feelings.

Wackenroder's unique contribution to an expressive aesthetic — unique not least since it was refreshingly innocent of any fashionable theorizing — fell on fertile soil with the Nazarenes, the group of Rome-based German painters intent on revitalizing an outworn Christian art. More immediately however Wackenroder's religion of art and panegyric of feeling continued in Tieck's *Franz Sternbalds Wanderungen,* an artist's novel which directly influenced Philipp Otto Runge's notion of painting. Novalis' definition of poetry as 'the representation of the soul (Gemüth), of the inner world in its totality' was very much part of this Romantic attitude.[7] It made plain moreover what the Romantics generally understood by their rather unspecified use of the word 'feeling' as the substance of art. It simply stood for man's mental life outside the strictly rational. It embraced Wordsworth's 'flux and refluxes of the mind' as much as Coleridge's 'modes of inmost being' residing in 'the twilight realms of consciousness'.[8] The word feeling, in short, covered everything visionary, intuitive and imaginative as well as everything passional, instinctive and subconscious.

Embodying feeling, the work of art evidently aroused feeling in the beholder, in the audience. In this wider sense, art in A.W. Schlegel's terminology becomes *Gemüthserregungskunst,* an art that stirs the spirit and the soul of man. One of its prime functions was to purify and enrich human sensibility, instil a tone of unity and harmony. An equally important function for the Romantics was its ability to break new ground, to penetrate into regions of awareness hitherto uncharted or unknown. Thus Wordsworth insisted that 'the only infallible sign' of genius 'is the widening of the sphere of human sensibility ... Genius is the introduction of a new element into the intellectual universe'.[9] Wordsworth's views were echoed by many Romantics who maintained that the true artist excelled in originality, in creating novelties.

A vital feature of Romantic literature and art, this quest for novelty and originality contained both promise and temptation. Friedrich Schlegel unknowingly voiced the latter when he wrote that 'from the Romantic point of view the most curious sorts of poetry, even the eccentric and the monstrous are of value ... provided there is in them some grain of originality'. Schlegel's provocative view should be read however with his scathing ridicule of the Germans' 'mania for originality'. As his critical reflections on 'communication' clearly show, the demand for novelty had to comply with the strictest of conditions.[10]

B. 'No Mimic Show'

The Romantics' embrace of emotion as the mainspring of art perforce denied the claims of imitation as the proper object of poetry and painting. The artist's first obligation was to heed the voice of his heart and not to imitate the externals of nature, be it in the idealised forms of Neo-classicism or in the more straight-forward manner of Realism. Not the external world, insisted Caspar David Friedrich, but 'the artist's feeling is his law'.[11] Hence Friedrich's much-quoted advice to his fellow-painters: 'Shut your corporeal eye so that you see first your picture with your spiritual eye. Then bring to light that which you saw in the darkness, that it may reflect on others from the outside to the inside'.[12] Friedrich's art still relied on the outward forms of nature but it is always nature transfigured by the inner light of the *Beseelung*. It is nature painted with the spiritual not the corporeal eye.

Blake, guided by his own visionary light, was far more scathing and outspoken in his dislike of imitation. No sane person, he wrote dismissively, could ever think that imitating 'the objects of nature is the art of painting'. At its lowest, imitation reduces art to 'the sordid drudgery of facsimile representations', doubly sordid since they were representations of merely mortal and perishing substances'. At its neo-classic highest, imitation made a mockery of inspiration. Blake showed undisguised contempt for Joshua Reynold's doctrine of mimesis which generalized from the particulars of nature to compose the most perfect forms. Mincing few words, Blake called it an idiot's procedure. Painting, like

poetry and music, had to be delivered from this dreadful mimicry to follow its own inventiveness and 'visionary conception'.[13]

Blake's much younger contemporary and staunch admirer Samuel Palmer was in his gentle way even more radical and provocative when he wrote: 'Nature is not at all the standard of art, but art is the standard of nature. The visions of the soul, being perfect, are the only true standard'. Palmer's Shoreham pictures are such visions of the soul which 'breathe on earth the air of Paradise',[14] visions that do not so much judge as redeem nature. Good art, of course, has always revised and channelled our perception of landscape. In this sense art is indeed the standard of nature.

Poets similarly dismissed the precepts of mimesis as incompatible with the inspirations of genuine art. For Wordsworth poetry was 'no mimic show' but 'itself a living part of a live whole'.[15] All true poetry proceeded from imagination and feeling. Coleridge's denial of imitation implicitly followed from his conception of the poetic imagination which modified all objects in accordance with a 'predominant passion'. More generally, in poetry the images of nature must always reveal the imprint of 'the poet's own spirit'. As Coleridge wrote elsewhere, if there is only 'likeness to nature without any check of difference, the result is disgusting'.[16] Although Coleridge insisted that art should imitate nature, he had in mind a form of 'creative imitation' which involved the artist working in strict harmony with the formative drive active in Creation, of which more will be said in Chapter V. This creative imitation necessarily excluded purely descriptive verse, which Coleridge declared to be the product of inferior fancy, ruled by sense and the law of association. True poetry transcended sense and the recurrent impressions made by it upon the mind. In Shelley's eloquent phrase; 'poetry defeats the curse which binds us to be subjected to the accident of surrounding impressions'.[17] It recreates the universe in the light of the poet's imaginative vision which, suspending our prosaic and routinized awareness of the phenomena of nature, restores to us the wonders and delights of the world.

There is no want of Romantics passionately opposed to the doctrine of mimesis. Whatever their reason for rejecting imitation, it implicitly or explicitly followed from their belief that the principal

function of art was to express emotion. Predictably this expressive bias brought about the substitution of important criteria of evaluation, of how a poem or painting, or any other work of art, ought to be judged. Immediately 'truth to nature', a standard which in one form or another had been the very bedrock of art for centuries, gave way to 'truth to feeling', a precept which in turn suggested other 'affective' criteria such as 'sincerity', 'authenticity', 'spontaneity', 'intensity' and, of course, 'novelty' or 'originality'. All these criteria are still the cherished canons of today, a case in point again of how much we are the heirs of a romanticism which in Baudelaire's well-known words was 'precisely situated neither in choice of subject nor in exact truth, but in a *mode of feeling*'.[18]

C. Anticipations of Modernism

The Romantics passed down more than just a number of important criteria for appraising literature and art. As Robert Rosenblum and other critics have repeatedly shown, the very momentum of their expressive aesthetic carried them to the edge of modernism, near such movements as Expressionism, Surrealism and non-objective poetry and painting.[19] Owing to their greater speculative bend and intellectual agility the early German Romantics in particular developed aesthetic concepts and ideas far ahead of their times. Thus Tieck's *Sternbald* frequently voiced sentiments which we meet again and again in the Expressionists. 'Not these trees, not these mountains do I wish to represent', insisted Sternbald the Romantic painter, 'but my soul, my mood, which governs me at this moment. These I want to express and communicate to like-minded men'.[20] Imitators are given short shrift in the novel. They are classified no higher than those who mimic the cries of birds and other animals.[21] Elsewhere in this strangely meandering tale one of Sternbald's companions contemplating a glowing sunset dreams of an art consisting of nothing but 'garish colours without connections', a form of painting, in other words, which makes its appeal primarily through non-representational means.[22] Tieck in this context implied a point of view which Baudelaire expressed with great lucidity later in the century: 'Painting is only interesting

by virtue of colour and form ... both make us think and dream; the pleasures resulting from them are ... absolutely independent of the picture's subject'.[23] Although Baudelaire did not think of non-objective art, his words describe accurately the peculiar benefits of this form of painting.

For its fictional birth in Romanticism we must turn to one of Tieck's successors — the later Swiss Romantic Gottfried Keller whose *Grüne Heinrich*, another artist's novel, describes in great detail and with an almost uncanny foresight the pictorial and psychological processes terminating in abstraction which at last liberates the artist from the dead weight of imitation, from the burden of having to portray an 'abominable reality' that everywhere impedes the advance of beauty and perfection.[24]

Both Tieck's and Keller's ideas on art were far ahead of then popular tastes. Tieck in fact deleted some 'daring' passages from subsequent editions of his work once his outlook had become more conventional. Tieck's audacity at the time of *Sternbald's* first publication was not least revealed by Goethe's growing irritation with him and his close friend Wackenroder, an irritation which made him maintain that art was far more endangered by the 'sternbaldisizing' Prosperos and art-loving Friars than by all the reality-demanding Calibans.[25]

In terms of poetry Tieck and his fellow-Romantics proved just as prophetic and provocative in their conceptions. Thus Tieck again made it plain what he preferred most in a poem: its sound qualities and indefinite suggestiveness, never mind its referential significance and thematic meanings which in any case were of interest only to the philistines. 'Why should it be the content which makes a poem?,[26] he demanded thereby denying at one stroke a tradition which ever since Aristotle judged poetry for its ability to portray nature and human thought, action and character. A.W. Schlegel's deliberately reductive definition of poetry similarly stressed the poet's freedom from the shackles of the past. The most beautiful poem, Schlegel wrote in a manner reminiscent of Mallarmé and the Symbolists, 'consists of verses, verses of words, words of syllables, syllables of sounds'.[27] In short before a poem 'means' anything it is a self-enclosed, self-contained structure of linguistic and acoustic relations.

Novalis developed such ideas still further in his notion of tales

and poems 'melodious and full of beautiful words but destitute of meaning or connection'. This 'true poetry' as Novalis imagined it would possess but 'an allegorical significance and an indirect effect like music'.[28]

Novalis' unmistakeably modern notion of poetry may have been influenced by his persistent and perceptive preoccupation with semiotics, in this case with language as a system of signs. Semiotically speaking, linguistic signs are of course no different from any other series of signs. Evidently the 'emptier' the sign the purer the system and the purer the system the greater the possibilities of combination within its own domain and in relation to other semiotic systems. This could explain Novalis' conception of the Word freed from its everyday semantic meaning on the one hand and, on the other, his repeated effort to link language including poetry not only with music — the most inward-looking of the arts — but also with algebra or mathematics, the purest and most self-contained system of signs discovered or invented by Man. Like mathematics and music, true language for Novalis was non-referential. It only related to itself. 'If only one could make people understand', he urged, 'that language is like mathematical formulae. Both constitute a world unto themselves, both only play with themselves and express their own mysterious nature'.[29]

This audacious conception clearly anticipated the modernist's disregard of the external world, his complete self-absorption in the media based on the belief that the imagination is essentially a constructive activity which creates its own autonomous reality. We shall come back to such potent notions shortly in the context of music which to the Romantics was of paramount importance.

For all his semiotic interests, the poetry envisaged by Novalis was not meant to be a merely formalistic, much less a formulaic exercise. In the end it transcended semiotic considerations. Cleansed of its mundane semantic connotations, genuine poetic language conveyed something numinous, something sacred which adhered to it from ancient times. 'As the garments of saints still retain wondrous powers, so many a word is made holy through a glorious memory', the memory perhaps when the word related to or was itself the *logos* — the creative spirit of the universe or, alternatively, the memory of Early Christianity when the Word proclaimed salvation through Jesus Christ.[30]

Once again this quasi-cabbalistic notion of language looked forward to Rimbaud's *Alchimie du Verbe*, to Mallarmé's 'immaculate words' and, in our century, to Hugo Ball's well-nigh liturgical conception of poetry which sought to safeguard 'its last and holiest sanctuary' by stripping language of everything profane.[31]

How many of these bold anticipations of modernism found their way into the Romantics' own poetry and painting? Novalis' tales or poems 'destitute of meaning or connection' remained but a projection, although he did succeed now and then in creating alternative realities in some of his narratives which owed little to the known world. Tieck came closest to realizing his ambition in poems unburdened by too many descriptive and conceptual elements. In his poetry, as A.W. Schlegel approvingly observed, language has indeed freed itself from things material; it 'dissolves into a spiritual vapour', into an intimate union of 'sound and soul'.[32] This is true as well of Brentano's major lyric and of the poetry of other German Romantics. As to Tieck's notion of paintings composed of nothing but 'garish colours without connections' this had to wait for the vibrant brush of Turner's later compositions.

D. Nature Ensouled and Dematerialized

Whatever influence Romantic theory may or may not have had on Romantic literature and art one fundamental feature stands out clearly: the anti-mimetic intent of this literature and art. To be more positive what stands out clearly is their 'truth to feeling' rather than their 'truth to nature'. Evidently nature did not simply disappear from art. 'Truth to feeling' pointed to a new, to an altogether different attitude to reality without. Beginning with Romanticism, the poet's and painter's relationship to nature and to the world at large radically and irrevocably changed. Henceforth external objects and events ceased to have any claims upon the artist. Their value and significance resided solely in their capacity to serve as filters for human feelings, as catalysts and receptacles for Man's passions and emotions. In other words, the nature that appears in Romantic literature and art is invariably a nature transformed by

'the modifying colours of imagination'. It is a reality 'ensouled' by the radiance or intensity of the artist's inner life, by its joys, pains and pleasures, its solitudes and restless strivings.

Without labouring the obvious, this is clearly evident in Romantic painting. While still being an art of representation, the latter is never an end in itself but a medium to communicate feelings. Even the most cursory examination of Romantic art testifies to the painter's effort to translate natural scenes in an attempt to establish a mood rather than a record of appearances. When we look at a Constable or Friedrich, we are less conscious of *these* mountains, *these* streams, *these* trees as objects existing independently. Their appeal lies first and foremost in their capacity to project feelings. To that extent, the descriptive element always serves strictly emotive and meditative ends. The German phrase *Stimmungsmalerei* — mood-painting — is an apt generic term descriptive of this form of art which transformed landscape into 'soulscape'.

Yet Romantic painting pressed further. As we have seen in the previous chapter, its inherent tendency was to move away from the self-contained concrete object towards the 'non-objective'. This tendency came to the fore, of course, whenever the painter strove to express feelings of oneness. Such feelings were often thought to be incompatible with rendering the minute particulars of nature. Instead the painter's gaze focused on illimitable seas, on infinite horizons, on the vastness of aerial perspective, on phenomena, in short, that are on the verge of becoming intangible and invisible. In Turner's case it is often difficult to decide where visible nature ends and the visualization of the artist's emotion begins. The link to the external world has become extremely tenuous indeed.

It was just as tenuous in the case of other Romantics, notably with such visionary poets as Blake, Shelley or, as previously mentioned, Novalis whom Schelling apparently accused of 'frivolity' against objects.[33] In Blake this frivolity became at times unqualified disdain. Thus looking down from the pinnacles of his prophetic heights he could dismiss material creation as 'the Dirt upon my feet'.[34] There is some truth in Robert Rosenblum's remark that for all 'the reflections of the visible world' to be found in Blake's art, he might 'almost have been blind'.[35] Confronted with Wordsworth's much surer grasp of things, Blake once

confessed that 'Natural Objects' did 'weaken, deaden and obliterate imagination' in him.[36] It is only in his later works that he takes delight in visible creation.

In its own way Shelley's imagination was just as free-floating and defiant of the fixities and definites of nature. Peter Conrad rightly likened it to Ariel, the winged restless spirit of the air who runs dizzying circles around all objects until they join to celebrate life as a maenadic dance.[37] What is at work in Shelley and elsewhere in Romanticism is a dematerializing imagination, one at home with everything that moves, flutters, flickers, shifts and never keeps still. Tieck provided an almost classical description of this state of mind floating on clouds and air or, just as often, on streams of eddying waters which flooded everything concrete, a state of mind, in short, which has severed almost all its links with external nature:

> the spirit of the poet is an eternally moving river, whose murmuring melody remains never silent, every breath touches him and leaves a trace, every ray of light is reflected, he has the least need of wearisome matter (lästigen Materie) and relies mostly on himself . . .[38]

Hegel may well have underscored these crucial lines in Tieck's *Sternbald* for they unambiguously proclaim what he came to predicate of Romantic art: its inclination to live internally, its aspiration to create an inner world which 'celebrates its triumph over the outer world', over an external reality that now sinks to the level of an 'indifferent medium' which could be used or discarded at will.[39]

Valid as Hegel's observations are, valid, that is, in terms of defining a general Romantic disposition, they nonetheless require an important qualification. While a conspicuous feature in some poets and painters, this lordly attitude towards the Creation, this Romantic 'occasionalism' which simply used and exploited objects for the soul's self-expansion, was but one tendency, one pole of the Romantics' often complex and ambivalent relationship to nature. The other pole of this relationship consisted in a wholehearted surrender to nature and the universe, in a selfless participation in all modes of being. If the first tendency represented, as it were, a conscious or unconscious Fichtean

perspective which affirmed the priority of the ego, of the 'I am', the second represented a Spinozistic orientation in its devotion to the object, to the 'it is'.[40] Yet this Spinozistic inclination was no compromise with objectivity, with things viewed in 'disconnection, dead and spiritless'. As we shall see clearly in the following chapters, for the Romantics human subjectivity still determined the value and the significance of reality without. In a much deeper sense than Ruskin implied in his witty remark concerning Wordsworth's relationship to the external world — will it be able to get on without him?[41] — the Romantics did believe that nature required the love and spirit of man to awaken to her own spirituality. Nature craved to return from exile in a soulless degrading objectivity, it aspired to be known as a 'Thou'. Only Man, a kindred spirit, could address her thus.

E. The Denial of Immutable Forms and Standards

An art intent on expressing feeling is not an art seeking for finality and excellence of form. The Romantics' expressive aesthetic was by definition anti-formalistic. It rejected formal perfection since this would have impeded and impoverished the flow and richness of the inner life. The formal drive in art must never overwhelm the expressive urge, the voice of the emotions. In sum 'truth to feeling' not 'truth to form' must be the operating force in all genuine creation.

This outlook brought the Romantics into immediate conflict with the reigning classic and neo-classic conceptions of art. To be sure, some did not object to classic forms as such if they were the means best suited to express emotions. Thus Blake and Runge in their figurative paintings and Friedrich in his landscapes frequently made successful use of classicizing principles of composition, principles which stressed frontality, linearity, symmetry, control and succinctness. What the Romantics did abhor was academic classicism, the mindless imitation of antique models and the servile copying of Old Masters on the mistaken grounds that the forms and figures produced by them were the perfect embodiment of eternally valid and universally binding norms or standards. There are no such immutable norms, no such unchanging absolute standards,

the Romantics impatiently declared, and if there were it would mean the end of all creative efforts. Art was not the prerogative of any particular time and place be it classical Greece or Renaissance Rome. 'A different inspiration' insisted Schelling, belonged 'to different epochs'.[42] Wackenroder, invoking divine providence, was even more emphatic. A different inspiration belonged not only to different epochs but to different peoples or nations and, beyond that and most important, to each and every creative individual. God, according to Wackenroder, loathed sameness or uniformity. He loved nothing better than a colourful and rich diversity. For this 'diversitarian' divinity the war chant of the savages was as pleasing a sound as the most artful choral music, the Greek temple no better or higher than the towering Gothic cathedral.[43]

This denial of uniformity, hence of formalism, in favour of a providentially ordained diversity bore abundant if at times exotic fruit in Romantic literature. Some critics here equate the Romantics' anti-formalism with a tendency towards formlessness, a criticism not unjust at times. It is often difficult to discern any organising inclination in the seemingly wilful digressions and studied confusions that characterize many Romantic works from Tieck's *Verkehrte Welt* and *Gestiefelter Kater* to Brentano's *Godwi* and Friedrich Schlegel's *Lucinde* not to mention some of the topsy-turvy tales of Jean Paul and E.T.A. Hoffmann. Friedrich Schlegel's paean to poetic *Willkür,* by which he meant the operations of a sovereign will which brooks no other law beside itself, merely reinforces the impression of capriciousness some of these works convey.[44] If there is any unity in this 'literary libertinage' as Lilian Furst aptly called it, it is that Novalis demanded of the true poem: unity of soul (Gemüt).[45]

Defiant of form this love of diversity and indeterminateness made a resounding virtue of things incomplete and imperfect. The Romantic period was the great age of the sketch and the fragment, of the unfinished poem and painting, and, above all, of the unfinished novel. This was the first great age as well of the experimental, for the unfinished frequently suggested different possibilities and combinations of media and styles, of modes and manners of expression. While detrimental in some respect the praise of the experimental and the imperfect proved immensely salutary for it sharpened the Romantics' sensitivity not only for

what was potentially of value, but for everything spontaneous and accidental, for everything that stimulated the imagination in a way nothing finished or complete could ever do.

Friedrich Schlegel provided a rationale and justification for the Romantics' delight in diversity and their elevation of the incomplete. 'Romantic poetry', we read in his famous Fragment 116, 'is still in the process of evolution: this indeed is its very essence that it is eternally evolving, never completed'.[46] The context makes it plain that Schlegel meant not only poetry in the narrow sense but also the novel and, by implication, the whole of literature which is apprehended as an open-ended, dynamically expanding process — a never-ending work of art.

Reading the entire fragment, one is tempted to dismiss Schlegel's ideas as the product of an overwrought undisciplined mind. Yet exaggerated and extravagant as Schlegel's counter-classical programme undeniably is, it reflected something far more fundamental, something we touched upon before: the Romantics' dynamic-developmental view of life, their vision of nature as perpetually changing and productive of novelties. 'Living nature everywhere', wrote Karl Friedrich Burdach, 'eternally brings forth the new. Uniformity she suffers none'.[47] Hence the Romantics' repeated saying that in nature no two leaves were ever alike. Diversity and with it originality was the law or norm of Creation, the only law or norm to which each man, and, in particular, each and every artist must conform in order to fulfil a cosmic destiny.

It is precisely this 'grounding' of artistic creativity in nature or, as in the case of Wackenroder, in God Himself that was uniquely Romantic and set it apart from all previous attempts to explain the artists' striving for novelty. Sadly, who could have foretold then that this very striving for things original and unconventional would in our age degenerate into the dreariest and most destructive of conventions which in the end condemns art to consume itself and be its self-appointed undertaker.

While tending towards the diffuse and formless and forever defending the unfinished or incomplete, the Romantics were by no means without some notions of form. Indeed one of their greatest contributions to aesthetics was the concept of organic form, a most important concept as we shall see later. True to their vision of nature as an open-ended process they also subscribed to the notion

of 'open' or 'indeterminate' form, a notion which could easily be subsumed under the 'organic'. To a lesser extent, this is true as well of the recurrent concept of the 'arabesque', a somewhat complex and confusing concept if judged by the speculations of Philipp Otto Runge and above all, by those of Friedrich Schlegel. For both, the arabesque implied more than just a merely playful ornamental pattern, a decorative design. It expressed the spirit's restlessness and the soul's mobility, the unceasing flow not only of the inner life but also, according to Runge, of the deeper life of nature. Runge made demonstrative use of the arabesque in the form of plants and flowers in his painting and etching of the 'Times of Day'. Closer inspection clearly reveals their non-decorative intent, their symbolical and hieroglyphic significance although in truth we do not always know what that significance precisely is. An esoteric painter whose private mythology owed much to Jacob Boehme, Runge rarely shook off 'his reputation for allegorical obscurity' in the words of William Vaughan.[48]

Schlegel's various and not always consistent notions of the arabesque in literature included the 'grotesque' — virtually a synonym of the arabesque — as well as what he called 'chaotic form' which was not so much a contradiction in terms as a confirmation that true form must hint at or express the 'original chaos of human nature'. In terms of painting the arabesque denoted landscapes deprived of any human figures, fantastic landscapes of the mind or soul: 'Landscapes without any figures, Idyllic, Romantic in the great style, — *arabesques* are absolute (absolutely fanciful) painting'.[49]

Schlegel's 'chaotic form' found an echo in Brentano's notion of the 'unformed' which, he insisted, can possess 'more form than things shaped can endure'. He compared it to an expanding soap bubble which mirrors all the surrounding colours while its inner space represents 'a thought'.[50]

Schlegel's and Brentano's sometimes far-fetched speculations simply highlighted the perennial problem faced by most Romantics: how to find formal solutions for increasingly more inward-looking visions. In the end each artist had to arrive at his own means of expression, discover forms which neither distorted nor emasculated the emotions. In other words, feeling always and everywhere determined form and not form feeling. A corollary of

this was the Romantics' tireless insistence that in the work of art content (*Gehalt*) takes precedence over form (*Gestalt*). Their expressive aesthetic was of necessity a *Gehaltsaesthetik*.

F. The Magic of Colour and of Music

Inevitably this anti-formalistic expressive urge of the Romantics turned to colour and to music as the media best suited to express the inner life of man. The evocative power of colour captivated the Romantics in a way which points to the presence of a new colour sensibility, one that triumphed over more tangible perceptions, over a reality experienced as solid in its objects and distinct in its lines of demarcations. A.W. Schlegel hinted at this radical shift in sensibility when he wrote: 'The spirit of the whole of ancient art and poetry is *plastic* while that of modern poetry is *picturesque*'.[51] Central to the picturesque tradition was rich, pure and mellow colouring. Brentano was more direct. Colour, he observed in *Godwi*, comprised the most important characteristic of the Romantic outlook. It was the medium, the tinted glass in Brentano's example, through which all things appeared and received their particular being.[52]

For the Romantics colour, needless to say, was clearly not a secondary or subjective quality as understood by Newtonian science. Nor was it merely a natural attribute of things, a delightful property adhering to them. Colour was at once natural and supernatural, a primal phenomenon which appeared together with God's original illumination of the world. Its function: to act as intermediary between the physical and the spiritual, the earthly and the divine. Colour, in short, was always symbolical, a pointer to the spiritual world.

Romantic literature, foremost the German, bears witness to this new-found colour sensibility. Surging beyond all formal limitations on the crest of feeling it dissolved all things into a rich aura of suggestive hues. Landscape invariably turns into an 'atmospheric conjunction' of subtly graded or freely intermingling tonalities: dark forest greens, sunset reds and yellows, the pale golds of dawn or the deeper golds of dusk, the silver blues of lakes and rivers — gentle, mellow colours for the most part, radiating

from and returning to the distant glow of heaven. Among English poets only Shelley could use colour more boldly in his distinctly Turneresque visions of blazing lights and burning incandescent hues. His poetry indeed seems to confirm the Romantics' belief in the chromatic-musical content of language itself. A.W. Schlegel and to a lesser extent Coleridge looked for this content by identifying the various sounds of vowels with different colours and feelings.

The same colour sensibility characterized the painters' response to the external world and to the art of the past. It inspired their admiration of the Venetians, for Rubens or for any painter deserving the title *malerisch*. Increasingly 'the poetry of colour' — a recurrent phrase of praise — was enjoyed independently of the things portrayed on canvas. Properly appreciated good colouring did indeed take away all sense of subject, as Washington Allston enthusiastically remarked in his descriptions of Venetian art.[53] At its most lyrical or intense, colour, according to some Romantics, accomplished still more: not only did it take away all sense of subject, it abolished the separation between self and things and made the human soul throb in harmony with the soul of the world. The Romantics were wide awake to the self-enveloping and self-absorbing quality of colour.

Runge was right in the forefront of this mystical colour sensibility. Although his pictures show but brief and tantalizing glimpses of it, his theoretical reflections reveal an acute if sometimes recondite understanding of colour. The art of colour, he insisted, was the last and greatest art, one, alas, beyond man's comprehension.[54] Yet this admission did not stop Runge from devising his own theory which probed into the phenomenological aspect of colour, its harmonies, contrast and interrelationships. On canvas Runge's colour took on a deeply symbolical significance derived from his knowledge of Jacob Boehme's theosophy and the pieties of his Protestant faith. Their joint influence — to give but one example — enabled Runge to interpret the three primary colours of red, yellow and blue as 'the natural symbol of the Trinity'.[55] Runge's long poem which was supposed to accompany the 'Times of Day' provides further clues to his sometimes involved symbolic meanings. The poem is one sustained homage to the revelatory power of colour as manifest in specific flowers,

colours that commemorate Creation in the redeeming light of eternity.[56]

The real genius of Romantic colour was of course Turner. Indifferent to orthodox religion and not given to overtly mystical reflections, Turner imparted to his mature compositions a chromatic vibrancy and richness never seen before. His art demonstrates the previously mentioned shift of sensibility at its most dramatic and intense. While to the neo-classic painter colour was but a sensuous adjunct subject to the clarity of line and form and to the rationality of composition, on Turner's canvas it assumes its true magnificence, a sublime splendour which seems to sweep everything before it: — line, form, subject and at last, the object itself. The brilliant tissues of paint are often at the point of obliterating the descriptive element altogether (*Plates* 3 & 18).

Yet this is only one side of Turner, the 'modern' Turner as it were. He was a far more complex as well as highly competitive painter who did his cunning best to rival and sometimes outclass every past and present colourist of rank, every history painter of distinction. The complexity of his art can be such at times that it successfully blends 'truth to nature' with 'truth to sentiments' and 'truth to story' with 'truth to art'. In other words the 'abstract' Turner is himself an abstraction arrived at by discarding the totality of his work which was as much bound by tradition as by the quest for novelty. If today we single out the latter it is because our eyes, sensitized by modern art, have learned to respond to those canvases and watercolours of Turner in which the inherent expressiveness of colour as paint is the most striking feature. Turner no doubt would have approved of this response while berating our blindness to everything else in his art.

The Romantics' praise of colour as a means uniquely suited for emotional expression was exceeded only by their acclaim of music, an acclaim particularly marked among the Germans in keeping with their renowned musical tradition. The presumed interrelationship between these two media was taken as a matter of course and formed an important part of Romantic speculations — from Runge's search for musico-chromatic correspondences to A.W. Schlegel's related investigations into the sounds and hues of language. German Romantic literature inspired and reinforced such speculations by its pronounced inclination towards *audition*

colorée, a tendency touched upon in a previous chapter when discussing the Romantics' attempt to unify the arts and the different spheres of sensibility.

What of music itself, its significance and status? For the German Romantics it was quite simply the master art, the unsurpassed and unsurpassable medium of expression. The numerous claims made on its behalf merely reflected their immense veneration for this specific form of art. Music, the Romantics enthused, was the Spirit made incarnate, the key to the heart of the world, the means of unification and purification. Music was at once revelation and salvation. Through its wondrous tones one established contact with the creative force of life, with realities eternal. As E.T.A. Hoffmann, no mean musician and composer himself, put it: 'Through the sounds of music we are brought into the presence of the highest and the holiest of things, of the spiritual power that kindles the spark of life in the whole of nature'.[57] For many Romantics nature itself was emitting music. They compared it to an Aeolian harp whose mysterious sounds released the soul's deepest urges.

That music should have enjoyed this position of unrivalled eminence is scarcely surprising. Two related factors determined its unique significance: music's non-mimetic character and its seeming ability to express moods and emotions directly. 'Music', wrote Coleridge, 'is the most entirely human of the fine arts and has the fewest *analoga* in nature'.[58] For Novalis it had no analogues at all in phenomenal reality. 'The musician', he marvelled, 'takes the essence of his art out of himself and not the slightest suspicion of imitation can befall him'.[59] It was precisely this freedom from nature according to the Romantics that enabled music to concentrate upon its own means of expression and thus turn it into a mirror of the human soul. Unlike other forms of art which had to make use of external objects or events to express the inner life of man, music, insisted Wackenroder, 'streams it out before us as it is in itself ... In the mirror of tones the human heart comes to know itself' and 'learns to feel feeling'. No other medium but music, Wackenroder claimed, was capable of expressing the infinite diversity and ambivalent complexity of human feelings.[60]

For most German Romantics the exemplary nature of music made it the ideal model by means of which to judge the

comparative merit of other forms of art, the extent to which their matter and manner of working permitted undiluted expression of Man's inner life. Immediately this relegated sculpture — the most material and imitative of the arts — and architecture — the most functional — to an inferior position. To put it a shade more poignantly, during the Romantic age the youngest of the arts, music, replaced the oldest as the primary vehicle of emotional and spiritual expression. Henceforth, the Romantics urged — anticipating Pater and the French Symbolists — that all the arts had to emulate music; each had to achieve a maximum of musical effects within the confines of its medium. 'The plastic arts, at their most perfect' wrote Schiller, 'must become music and move us by the immediacy of their sensuous presence'.[61] As Schiller noted elsewhere, this required an imagination freed from the pressures of imitation, one able to express 'a given state of mind' without recourse to an external object.[62] Von Kleist's acknowledgement of music as the 'root' of or the 'algebraic formula' for the whole poetic sphere pointed in the same direction: the musicalization of the arts.[63] It was to achieve a conspicuous measure of success in lyrical poetry which ever since its oral and Orphic tradition had professed a close kinship with song and music.

This is not the place to discuss in depth the similarities and differences between 'the music of poetry' and music proper. Briefly stated, the example set by music inspired lyrics of diminished mimetic intensity, verses, that is, expressive rather than descriptive. It encouraged the poet to concentrate on rhythmical effects, on alternating metric patterns and, beyond that, on the acoustic properties of language itself, its sound-strata, in order to cull from it more or less self-supporting tonal configurations that appealed directly to the listener. Music engendered the practice of onomatopoeia be it in the form of emulating the specific timbres of instruments or the specific sounds of nature: — the rustling of leaves, the murmur of brooks, the lovecall of birds. Music also persuaded the poet to make use of musical forms and movements from the relatively simple repetition and variation of motif and theme to the more complex forms of the symphony which Tieck sought to exploit in his *Verkehrte Welt*. For the most part, however, the 'music of poetry' stood for the pronounced presence of rhythmical and melodious effects, for the poet's sensitivity to

the sounds of language, its sequels of vowels and consonants, its alliterative and assonantic potentials.[64]

Some of Brentano's lyrics are superb examples of poetry aspiring towards music. As John F. Fetzer's fine study has conclusively shown he was indeed the Romantic Orpheus with no equal. Only Eichendorff and Heine occasionally match his brilliance with their own brand of musicality. Shelley too comes close to it at times in verses expanding with syllabic delight and moved by a rhythmic gusto which creates a distinctly musical impression. Now and then Shelley succeeds in completely submerging the reader beneath a flood of euphonious words that numb all irritable reaching after fact and reason. Even Wordsworth demanded his share of musicality. As he confessed to Catherine Clarkson: 'To you I will whisper that *The Excursion* has one merit if it has no other, viz, variety of musical effects'.[65] We are not told of their place, nature and significance in his poetry.

Whatever Wordsworth may have wanted to say, in its more conspicuous manifestations poetic musicality had the most dramatic and 'resounding' repercussions for it promoted forms of poetry impervious to all external standards. Intent on tonal values the poet paid scant attention to empirical connections and rational meanings. Words, cut loose from their semantic moorings and emancipated from the commonplace, now served strictly musical and emotional ends. The poem turned into a self-sufficient inner world moving by its own rhythm subject to no laws but its own acoustic and associative logic which defied translation into ordinary language. Of all the previously mentioned anticipations of modern literature and art the theory and practice of musicality proved the most consequential for it established what was to become a characteristic feature of modernism: —its complete introversion and concomitant commitment to the medium which produced wholly self-relating forms of art.

In the end painting was just as much affected. Musicality here signified the artists' growing disregard for purely literary and mimetic values in favour of the inherent expressiveness of the pictorial means — the life peculiar to lines, forms and, above all, to colours. From Delacroix to Gauguin and van Gogh, from Munch to Matisse and the Fauves right up to the Expressionists, painters progressively celebrated the 'music of colour' and insisted on the

seemingly common elements present in the art of painting and composing music. At last 'the music of colour' came fully into its own in the non-objective compositions of Kandinsky and other abstract painters.

It is a familiar tale by now but one still worth the telling for its innocuous and unsuspected beginnings in the Romantics' expressive theory of art, an aesthetic which by its very nature and momentum was destined to culminate in music and in the musicalization of the arts.

* * *

In retrospect, and by way of a conclusion, the Romantics' expressive point of view was an immeasurable gain. While liberating the artist from mimesis and from any externally imposed constraints, it encouraged him to concentrate solely on his innermost self. Evidently not everything dwelling there deserved artistic expression nor were the emotions expressed always uplifting and enobling. On the whole, however, the Romantics' expressive urge as manifest throughout literature and art has greatly contributed to our store of knowledge and experience, to our insight into what it is to be human.

Nowhere is this more in evidence than in the realm of music which during and directly in the wake of the Romantic movement flourished as never before, flourished to an extent which will ensure the continuing vitality of the Romantic outlook. Where would our emotional self-understanding be without such familiar composers as Schubert and Schumann, Mendelssohn and Brahms, Beethoven and Berlioz, Weber and Wagner and his successors? These eminent composers not only intensified and extended the scope of our sensibility, they were capable at the same time of moulding Man's emotions into unique responses, into whole clusters of responses beyond the range of any rational explanations. Indeed between them they managed to produce a new mentality, what Thomas Mann with reference to the Germans called 'musicality of soul', a condition which unfortunately is both a blessing and a curse.[66] It is a blessing since it enables the person under the influence of music to scale unprecedented heights of emotional and spiritual experience, a curse in so far as it can lead to

an estrangement from, if not outright rejection of, the external world. In its advanced stages, musicality of soul lives fully only in the medium that shaped it. For it, Romantic music is the deepest expression of a yearning which will not and cannot make its peace with a mundane world. Music in this case becomes 'a dangerous and bottomless abyss of longing and melancholy' in the telling words of Friedrich Schlegel.⁶⁷ Extreme musicality of soul as we know from Wackenroder's Joseph Berglinger and E.T.A. Hoffmann's Johannes Kreisler, spells extreme alienation from social reality. It seals and sanctions the complete internalization of life, its privatization, at the expense of the public sphere. The temptations of Romantic music are great indeed but then so are its redemptive features: — an intensification and spiritualization of life little known to less musical ages.

Chapter IV
The Hierophantic Conception of Art

A. 'Within leads the Mysterious Way!'

The Romantics' expressive theory of art has sometimes been interpreted as a wholly self-centred response to the world, an aesthetic narcissism which sees its own countenance in everything surrounding it. While a narcissistic component was undeniably present in Romanticism its expressive urge cannot be reduced to it since this would ignore the Romantics' surrender to powers beyond the self, their surge towards union and fusion with the heart of the world. More important, charges of self-centredness fail to take into account the Romantics' conviction that the creative expression of self was at the same time an expression of the creative spirit of the universe.

Seen in this much wider context the expressive theory obviously acquired a metaphysical and religious dimension which drastically changed its nature and direction. In effect it assumed a different connotation altogether, one which can be called the 'hierophantic conception of art' — hierophantic since in this view the artist appears in the role of hierophant, that is, as mediator and interpreter of truth transcendental and divine, or of truth immanent and revealed to sense. Evidently such beliefs went far beyond the immediate confines of art. They presupposed a Theory of Mind or Imagination which affirmed the reciprocal relation between man and things, their 'unremittant intercourse.' To be more precise — epistemologically precise — such beliefs presupposed an Idealist understanding of the world according to which the outer life of things, their forms, structures and significance was determined or conditioned by the inner life of man, the observer.[1]

While the English Romantics expressed the Idealist outlook spontaneously or through the ill-fitting framework of empiricist epistemologies, the *Frühromantiker* fell back upon and utilized the various systems of German Idealism as developed by Kant, Fichte and Schelling.

To be sure their attitude towards these sages was rarely one of unstinting admiration. It was laced with misgivings, recriminations and frequent recantations. Thus Kant, the father of German Idealism, was both an irritant and a stimulant for the Romantics. He was a stimulant by virtue of his daring supposition in the *First Critique* which radically reversed accepted epistemological assumptions: instead of the human mind having to conform to the object as was generally believed to be the case, Kant argued that in reality the object had to conform to the mind. The mind is no passive receiver of impressions from without. It is inherently active and constructive in perception. Its categories of the understanding and its forms of sensibility invariably mould the manifold of sense into objects of cognition. The object as perceived is an object already structured by the mind or, in Idealist language by the 'productive imagination' — the unifying power operative in all perception.

Kant's 'Copernican revolution' in reverse restored Man the Knower to the centre of the universe. He remade the world in the image of the human mind. His finely developed epistemological subjectivism at once launched the speculations of his Idealist successors and liberated the Romantic imagination to look ever more inward for the truth of the world.

Yet Kant was just as much an irritant to the Romantics — a deadly irritant to Kleist — through his stubborn limitation of knowledge to the objects of sense. The human mind, he maintained categorically — and he had the categories to prove it — possessed no power to penetrate the supersensible realities and 'the thing in itself', the presumed material substratum of the phenomenal world. Although the Romantics occasionally made use of Kant's curtailment of the intellect they totally disagreed with his denial of metaphysical knowledge. While the narrow understanding (Verstand) may be restricted to phenomena, the human spirit (Geist) borne on the wings of feeling, love and intuitions was well capable of approximating numinous realities.

Kant was not amused.

The Romantics' reception of Fichte was equally fraught with ambiguities, with affirmations and negations. For a time this Jacobine thinker fired their imagination as no philosopher had done before. His radical Idealism in the *Wissenschaftslehre* which extolled a transcendental ego (manifest in all finite egos) as a power productive of the non-ego — of the world — appeared to them an event of equal if not surpassing significance to the French Revolution. Here it seemed to them was a philosophy at last which underpinned the absolute freedom and autonomy of man. As Fichte himself described it: 'My system is the first system of freedom'. While the French nation rid itself of social chains, he, Fichte, delivered man from the tyranny of matter, from 'the fetters of "the thing in itself"'.[2] In their enthusiasm for this philosopher some Romantics dreamt of 'fichtesizing artistically' by spinning aesthetic substances wholly out of themselves in a manner analogous to Fichte's productive ego.[3]

However this enthusiastic response soon gave way to reservations concerning Fichte's utter denigration of the external world, a world which in his system merely served as a field of action and beyond that, as an obstacle (*Gegenstand*) to be overcome and subjugated by the ego. This imperious attitude towards the object revolted some Romantics including the later Eichendorff who charged Fichte's pure Idealism with being nothing more than Protestantism *in extremis*, the hubris of the subject before the Fall.[4]

Nonetheless Fichte was of profound importance to the Romantics not, as most critics assume, because his radical subjectivism could be exploited to justify the most capricious flights of fancy, but rather because Fichte's system — for all its glaring imperfections — demonstrated that a proper analysis of self or consciousness could sound the very depth of the world. What his philosophy required was the complement of nature to re-unite the ego with Creation.

This was the task Schelling, the most Romantic of the German Idealists, set himself. Inspired as much by Spinoza's pious pantheism as by Fichte's pure Idealism he strove to reconcile both by showing that mind and matter, spirit and nature, ego and non-ego had their common origin in an Absolute which was a pure

identity of subject and object. In the process of externalizing itself, the Absolute sundered into the subjectivity of mind and into the objectivity of nature. Although opposite in appearance, the same Absolute pervaded and sustained both realms. Present in nature as unconscious drive and energy, as a polarity of forces, the Absolute reached consciousness of itself in the mind of man whose task it was to raise the dormant spirit of nature to a comprehensive knowledge of itself.[5]

This elevated conception of man and the world forming a spiritual unity spearheaded by the human spirit was bound to enlist the Romantics' sympathies and so, as we shall presently see, was Schelling's exultation over art as the reconciler of spirit and nature. Schelling no doubt came closest to conceptualizing the Romantics' basic beliefs whatever their specific disagreements with him may have been. In the end, it is difficult, if not impossible, to define the Romantics' precise relationship to Schelling and beyond that to Kant and Fichte. It was, for the most part, a constantly shifting relationship with the Romantics taking and adapting whatever suited their particular positions.

Fortunately we need not tackle this knotty problem since the greatest debt the Romantics owed to Schelling and to the Idealists can be clearly stated. What they owed to them was a view of the human mind as constructive of reality or, more generally, the belief that the inner life of man provided the index to the mysterious life of the world.

While Schelling and the Idealists derived this index from an analysis of the conscious mind, the Romantics derived it by delving into the unconscious as well as into feelings, dreams and intuitions and into man's imagination. Theirs was not a rational but an *emotional* Idealism intent on using 'the heart' as 'the key to the world and to life'. It was just this belief in man's inner life as the light illuminating the ground of the world that sustained and inspired their constant recourse to emotions, their cult of feeling.

Novalis' often-quoted sixteenth fragment in *Blütenstaub* gave striking expression to the Romantics' colonization of 'inwardness' in search of the deepest source of life and the secrets of existence:

> We dream of journeys through the universe: is not the whole
> universe within us? We do not know the depths of the human
> spirit. Within leads the mysterious way. Within ourselves, and
> nowhere else, is eternity with all its worlds.

Novalis could formulate this Romantic credo still more tersely: 'We
search for the world's design: the design is in ourselves'.[6]

Was this gospel of inwardness which looked for the truth of the
world in the depth of the self something 'typically Teutonic' and
contrary to the 'good sense' that allegedly prevailed in English
Romanticism? A number of critics — notably Anglo-Saxon critics
— tend to support this interpretation.[7] Yet on closer scrutiny the
difference here between German and English Romanticism was one
of degree not of kind. While the *Frühromantiker* were admittedly
more radical in their formulations which invariably betrayed the
influence of metaphysical Idealism, the English Romantics stated
their respective credo in a manner less provocative and strident.
Nonetheless, and as we shall see presently below, the belief in
man's soul and imagination as the magic key to the world was a
basic tenet of Romanticism as a whole.

B. Art and the Final Truth of Things

Two consequences followed from this exalted view of the self:
one, it canonized the artists' retreat into his own being thereby
dealing a final blow to imitation and, secondly, it sanctioned artistic
self-expression as a form of metaphysical cognition. For if the truth
of things is to be found only deep within the human psyche and if
there is none deeper than that of the artist then its creative
expression becomes a revelation of what 'exists eternally and
unchangeably'. Hence the Romantics' repeated insistence that the
artist alone was the true mediator destined to disclose to his less
gifted fellows the deepest mysteries of life.

In one form or another this hierophantic conception of art as we
called it, this notion of poet, painter, writer or composer as the
mediator and interpreter of the highest truth inspired all the major
Romantic figures including even Wordsworth.

To touch briefly on each, beginning with the latter. Despite his

aversion to German Idealism of which he knew little or nothing at all, save what came to him from Coleridge, Wordsworth consistently looked to poetry as the vehicle of revelation conveying a truth superior to that of science. As he stated in the Preface to *Lyrical Ballads*: 'Poetry is the first and last of all Knowledge — it is as immortal as the heart of man'.[8] Presumably, Wordsworth meant not 'head-knowledge' but 'heart-knowledge' distilled from poetry understood as the spontaneous overflow of powerful feelings.

While this notion of poetic truth seems to have been influenced by Aristotle whose authority he claims, Wordsworth's actual poetry itself often sings of a truth much more elevated and sublime. The poet we are told 'sees into the heart of things'. His imagination proclaims 'Reason in her most exulted mood', a Mind

> That feeds upon infinity, that broods
> Over the dark abyss, intent to hear
> Its voices issuing forth to silent light
> In one continuous stream; a mind sustained
> By recognitions of transcendent power,[9]

Wordsworth's visionary voice alone would easily gain him entrance into that honoured brotherhood of hierophantic poets who reveal God's or Reason's ways to man. His sonorous solemnities are strangely reminiscent of the Germans' transcendental aspirations.

While Wordsworth searched for the final truth of things both within and without, Blake, not unlike Novalis, looked steadily inward and beyond to a truth vouchsafed by the imagination: 'Vision or Imagination is a Representation of what Eternally Exists Really and Unchangeably'.[10] The precise meaning of this and a host of similar passages may be apparent only to the Blakean scholar conversant with his private cosmology compounded from a variety of hermetic writings: Gnostic, Manichean, Neoplatonic and Swedenborgian. Blake throughout his life never failed to insist that his poems and pictorial representations were 'Visions of Eternity', imaginative embodiments of ultimate truth.

The difference between Blake and Coleridge seems at first sight too great to be bridged. However, a connecting link can clearly be discerned in the latter's concept of the imagination. Although the

Coleridgean imagination has assumed a place of great prominence in poetry and literary discussions, its more specific hierophantic and mediating significance remains somewhat obscure and requires elucidation.

There can be little doubt that the Primary and Secondary imagination as originally conceived by Coleridge carried with it overtones of cosmic and spiritual revelations. In its Secondary 'poetic' form, the most important function of the imagination was to resolve opposite and discordant qualities. Their successful resolution in the work of art recapitulated and, by implication, revealed in finite form the original unity underlying all. Seen thus, the Secondary imagination was a distant echo 'in the finite mind of the eternal act of creation in the infinite I Am.'[11] As Coleridge wrote elsewhere, the shaping and unifying power of the imagination yields a 'dim Analogue of Creation, not all that we can *believe*, but all that we can *conceive* of creation.'[12] In other words, the aesthetic activity, according to Coleridge, provided the closest conceivable parallel to that almighty creativity which we assume to be productive of the world.

Throughout his writings on the imagination Coleridge's emphasis was repeatedly and consistently on mediation and reconciliation. Hence his much-cited conception of art as 'the mediatress between, and reconciler of nature and man' or, alternatively, his belief that the 'mystery of genius in the Fine Arts' consisted in its magical power to retrieve and blend into one the 'rays of intellect . . . scattered throughout the images of nature', a creative transaction which resulted in making 'the external internal, the internal external', in making 'nature thought and thought nature'.[13]

Coleridge's formulations here derived from Schelling's celebrated essay, sections of which he not only paraphrased but literally transcribed.[14] Indeed, much of his aesthetics, including its implicit ontological and epistemological assumptions, can be traced back to the speculations of his German contemporary who, as we shall see below, construed an imposing system around the revelatory significance of art. In view of this incontestable indebtedness to Schelling it is difficult to understand why some of the foremost critics should insist that Coleridge disclaimed any cognitive privilege for art.

In Shelley's case there was no such reliance on German modes of thought. His famous 'Defence of Poetry' drew instead on Plato, Renaissance Neoplatonism and on a variety of contemporary sources including Wordsworth. A key document in the hierophantic tradition of art, the 'Defence' forms less a reasoned exposition and more of an impassioned declaration of faith which makes use of striking imagery and metaphors to establish the transcendental nature and function of poetry and art. Like Coleridge, Shelley conceived of the creative imagination as a synthetic power which 'subdues to union ... all irreconcilable things'. Unlike Coleridge, he looked to poetry as the *direct* manifestation of something divine — 'the very image of life expressed in its eternal truth'. Poetry to Shelley made 'immortal all that is best and most beautiful in the world'. It redeemed 'from decay the visitations of the divinity in man'. This naturally endowed the poet with a special insight into things supernatural and divine. The true poet, according to Shelley, participated 'in the eternal, the infinite and the one'. And since the poet partook of Infinity, 'All high poetry' was necessarily 'infinite' and each great poem 'a fountain for ever overflowing with the waters of wisdom and delight'.[15]

In his 'Defence' and other writings Shelley made striking and repeated use of an image recurrent in the hierophantic conception of art: the image of the poet removing the veil from visible things to reveal their invisible meaning. Poetry he tells us 'strips the veil of familiarity from the world and lays bare the naked and sleeping beauty which is the spirit of its forms'.[16] As several critics have noted this recurrent image throughout Romanticism testified to an abiding faith in the mediating power of the emotions and the imagination.

While for Shelley poetry revealed the reality of the supersensuous, for Keats it disclosed the enduring presence of the sensuous. To him the poet culled his timeless thoughts from the rich well of sight and sound. Yet Keats too had his moments of 'vertical transcendence', when, like Blake and Shelley, he could soar into a world beyond. In *Endymion* he tells us that the poet 'presents immortal bowers to mortal sense'[17] and in 'I Stood Tip-Toe' we follow the poet prising loose his 'mortal bars' and ascending 'into a wondrous region' from whence he returns

bearing 'Shapes from the invisible world'. However such moments were rare, for Keats' confidence in the visionary imagination was always beset by doubts and suspicions. He never quite trusted its persuasion and in the end came to reject it altogether. One the whole, Keats preferred to sing of truth immanent and revealed to the poet's sympathetic identification with things, rather than of truth transcendent and divorced from the concrete. In other words, poetry for Keats was a process of dynamic *sensuous* cognition and his famous 'fellowship with essence' was essentially a fellowship with the actual or implicit beauty of things, a beauty that to him constituted their abiding value. Hence his seemingly enigmatic 'What the imagination seizes as Beauty must be truth' or more simply: 'Beauty is truth, truth beauty'.[18] If that equation teases us out of thought, Keats believed the fault to lie in our intellectual obsession with facts and reasons.

Turning to the Germans, their faith in the cognitive function of art was as absolute as it was sometimes singular in its devotion to unravel the cosmic mystery of art and its unrivalled revelatory significance. None was more devoted to it than Schelling in his lofty *System of Transcendental Idealism*. For Schelling 'the marvel of art' was its ability to overcome 'the infinite contradiction' between the conscious realm of mind characterized by freedom and the unconscious domain of nature ruled by strict necessity. How did art succeed in surmounting this primordial opposition?

Schelling set out from the indubitable fact that aesthetic production exhibits the co-presence of conscious and unconscious drives. Following the lead of Kant and Schiller, he argued that the unconscious active in artistic creation was none other than the voice of productive nature which through art achieved a second and higher conclusion. Yet this unconscious power of nature active in art at the same time coexisted with a conscious element. The true artist always 'knows' what he is about and with this knowledge comes the consciousness of freedom — the freedom at least to accept or to reject the solutions proffered by unconscious promptings, the freedom to guide the aesthetic process towards a desired end. Genuine art always combined *natural* necessity and *ideal* purpose. While in the beginning of the aesthetic activity their relation is one of conflict, this conflict progressively resolves itself until in the completion of the work the unconscious has been

wholly reconciled with and raised to the level of the conscious, while consciousness thus enriched confronts its own object in which the Spirit at last can contemplate itself in all its full concreteness.

Schelling's argument reached its climax with the assertion that art and art alone comprised the unique meeting-ground of the subjective and the objective, of the ideal and the real, of freedom and necessity. Only in artistic creation did the unconscious soul of nature merge with the conscious soul of man to produce works in which nature becomes spirit and spirit an enobled and redeemed nature. Art reproduced their original identity but on a higher plane. For this reason it was an 'eternal revelation', the one and only 'that exists'. Schelling here is his own best expositor:

> Art is the only true and eternal organ ... of philosophy which always and continually proclaims anew what philosophy cannot concretely represent, namely, the unconscious in activity ... and its original identity with the conscious. For this very reason art is for the philosopher the highest manifestation because it opens to him, as it were, the Holy of Holies itself, where in eternal and primal union burns in one flame what in nature and history is sundered, and what in life and action, just as in thought, must eternally flee itself ... Each glorious painting owes its origin [to an act] that removes the invisible wall separating the ideal from the real world ...

From this it followed for Schelling that

> If ... it is art alone that can succeed in making objective, with universal validity what the philosopher can represent only subjectively, then it is to be expected ... that, just as in the childhood of knowledge, philosophy ... was born from and nourished by poetry, so, after its fulfilment it will flow back as so many individual streams into the universal ocean of poetry which was their original point of departure.[19]

Schelling's apotheosis of art stands in a class of its own. No prior or subsequent philosophy pursued its argument so relentlessly and rhapsodically in order to prove that aesthetic production by its very nature is a raid on the Absolute with the work of art its revelation.

Schelling gave systematic expression to what the *Frühromantiker*

conveyed more spontaneously but with just as much conviction. Without fail they praised poetry and art for their ability to raise 'the veil of mortality' and to communicate 'the secret of an unseen world in the mirror of a penetrating imagination'.[20] For Novalis it was this penetrative imagination in the poet that pierced the shell of nature and revealed its living spirit. True poetry made for 'the deepest insight' and the 'innermost communion of the finite and the infinite'. Hence Novalis' abiding conviction that poetry and poetry alone was 'absolutely and genuinely real . . . The more poetic, the more true'.[21]

Friedrich Schlegel was no less emphatic in his insistence that the processes of art contained the master key to the creative processes of the universe, a belief which informed his seemingly preposterous statement which urged man to 'comprehend the essence of physics' by becoming 'initiated into the mystery of poesy'.[22]

Extravagant as Schlegel's claim may sound it makes a kind of provocative sense provided we remember that for the *Frühromantiker* art worked out of and in strict harmony with the creative force of life, of which more in the next chapter. Once this premise is accepted any insight gained into the formative principles active in poetry and art would at the same time communicate a knowledge of the causes implicit in all universal growth and production. While foreign to the modern outlook, this notion is not lacking in support even today. Indeed the belief that art 'unveils to us some of the secrets of the inventiveness of nature' is advanced by a formidable modern critic who argues that since artists are Man and since Man is part of the Whole, what happens in the creative process 'suggests the presence, at the origin of universal becoming, of an inner force of invention and creativity that, everywhere at work in the world of matter, achieves self-awareness in the mind of the artist.'[23] Schelling could hardly have said it any better.

C. Art's 'Profound, Unchanging Holiness'

For the Romantics the cognitive function of art frequently overlapped and coincided with its religious significance. At its

greatest and purest art was both metaphysical revelation and a form of religious divination. Hence their constant effort to associate art more or less intimately with religion, their tendency more precisely to regard poetry, painting and music as the mediators of religious truth. The artists' task, they urged repeatedly, was to communicate God's message to man.

Wackenroder's homilies in *Herzensergiessungen* and *Phantasien* were very much instrumental in fostering such conceptions. For this impressionable devout Romantic the artist was indeed the true religious mediary and his work the vessel of divinity. The highest mission of art and its greatest fulfilment according to Wackenroder was to minister to the glory of God. Each genuine painting compressed 'the Spiritual and Supersensible' into enticing forms and figures. Their contemplation by the viewer called for an attitude of true humility and reverence towards 'the profound, unchanging holiness' of art.[24]

Wackenroder's devotional tract of essays and anecdotal stories of painters and paintings (his central subject) firmly established the role of the artist as the servant of God. As mentioned in the previous chapter his 'medievallizing' piety paved the way for the Nazarenes' self-conscious revival of Christian art, a revival reinforced by Tieck's *Sternbald*, Novalis' essay 'Christianity or Europe' and by Friedrich Schlegel's interpretation of Renaissance painting.[25]

The backward-looking Christian Romanticism of the Nazarenes contrasted strangely with Runge's anti-traditional religious imagery which invested things natural with revelations of divinity. While influenced by Tieck and by his one-time teacher the poet and nature-mystic Gotthard Ludwig Kosegarten, Runge's greater debt was to Jacob Boehme's 'illuminations'. Runge never doubted that the artist's soul was of 'divine origin', his work therefore a reflection of the deity, one manifest in rays of light and colour.

Runge's greatest dream was to create a new art of landscape, a hieroglyphic and arabesque language of forms which, composed in parts of flowers, plants and infant children, would animate the whole of nature and thus become symbolical of man's intimate connection with the universe' and of his relationship with God.[26]

Runge's early death cut short his considerable promise as a painter and it was left to Caspar David Friedrich to embody some

of the Romantics' religious feeling for landscape. Less programmatically and allegorically inclined than Runge, Friedrich's singular vision focused on the immensity and stillness of nature to convey the majesty and mystery of God (*Plate* 19). For all their striking differences, in the end both Runge and Friedrich produced a truly religious art which at once secularized the supernatural and sacralized the natural in an effort to revive and expand man's awareness of God.

Friedrich's faith and still more that of Runge testified to the Germans' often unconventional notion of divinity, a divinity both immanent and transcendent, 'pagan' and Christian. At times this God was envisaged as an eternally procreative *Urgrund*, a fertile 'chaos' perpetually 'striving after new and marvellous birth'.[27] Evidently this dynamic deity called for new symbols if not an altogether new mythology as Friedrich Schlegel, Schelling and Novalis repeatedly insisted. According to Friedrich Schlegel nothing less was involved than a radical reformulation of the Scripture, a herculean labour which he himself hoped to undertake. Predictably the project came to nothing. Coleridge's related scheme to compose the *magnum opus* of the age, his promised LOGOSOPHIA which was supposed to culminate in a commentary on the Revelation of St. John, likewise remained but a dream. As we shall see shortly, such seemingly extravagant and frivolous ambitions concealed a genuine religious problem.

In English Romanticism we meet with a corresponding though far less effusive emphasis on poetry and art as the mediaries of religion. That poetry pursued religious ends was either implied or explicitly stated by English Romantics. As Wordsworth reminds us in a letter to Landor: 'All great poets' conversant with the Infinite are 'powerful Religionists'.[28] None was more outspoken a religionist than Blake for whom poetry, painting and religion were but different manifestations of the Poetic Genius — the Divine Imagination in man which was synonymous with eternity. Blake's creative endeavours, what he called his 'great task' served one end: 'To open the eternal Worlds, to open the immortal Eyes / Of Man inwards . . . into Eternity.'[29]

Like the Germans, the English Romantics embraced an eternity that was anything but orthodox in conception. Even Wordsworth, while remaining a staunch advocate of the church, had pantheistic

inclinations which could hardly be reconciled with a triune, transcendent and personal God. Nor was Coleridge always the austere defender of the faith. His contentious Christian apologetics can be understood only in terms of his prolonged preoccupations and involvement with the different varieties of Pantheism. Blake, of course, was defiantly heretical and disconcertingly original in his transformation of Christianity into an apostolic religious humanism. This religious humanism bordered at times on Existentialist thought in its affirmation of the manhood of Christ and the divinity in every man. 'Thou art a Man, God is no more / Thine own Humanity learn to adore.'[30] Keats and Shelley were still further removed from the orthodoxy of faith to the extent of remaining either implacably hostile or completely indifferent to it. Yet both confirmed — as if it needed any confirmation — that denial of religious creed is not identical with the absence of religious faith. Each in his own way was a 'passionately religious poet'.[31]

This applies to virtually all the major Romantics in England and Germany. And they were passionately religious poets not only in the narrow sense of experiencing moments of genuine transcendence, but in the wider sense of possessing a profound feeing for the Numinous at a time that witnessed its gradual erosion in the wake of a triumphant rationalistic and scientific outlook. Put another way, and in keeping with our preceding theme, their poetic quest for the Whole was at the same time a religious quest for the Holy which in an age of Deism and 'natural religion' had become encrusted with convention and devitalized by reason. The Numinous as an all-illuminating presence in the human heart was either on the retreat or, equally serious, it lacked the necessary symbols reflecting man's changed and subjective awareness of it. In its Christian, notably Protestant, form, the Numinous additionally suffered the fate of *symbolic* destitution. The once powerful and authoritative religious symbols were losing their mediating and sacramental values. Hence the efforts of the *Frühromantiker* to evolve a radically different symbolic language that would restore the immediacy and vitality of faith.

D. Romantic Mythopoeia

Knowingly or not, a spontaneous and irresistable urge to revitalize Man's feeling for the sacred — whatever its connotation — motivated the majority of the Romantics. And this urge revived what has always been the generative force and the unique vehicle of all true religions — the mythopoetic imagination. Emanating from the primitivity of deep religious feelings, the mythopoetic imagination weaves its cosmic-cosmogonic similes and symbols into an elaborate fabric of meanings which, in Milton's well-worn lines, 'assert Eternal Providence / And justify the ways of God to man'. While it may, and indeed often does, make use of mythic prototypes, it arrives at an essentially personal and original vision that embraces all things natural, human and divine.

Almost all the major Romantic poets were mythopoeic and symbolists 'whose practice', in the words of René Wellek, 'must be understood in terms of their attempts to give a total mythic interpretation of the world to which the poet holds the key.'[32] What has been less understood perhaps is the reason for such mythological constructions. The reason clearly must be sought in the poet's compelling religious need which drove him to embody the Divine in symbols relevant to himself and to the culture of his times.

Mythopoeia flourished freely if somewhat whimsically in the German poets. In the case of Novalis, it appeared in the guise of cosmic-religious fables — 'fairy tales' as he unfortunately called them. With different and altogether tragic emphasis, mythopoeia emerged in Hoelderlin who employed myth to lament the death of myth. While greatly in evidence among the Germans, it was however in English Romanticism that the mythopoetic imagination achieved a *poetic* stature unmatched anywhere else.

Mythopoeia at once dominated and defined Blake's genius. Where Friedrich Schlegel merely toyed with the idea of rewriting the Bible, Blake's religious fervour composed a whole new Scripture in the form of visionary poems and paintings. Incorporating Greek, Hebrew, Christian and still older archaic sources, Blake's series of 'Holy Books' — from *The Marriage of Heaven and Hell* right up to *The Four Zoas*, *Milton* and *Jerusalem* — collectively present the claims of an *Everlasting Gospel* which

aspires to explain the birth, life, death and ultimate redemption of man and the Creation. In its sheer complexity and unrivalled inventiveness Blake's myth has no equal.

Ancient mythological motifs appear metamorphosized in Keats' *Endymion* and *Hyperion*; in Shelley's *Prometheus*, *Adonais* and *Witch of Atlas*. Above all, there is Shelley's remarkable 'Ode to the West Wind', a largely self-generated myth in which the image of a creative and destructive wind re-enacts the timeless themes of death and resurrection. Coleridge's mature poetry, notably the *Ancient Mariner* whose voyage leads through crime, penance and repentance, clearly carried the stamp of the mythopoetic imagination which he so greatly admired in the Hebrew prophets. Poetry of this kind vindicated his understanding of the symbol as 'a translucence of the eternal through and in the temporal.'[33]

Of all English Romantics Wordsworth seemed least inclined to borrow from the world of myth — discounting his rather premeditated classical mythologizing in later poems like 'Laodamia'. Yet it was he who concurred with Coleridge that the great storehouse of the meditative imagination was to be found in 'the prophetic and lyrical parts of the Holy Scriptures' to which he added the verse of Milton and Spenser.[34] It was also Wordsworth who glowingly described the ancient mythic mind as manifest in the religion of Near-Eastern peoples, a description which was to have profound repercussions for the poetry of the younger Shelley and Keats. These brief passages in Book IV (630–887) of *The Excursion* at the same time contain the key to Wordsworth's own spontaneous mythologising. Thus when he praised the mythopoetic imagination of ancestral man for its ability to hear 'the articulate voice of God', for its power to perceive 'Life continuous' and 'Being unimpaired', he in effect characterized the goal and substance of his uniquely personal mythopoetic efforts. Indeed Wordsworth's major poems, *The Prelude*, 'Intimations of Immortality' and parts of *The Excursion*, are arguably the purest and most convincing examples of myth-in-the-making rather than traditional myth being transformed — it is the myth of animated nature in which everything respires with 'an inward meaning' or, alternatively, the myth of the One Life pervading Creation's mighty forms who communicate 'unutterable love' through which the human soul advances 'in peace of heart, in calm of mind / . . . to

mingle with Eternity.'[35]

Whether partly derived or wholly spun out of themselves, all these diverse and richly inventive mythopoetic tales fashioned by the Romantics, testified to the poet's rediscovery of something Sacred as a compelling psychic factor. And this rediscovery meant at once to be liberated from any loyalties to traditional symbols and to proceed to the making of new symbols in accordance with the poet's deepest wants and yearnings. Such wants and yearnings invariably longed to escape from the 'agonies' of time, that is, from a purely profane historical awareness to an a-historical mythic apprehension of the world which saw everything irradiated by the presence of the Sacred.

Unfortunately, no study exists as yet which traces this Romantic quest for myth in keeping with categories peculiar to mythic thinking, in the light, that is, of a *phenomenology* of myth which charts the structure and function of man's myth-making dispositions. Alas, the same is true of Romantic painting whose quest for myth has not received the attention it undoubtedly deserves. This quest was obvious enough in Blake's pictures and engravings which admittedly have been studied in detail but strictly from an iconographic point of view. Runge has been similarly treated in his attempt to mythologize landscape, which reaches a climax in his most ambitious project, the unfinished *Tageszeiten*, a series of works which was supposed to comprise a cosmic-cosmogonic cycle of birth, becoming, generation and destruction involving not only the life of the individual, but the life and fate as well of entire peoples and civilizations.

That Turner was a mythopoetic painter of the first rank has yet to be accepted by historians of art. Almost all treat his overt mythologizing as a convention inherited from a preceding pictorial tradition whose literary conceit, it is implied, was all the more attractive to a largely self-taught barber's son. Of course Turner's mythological pictures can be interpreted against the background of that tradition, against the background as well of then contemporary scientific conceptions of nature, as John Gage has persuasively shown.[36] Essential as these explanations are for an understanding of Turner they rarely touch however on the substance of such major compositions as *Ulysses deriding Polyphemus, Mercury Sent to Admonish Aeneas*, or the Carthaginian pictures, including the

various apocalyptic paintings to which we shall presently turn. While traditional myths figure prominently in all these paintings, each one exhibits an original mythological achievement or, at least, a highly creative transmutation of familiar mythological motifs which suggest that for Turner the world of myth possessed an actuality and ultimately a religious significance which cries out to be analysed in depth. Accustomed or, better still 'conditioned', as we are to respond only to non-objective forms and colours, we see in Turner's recourse to mythology no more than a convenient vehicle which he apparently employed to exercise his imagination more freely or to outdo Poussin and Claude.

Yet the mythopoetic instinct in Turner was just as central to his art as was his fascination with the inherent quality of painting. And this instinct functioned undiminished right up to, and including, his latest works. If, as one perceptive critic rightly observes 'the grandeur of Turner's later pictures was sustained by a grand conception of the imaginative artist,'[37] the judgment is incomplete without the necessary and vital addition that the imagination at work was predominantly mythopoetic. And it was mythopoetic not only in the restricted sense of creatively converting familiar mythological themes, but also and perhaps even more persuasively so, in his original transformation of nature's forms and forces into a personal mythology of light and colour. In other words, Turner gives us a myth within a myth: one which assimilates and re-fashions the legends of old in the light of his own pantheistic visions; and another which celebrates in luminous tissues of paint the cosmic harmony and conflict of the elements.

E. Prophecy, Millenarianism and Eschatology

The thrust of the mythopoetic mind explains in part another important function the Romantics assigned to the poet and artist: that of prophet. This prophetic function clearly placed art in the orbit of religion and nowhere more conspicuously so than in Blake's visionary writing. For Blake the genuine poet was a sage and bard 'Who Present, Past and Future sees; / Whose ears have heard / The Holy Word / That walked among the ancient trees.'[38] A less overtly religious sage but one nonetheless prophetic appears,

of course, in Shelley's famous formulation from which derives the title of the present chapter — in his notion of poets as 'the hierophants of an unapprehended inspiration' and as 'the unacknowledged legislators of the world.'[39] The Germans' high regard for art as religious mediation similarly stressed the poet's prophetic power. 'The feeling for poetry' wrote Novalis, 'is closely related to the feeling for prophecy, to religious divination altogether.'[40]

Novalis, Blake and Shelley here obviously revived the ancient notion of the *sacer vates*: the poet-prophet-priest which is the most literal and direct expression of the hierophantic conception of art. According to Blake, the 'Spirit of Prophecy' was indeed identical with the Poetic Genius itself from which in turn sprang the world's genuine religions. However as Blake implied and as Shelley was at pains to point out, the poet was not a prophet in the vulgar sense of the word, that is, one who could accurately predict events to come. The poet perceived the future in and through the present; 'his thoughts are the germs of the flower and the fruit of latest time.'[41]

Nonetheless, none of these poets and their fellow-Romantics left any doubts that 'the fruit of latest time' was latent with a glowing future, with an impending Golden Age in which all things would join in brotherhood and love. This age of 'everlasting peace' haunted the imagination of the early German Romantics. They looked upon it as the aeon of the Spirit redeeming a fallen and fragmented world. Novalis gave this millennial dream its most mystical expression when he celebrated the sacred marriage of 'men, beasts, plants, stones and stars' who act and converse as one single species.[42] For the *Frühromantiker* one of the foremost functions of poetry and art was to prepare and proclaim the coming of the Spirit. Hence Friedrich Schlegel's insistence that art 'aims for the last Messiah', for the millennium in sight.[43] Novalis meant much the same when he wrote: 'We are on a mission. To mould the earth is our calling'.[44] Novalis' beckoning call owed much to Francois Hemsterhuis' utopian conception according to which the Golden Age was not an event of the past but a future occurrence.[45]

This messianic-millennial vision was a salient feature of the Romantic movement. Not confined to the Germans, it haunted the thoughts of English Romantics as well. Indeed and as M.H. Abrams has shown in his masterly manner, millenarianism

characterized the period to its very marrow. Among its numerous utopian prophets Blake evidently was the veteran apostle. His passionate faith in the New Jerusalem to which poetry and painting paved the way was the enduring theme of all his major writings which mount to a millenarian crescendo in *Milton* and in Night IX of *The Four Zoas*. The Night celebrates the world's rebirth. All the evil has been overcome. Man at last beholds the spheres of heaven. 'And the fresh earth beams forth ten thousand thousand springs of life'.

While millenarianism assumed its most mystical and visionary form in Blake, it was no less conspicuous in Coleridge's *Religious Musing*; in Shelley's *Prometheus*; in Keats's *Endymion* and, above all, in his *Hyperion*. Nor was Wordsworth the exception he is often thought to be. Although sobered by political events in France he could never wholly quench his millennial hopes and longings. His fellow-poets however expressed them more directly. All looked forward to a time when the seeds of redemption will have ripened, when, as Shelley put it, 'The Spirit of the Hour' will rest 'exempt from toil' bearing Time and with it transcience, impermanence and man's lost innocence to his unmarked tomb in eternity. 'Time's creeping', in Keats's pregnant phrase, will come to its destined end and an eternal *now* begin. And for each of these poets it was the creative and mediating imagination that helped to bring about the world's transfiguration and redemption.

To be sure, such millenarian dreams were directly related to contemporary events, in particular, to the cataclysmic cultural upheavals of the French Revolution and its counterpart in the Americas; conjoined to which — in the case of Coleridge at least — was the conviction that these events could be interpreted in accordance with the scriptural prophecies of *Revelation.* The utopian visions of the younger poets Keats and Shelley again were partly inspired by certain rudimentary ideas on evolution.[46] However the millennial spirit in itself cannot be reduced to and explained by historical circumstances alone. They merely provide the occasion for what is essentially a natural concomitant of the mythopoetic imagination which, reflecting on the birth and life of man and the Creation, must needs give an account of their completion and redemption in the 'fullness of time'. Put another way, millennarianism is an original or "primitive" modality of the

religious mind which movingly expresses man's enduring longing for renewal and salvation.

The same millennial cast of mind in turn explains the Romantics' predilection for apocalyptic themes. The millennium to come demanded a prior cleansing of the earth, a universal conflagration that would burn away all evil. As Blake repeatedly affirmed, 'the Plow of Ages', must tear up this fallen and decrepit world to permit the planting of new life.

With varying degrees of emphasis this apocalyptic fervour also informed the outlook of Coleridge and Wordsworth, of Keats and Shelley. In one form or another each one subscribed to a Spirit of Creation yielding a dreadful sword. Turner painted this awesome spirit as a Seraphic angel standing in the sun, in a searing vortex of light and fire which commits the world to flames and ashes. (*Plate 20*)

Turner's interest in the apocalypse never ceased. He painted it in numerous versions, either in the guise of destructive storms and fires or, more explicitly, in the form of subjects drawn from *Genesis* and *Revelation*. Nor do we miss from Turner's repertory the famous apocalyptic rider on the pale horse. While themes of this kind were common enough among his predecessors and contemporaries he treated them in a highly unconventional way and with a deep conviction that betrays his passionate involvement. Admittedly Turner's pessimism, or tragic vision, seems to dwell almost exclusively on the powers of death and dissolution, on a world inexorably doomed. But the promise of light and redemption is never wholly absent from his painting. In the last analysis, apocalyptic passions of this kind are rarely, if ever, sustained without some deeper longing for rebirth.

Turner confirmed Shelley's belief that painters, like poets and philosophers, are the receptacles of unapprehended inspirations (of unconsciously received religious urges) which they are compelled to serve. While being creators, they are at the same time the creations of their age — an age which in and through its most prophetic minds preached doom and devastation for the sake of deliverance and salvation.

The *Frühromantiker* proved no exception to this apocalyptic fervour. It pervades Novalis' poetry and prose, his vision of a 'feast of love' and peace 'upon smoking battlefields' and wastes of

desolation.[47] Runge's projected *'Times of Day'* were truly eschatological in conception, a series of hieroglyphs relating to the First and Final things. Runge was convinced that the world had reached its 'autumn' which was to be followed by a winter of destruction. 'Blessed he who will be resurrected'.[48] Caspar David Friedrich painted such wintry premonitions in many a 'landscape of death' (Totenlandschaft) as the contemporary poet Theodor Körner called one — landscapes depicting barren trees, snow-covered graveyards with overturned crosses and the recurrent Gothic ruins, a reminder that faith itself must undergo a dramatic transformation. As he put it himself: 'The time of the temple's glory and its servants are gone, and from the ruined whole emerges another time and another demand for clarity and truth'.[49] (*Plate* 21)

* * *

Friedrich lived long enough to witness in his own person the Romantics' changing attitude towards the Millenium and the Apocalypse. When the New Jerusalem failed to come about by *Revelation* or by Revolution, millennial preoccupations did not simply disappear. Being an archetypal religious response they persisted but instead of looking outward they turned inward upon Man's inner transformation — upon what M.H. Abrams aptly named 'apocalypse by imagination or cognition'. As Abrams points out in the context of Wordsworth and his Romantic contemporaries, once their faith in the French Revolution had given way to disillusion and despair, the poet 'transferred the power of renovating the earth to an imaginative act of creative perception'.[50] In other words, the creative imagination was invested with the energy to make all things new.

The same shift towards an inner millennium marked the attitude of the Germans. As Fichte was to put it in his 'Vocation of Man': 'That which we call heaven does not lie beyond the grave; it is even here diffused around us and its light arises in every pure heart'.[51] Brentano's 'sage' in *Godwi* conveyed a similar message: 'Within you is the depth, the fullness, the clarity' and illumination of redemption.[52]

Where Fichte and his Idealist friends discovered the inner Kingdom, 'the True Life and its Blessedness' in a 'Doctrine of

Knowledge', the *Frühromantiker*, like their English counterparts, found it in the act of 'creative perception', in the 'shaping spirit' of the imagination which reconciled spirit and matter, heaven and earth. For both the New Jerusalem was deep within the human soul, deep within the vast inner spaces of the self.

Once again we are back with the Romantics' willed introversion of the self and its alleged cognitive and redemptive powers which was our original point of departure. Of all Romantic accomplishments this 'myth' of the redemptive self has, with few changes, passed down almost undiminished into our own age. And this 'redemptive Romanticism', to paraphrase Morse Peckham who views it with the greatest of misgivings, invariably invests the arts with the salvation of the race and, if we accept Robert Rosenblum's argument, with the survival of the sacred in secular disguise.[53]

Chapter V
The Organic Theory of Art

A. 'Not to Create from but like Nature'

With the organic theory of art we touch on a most important Romantic contribution to aesthetics. Indeed, some critics consider this theory to be the major achievement of Romanticism if not its defining characteristic. In the light of the foregoing analysis such claims must seem too restrictive by far. Nonetheless this is not to question the importance of the theory which has been the subject of numerous critical discussions foremost among them M.H. Abrams' brilliant appraisal in *The Mirror and the Lamp* to which the following analysis is much indebted. Unlike Abrams, however, whose discerning eye — to anticipate a recurrent Romantic metaphor — barely misses a leaf on what turns out to be a luxurious and prolific tree, the present account concentrates rather on the main essentials of the organic theory including some of its more conspicuous ramifications.

Predictably the organic theory of art was not unrelated to the theories already discussed. As we shall see presently, they shared certain basic features. At the same time, each theory approached the phenomenon of art in its own characteristic way and with its own particular end in view. Thus while the expressive theory set out from the creativity of the 'subject' which, by way of the hierophantic conception of art, it grounded in something higher than the self, the organic theory proceeded from the opposite direction by setting out from the productivity of the 'object', that is, of nature from which it reasoned backward to the creative self. Put more generally, though a shade less accurately, with the organic theory the emphasis shifted from the inner to the outer,

from a notion of poetry and painting as 'self-expression' to a conception of art as a manifestation of something cosmic, as an expression, that is, of the creative force of life.

In its 'cosmocentric' orientation the organic theory admittedly had much in common with the holistic theory of art. Yet unlike the latter, it was less concerned with laying down the subject-matter for poetry and painting and more with uncovering the dynamics inherent in artistic creation. In other words, the organic theory was preoccupied with discovering the "how" of art — its formative principles — in the process of which it paid scant attention to the content or the "what" of art. The failure to understand this Romantic procedure or, alternatively, the attempt to interpret the organic theory in terms of both the "how" and the "what" of artistic invention has only spread misconceptions and confusion.

As formulated by the Romantics the organic theory of art derived from a more comprehensive, more inclusive philosophy of organicism which as we shall see below viewed the entire universe as a living whole. This organismic creed was not unique to the Romantics. One of the oldest and most enduring visions of the universe, it appeared in the pre-Socratics, in Plato, Aristotle and Plotinus from which it passed down into Renaissance and post-Renaissance forms of Neoplatonism. Closer to their own time, the Romantics' organicism — notably that of the Germans — received some of its strongest impulses from the system of Spinoza, from Herder's historical and cultural organology, from Kant's *Third Critique* and, not least, from Goethe's consistently morphological understanding of nature. A still closer source of inspiration was Schelling's metaphysics and, for the English Romantics, Coleridge's finely worded organic distinctions. There were other influences as well as we shall see shortly.

Although organicism achieved its fullest systematic development in German speculations, especially in the philosophies of Schelling and other Idealists of Nature, organic thinking in itself once again transcended any narrow national divisions. Thus it was manifestly present in English thought prior to Coleridge's missionary efforts. While Coleridge's contribution was indeed immense — his German-inspired organology provided much needed definitions and directions for application — it pre-supposed that pronounced inclination towards the organismic which had already begun to

sway the thoughts and feelings of his fellow-Romantics in England. This should be kept in mind throughout for the present exposition relies more on the testimony of the Germans. It does so not only out of historical considerations but for exegetical reasons as well. The Germans by and large pursued the matter more systematically and occasionally evolved the finer distinctions.

Organicism has been defined as a 'philosophy whose major categories are derived metaphorically from the attributes of living and growing things'.[1] In the case of the Romantics this requires a minor adjustment. Their organismic creed began with a contemplation not only of individual instances of growth but with nature as a living totality. Invariably they looked upon Creation as a supremely fashioned organism comprehending all stages of evolution from unconscious matter up to the mind of man, an autonomous organism in continuous flux and transformation. It was precisely this vision of a dynamically evolving universe productive of an ever-increasing diversity that distinguished Romantic organicism from older organologies which accounted for nature's mobility and transformations within the strict limits set by a pre-determined order. To the Romantics no such pre-determined order existed. The universe was 'infinite in essence, infinite therefore in expression'.

With a passion born of deep conviction the Romantics paid persistent homage to a universe organic throughout, organic in its least manifestation. Everywhere they saw a vital force diversely active in Creation, a living force pulsating through everything, each — from shell, mineral and stone to tree, plant, man and beast — following its own mysterious impulse of growth and generation, its own formative drive which came to fruition in the formation of living form, one whole and complete in itself. What the Romantics loved and admired in all these organically created things, borrowing the words of Schiller, was 'their calmly productive life, their serenity and spontaneity, their existence in conformity with their own laws, their inner necessity, their internal consistency with themselves'.[2]

The Romantics lost no time at all in transferring the above attributes of organic nature to the specific activities of art. Everything that hitherto had been exclusively predicated of living and growing things was now enthusiastically applied to the

processes and products of the creative imagination. Henceforth a true work of art was something uniquely self-generated obedient only to its own laws of growth, its own inherent *Gestalt*. For the Romantics there was really no such thing as the making or assembling of a poem or painting in keeping with a set of pre-determined rules. The point was forcefully put already by Edward Young, the mid-18th century poet to whom the Romantics were much indebted. 'An Original', according to Young 'may be said to be of *vegetable* nature'. As such 'it rises spontaneously from the vital roots of genius; it *grows*, it is not made' unlike works of 'Imitations' which, for the most part, are manufactured products 'wrought by those Mechanics, Art and Labour' out of second-hand materials.[3]

The Romantics retained and refined this basic contrast equating imitation and the uncritical acceptance of neo-classical rules with 'manufacture', with an inclination, in other words, that unknowingly mirrored a mechanistic outlook. Displaying a dogged persistence that brooked no deviation, they continuously drew a sharp distinction between 'mechanical making' according to pre-existent norms imposed on art from without and 'organic creation' which, originating from the artist's innermost being, unfolded in keeping with its inherent form.

The well-known Schlegel-Coleridge distinction clearly defined the Romantics' vital comprehension as it related to the processes and products of art:

> The form is mechanic when on any given material we impress a pre-determined form ... The organic form, on the other hand, is innate; it shapes as it develops itself from within, and the fullness of its development is one and the same with the perfection of its outward form.[4]

This affirmation of art as an organic event implied a precept of profound importance, an imperative in fact which, briefly stated, proclaimed that in its generation and formation the main function of art was not to create *from*, but *like* nature. Like nature — 'creating autonomously ... itself organized and organizing' — art must form 'living works' set in motion not through an alien mechanism but through a self-generated 'indwelling power'. The words are A.W. Schlegel's.[5]

Once again this organismic comprehension put paid to the prevailing idea of art as imitation. As an autonomous production, the primary impulse of art was essentially non-mimetic. Evidently and like any other organically created entity, the work of art required a specific 'soil' and 'climate' — the artist's personality and socio-cultural ambience respectively — in which to flourish and reach completion. But these provided but the conditions for development and not the final cause or reason for the birth and being of the work of art.

This point of view put paid as well to the rationalists' view of art as a process governed by a calculating, premeditating consciousness fully aware of the ends to be achieved. As we have seen more than once, the Romantics would have none of this. Similar to any plant or tree, a poem or painting developed in defiance of any rational deliberations. It grew spontaneously and, for the most part, unconsciously in the artist's innermost depth in close collaboration with his chosen material or medium.

While placing the greatest emphasis on the unconscious element in art, the Romantics stopped well short however of embracing a blind deterministic organicism since this would have reduced the artist to a wholly passive and wholly mindless producer of unpremeditated 'vegetable offspring'.

B. The Metaphysical Foundations of Aesthetic Organicism

The Romantics' organismic outlook received an unexpected boost from Kant's examination of art and nature in the *Third Critique*. Reflecting on the spontaneity of the creative process, its unfolding from within according to an immanent teleology, Kant arrived at the tentative conclusion that in the productions of fine art we meet something analogous to the phenomenon of growth in nature. Taking his hypothetical argument a step further Kant suggested that the creative imagination may be the medium or instrument through which nature lays down the productive rules for art — indefinable rules that could not be taught. This in turn explained Kant's still more provisional conjecture of art and nature comprising parallel phenomena flowing from a common source, an original unity of mind and matter.

Such thinking was very much to the anti-mechanistic taste of the times. It impressed even Goethe who otherwise stood aloof from Idealist speculations which he found much too abstruse and opposed to nature's visible richness and concreteness. Nonetheless in this instance Goethe hailed Kant's vision of art and nature as collateral activities, each one proceeding 'in accordance with great principles without purpose', each one, that is, propelled by an internal teleology and not by any external functional necessity.[6]

With characteristic daring the Romantics seized upon Kant's cautiously qualified conjectures and turned them into bold metaphysical assertions which received their philosophical blessing in the system of Schelling and in the more sporadic speculations of his English counterpart Coleridge. Stripped of all rhetorical embellishments these metaphysical assertions supportive of the Romantics' aesthetic organicism can be briefly and succinctly stated.

According to this view, the creativity of art continued the creativity of nature. By virtue of his imagination, his feeling and intuition, the artist was capable of tapping the creative source of life, the formative energies at work throughout the cosmos. Thus Coleridge could speak of the 'essentially vital' character of the imagination which produced a 'form of its own' in accordance with rules which were 'the very powers of growth and production'.[7] Schelling put it still more simply when he wrote that 'the ideal world of art and the real one of objects are products of the same activity'.[8] In its deepest urges, the artist's soul always throbbed in unison with the creative soul of the world.

The two streams nature and art, flowed from the same source: in Schelling's term the 'Absolute', the *Urgrund* in the terminology of the Romantics. This *Urgrund* or Absolute was the primal force in both domains manifest as much in the formation of the poem or painting as in the forming of naturally created things. Seen from the Absolute, both nature and art occupied strictly correlative positions at different levels of reality, each one autonomous in itself and delighting in the production of self-generated, self-evolving living forms.

While intent on stressing the close affinity between art and nature the Romantics did by no means overlook what they believed to be some of the differences separating these two spheres. Those

following Schelling were quick to insist that in one important sense art was truly superior to nature for it raised into consciousness what in the natural sphere always operated unconsciously. As Schelling put it more than once, nature was but the unconscious poetry of the spirit, art its conscious consumation. Only in and through art did nature's purely instinctual teleology achieve knowledge of itself. Art and art alone, to recall Schelling's 'lofty' argument in the previous chapter, reconciled on a higher plane spirit and matter, the freedom of the human mind with the blind necessity of nature.

Even those Romantics indifferent to or disinclined to accept Schelling's arguments still looked to art as a 'higher nature', higher because unlike nature's plants or trees, it produced 'spiritually-organic' entities directly expressive of Man's soul and spirit. Making use of Goethe's triple distinction their position on the matter may be summarized thus: while in its form and formation the world of art was eminently 'natural' (natürlich), it was 'above nature' (übernatürlich) in terms of its content and meaning. Yet while above nature the true work of art was never 'out of nature' (aussernatürlich).[9] The genuine artist always created in harmony with the formative energies at the heart of the world.

C. The Lawfulness and Originating Power of Art

This view of art at one with the Creation enabled the Romantics to insist on the intrinsic lawfulness of the artist's efforts. And they were compelled to do so repeatedly in order to defuse a charge hurled against them by their many neo-classic critics. If art, like nature, enjoyed absolute autonomy, a freedom bound by no constraints, what, these critics argued, was to prevent the poet and the painter, the writer and the composer from lapsing into outright lawlessness and license? If the creative imagination suffered no law higher than itself, no wise governing intelligence without which no human life can flourish, the result surely could only veer towards the monstrous and the vile, the ugly and the grotesque, not to mention the trivial, the ephemeral and childish.

For the Romantics all such fears were totally unfounded; the alleged dilemma in fact did not exist. Resting their case upon the

common origin and parallel development of art and nature, they affirmed that just as natural phenomena evolved according to their own ineluctable rules of growth, so the work of art, sibling in creation, was self-regulating and of irreproachable integrity, an organic transaction taking place in the human mind in keeping with norms inherent in its own productions. The issue, Coleridge urged, was not that of 'genius' being opposed to rules, but of its loyalty to laws generated by itself. Hence Coleridge could claim: 'No work of true genius dare want its appropriate form; neither indeed is there any danger of this. As it must not, so neither can it be lawless. For it is even this that constitutes its genius — the power of acting creatively under laws of its own origination'.[10]

This vision, as we have seen, was shared by Goethe. Although he accused the Romantics at times of the very things they sought to refute, that is, anarchy and license, his consistent emphasis on the lawfulness of art was particularly suited to support their argument. As a noted biologist with a special interest in the morphology of plants, Goethe could not help but view artistic processes in purely genetic terms. Fond of comparing art with nature, though always keeping their identities intact, he was convinced that the laws active in one were the laws operating in the other. Hence his much-quoted reflections on some buildings of classical antiquity: 'These high works of art, like the highest works of nature, were produced by men according to true and natural laws. Everything arbitrary, fanciful falls together: here is necessity, here is God'.[11] The Romantics claimed no less for Shakespeare's 'rival originality', as they did for Goethe's own creativeness which to them reflected a truly 'divine necessity'.

This conception of art working to 'true and natural laws' prompted the corollary belief that art made manifest such laws. It reinforced, in short, the previously discussed notion of art as revelation, in this case the revelation of the morpho-genetic mysteries of nature.

Related to this was the Romantics' equally ambitious claim that in its generation and becoming the work of art not merely recapitulated the ways of organic nature but the cosmogony itself, the original act of divine Creation. Schelling hinted at it in his notion of art as the 'immediate reproduction' of the world's 'absolute production'.[12] K.C.F. Krause, the Romantic philosopher

of nature, conveyed it more directly when he wrote 'Poesy is the magic power of the spirit which in the form of free beauty repeats the creation of the All'.[13] Alternatively, the Romantics could invoke Shaftesbury's concept of the artist as a 'second Maker, a just Prometheus under Jove' who, from the common clay of the earth, formed a whole 'coherent and proportioned in itself'.[14]

All these elevated and seemingly far-fetched claims served to highlight one of the most essential tenets of aesthetic organicism — its persistent emphasis upon the autonomy of art and its power to originate new orders of being. With Addison, an important precursor, the Romantics stressed repeatedly that the main business of art was not to compete with nature but to contribute to her riches and thereby increase the stock of originally created things.

This notion of art as an originating power making additions to reality forthwith replaced the hitherto important metaphor of art as a 'mirror of nature' with that of art as a 'second nature', as a 'heterocosm' generated in a manner analogous to nature's organic productions or to God's creation of the world'.[15] This new-found status of the work of art immediately determined its mode of being in the world, its order of existence. Thus as a 'second nature', the work of art, like any work of nature, demanded to be treated as an end in itself. As such it had to be viewed in its own terms, judged according to its own criteria and not by any standards external to itself. Tieck put it aptly when, referring to the individual arts, he maintained that 'each moves in its own sphere in keeping with its unique truth which knows no other outside of itself'. The highest art, Tieck insisted, 'can only explain itself'.[16] From this it followed that artistic truth and natural truth should never be confused but kept separate and entirely distinct.

Henceforth the one and only stricture imposed upon the work of art was the demand that in its becoming and its being it meet with the requirements of organically evolved structures. In short and pressing this point of view to its ultimate conclusion of the poem and painting, it was no longer expected that they be true to nature, or true to anything else, but only that they be true to themselves. It took almost a century and the birth of modernism to realize and exploit this conclusion fully — the conclusion which now proudly proclaimed that a poem or painting, as MacLeish's lines asserted 'should not mean / But be'.

D. 'The Workshop of Nature'

The Romantics' organic theory of art throws considerable light on their often complex and occasionally ambivalent relationship to nature and to the external world. In so far as they were consistent organicists, this relationship can be clearly stated. Evidently and in keeping with the notion of art as an autonomous self-organizing power, the Romantic was not concerned with appearances and their imitation. His contemplation of outer nature sprang in large part from the desire to comprehend inner productive nature which he acknowledged and revered as a related spirit. This inner nature provided the paradigm, the exemplary model for organic productions of any kind. Its study therefore was of paramount importance for every poet and painter intent on creating on equal terms with nature. Only those trained in 'the workshop of nature' according to K.C.F. Krause, were in a position to 'awaken in her a second inward, but nature-like creation'.[17] Philipp Otto Runge put it almost identically when he spoke of a painting as a 'second creation the perfection of which will appear all the greater the deeper the painter penetrates into . . . natural phenomena'.[18]

This notion formed one of the key elements in Coleridge's paper 'On Poesy or Art' which made skilful use of Neoplatonic terms familiar then to every student of Spinoza. 'If the artist', Coleridge contended, 'copies the mere nature, the *natura naturata*, what idle rivalry! If he proceeds only from a given form . . . what an emptiness, what an unreality there always is in his productions . . . Believe me, you must master the essence, the *natura naturans*, which presupposes a bond between nature in the higher sense and the soul of man'.[19] By nature in the 'higher sense' Coleridge meant nothing else than the conception of nature as unconscious spirit coming to know itself in the human spirit.

Coleridge's prescriptions owed much to Schelling's essay 'Concerning the Relation of the Plastic Arts to Nature' which urged the artist to turn away from outer things, away from phenomena 'in order to raise himself to the level of creative energy', an energy spiritually apprehended.[20]

The Romantics' injunction that the artist must master the *natura naturans*, the formative drive within things, should not be construed as but another theory of imitation according to which art,

instead of representing nature's products would be representing nature's operations, the powers which do the forming. As Schelling's just-quoted words imply, the poet or painter penetrated into the workshop of nature with a view of releasing his own creative energy, in order, as Runge once put it, to 'unlock' his 'inner creativity' — that energy and creativity which ultimately flowed into the artist from the *Urgrund* itself.

It was towards this creative source at the heart of both art and nature that the Romantics were irresistibly drawn. To partake of its divine life, to plumb the depths of this overflowing fount of ceaseless birth and perpetual becoming was their greatest aspiration.

In the wake of this vision the Romantics urged that the *Urgrund* or as some following in the footsteps of Jacob Boehme called it, 'the procreative chaos', should shine forth from every poem and painting. 'The chaos', maintained Novalis, 'must radiate from every poem', the chaos moved by love and eros.[21] 'Chaos and eros', according to Friedrich Schlegel, best explain what is Romantic.[22]

His brother August Wilhelm gave a critical edge to this conception when he compared Romantic art with that of the Ancients. The latter, he averred, arose out of and conveyed a world of harmony and order, in stark contrast to the former which expressed man's 'secret attraction to a chaos which lies concealed in the very bosom of the ordered universe, and is perpetually striving after new and marvellous birth. The life-giving spirit of primal love broods here anew on the face of the waters'.[23]

Despite its rhetorical ring and evocation of *Genesis*, this high-minded conception followed implicitly from the metaphysical foundations of the Romantics' organic aesthetic. For once art and nature were seen to emanate from a common source, the veneration of this source was as inevitable as it was revolutionary in its repercussions — revolutionary since it encouraged and canonized an art dedicated, indeed consecrated to the recovery of the Origin. This art achieved its greatest triumphs and its most awesome manifestations in modern poetry and painting.

* * *

The Romantics' organic aesthetic proved one of the most decisive contributions to the modern theory of art. It became one of the main supports of modernism itself, notably where the poet and painter insisted upon the absolute autonomy of art. This autonomy was sealed the very moment the Romantics hailed art and nature as parallel phenomena, each one, in Kant's short-hand formulation, exhibiting 'a purposiveness without a purpose', each one, that is, growing out of itself and into self-supporting living forms the sole end of which was to be, to exist!

This conclusion, as we have seen, was implicit in the Romantics' demand that art must not imitate nature but create in her spirit. The imperative freed the artist not merely from every mimetic obligation, but, in the last analysis, from any allegiance he may have felt towards the external world. Working wholly from within through his chosen medium the artist henceforth obeyed but the promptings of organic forms and their evolution. Such forms no longer took their cue from anything outside their particular being. Possessing a logic all their own, they carried their reason for being strictly within themselves. Hence to enter fully into the life of these organically developed forms demanded unconditional submission to their peculiar laws which more often than not precluded the laws governing the world outside the 'heterocosmic' poem and painting.

In its concentration upon the innateness of form the organic theory evidently reinforced the expressive theory of art which stressed the inwardness and primacy of feeling. Indeed the organic theory corroborated and confirmed the Romantics' expressive aesthetic for the unfolding of organic form from within the artist's being was, in the final reckoning, nothing else than the progressive realization, the eminently lawful incarnation of man's innermost feelings.

Retrospect and Re-examination of Romantic Premises

On the surface, the various notions of poetry and art promoted by the Romantics present a wide spectrum of seemingly disconnected speculations. Yet as we had more than one occasion to observe, nothing in Romanticism was treated in isolation, nothing ever stood entirely by itself. While the theories discussed do not and were never meant to form a complete and unified system of aesthetics, each was the result of certain basic attitudes towards art and the world. Among these attitudes the quest for wholeness was supreme. It was the abiding Romantic passion. The tension arose — a creative tension — of how to approach the longed-for wholeness: through the 'subject', or through the 'object'; through an intense concentration on the inner reality of man, or through an equally intense contemplation of the realities external to man. As it turned out, the Romantics did both.

In general terms, what characterized Romanticism was precisely this now self-centred, now world-centred outlook. A heightened inner sense co-existed with a heightened outer sense. Each served as a point of departure. Each made for a more of less recognizable mode of reflection. Evidently, the expressive and the hierophantic theory of art proceeded from the Romantics' more self-centred preoccupations, whereas the holistic and the organic theory set out from his world-centred, or nature-oriented, outlook. Of course, and as we have clearly seen, each theory pressed towards including the point of view characteristic of the other. Each strove to achieve a synthesis which included the self, the world and its ultimate ground.

However this attempt at reconciliation presupposed a mobility of

mind of which we must grasp its most fundamental operation: the ready switch from the inner to the outer, the transition, that is, from an Idealism of the self to an Idealism of nature. It is this passage that requires a more systematic presentation.

In the Romantic's eye, what justified the movement from one to the other? According to most, it was an eminently legitimate procedure. If the inner, as they believed, mirrored the outer, the outer, conversely, mirrored the inner. Both therefore were interchangeable. This was clearly implied in Wordsworth's premises from which he compounded one of his best-known poetic arguments:

> . . . my voice proclaims
> How exquisitely the individual Mind
> . . . to the external World
> Is fitted: and how exquisitely, too —
> Theme this but little heard of among men —
> The external world is fitted to the Mind.[1]

Since mind and matter, man and nature, are strictly continuous phenomena each obviously can serve as the mirror image of the other. Novalis put it pointedly with reference to particular schools of thought: '*It is one and the same* whether I posit the universe in myself or myself in the universe. Spinoza posits everything without. Fichte everything within.'[2] Both approaches, one locating the world in the self, the other the self in the world, were leading to a comprehension of the Whole. Both in fact corresponded to the Romantic's monistic state of mind which readily identified the All as One and the One as the All, an equation which enabled him to move with seeming effortless ease from the individual soul to the world-soul and back, from a metaphysically conceived transcendental ego to an act of 'egocide',, or self-obliteration, in which the 'I', streaming forth into its opposite, nature, merged and fused with all that lived.

In other words, this monistic state of mind encouraged the conversion of the 'objective' into the 'subjective' and *vice versa*. The first procedure dissolved all things into the being of the ego. It tended to support — though not wholly explain — Novalis's motto: 'Within leads the mysterious way'; Coleridge's contention: 'substance is and must be in ourselves'; Shelley's notion of the

soul as 'the centre and circumference' of all existence.

The second procedure "submerged" the being of the ego in the reality of the non-ego, in a universal oneness of which the self was a subservient element or part. As we have repeatedly seen, this conception of a self-absorbing universe made its appearance time and again in Romantic poetry and art. We meet it in Keats's couplet: 'Melting into radiance, we blend, / Mingle, and so become part of it', in Byron's line 'I live not in myself, but become / Portion of that around me', in Coleridge's idea of man as 'part and proportion of one wondrous whole.' The same thought was fundamental to Wordsworth's vision of the One Life pervading all. 'We are like workings of one mind, the features / Of the same face, blossoms upon one tree.'[3]

The two modes of apprehension are perhaps best exemplified by citing apparent and ostensibly irreconcilable extremes. On the one hand, there is Friedrich Schlegel's notorious and as a rule completely misunderstood glorification of Man's irreplaceable uniqueness: 'It is precisely his individuality that is the primary and eternal element in man. To develop this individuality as the highest vocation would be a divine egotism.'[4] If nothing else, the reference to the 'divine' should prevent anyone from drawing the facile conclusion that Schlegel is preaching here no more than a form of Germanic self-aggrandisement.

On the other hand, and providing a sharp contrast, there is the lesser-known though equally important maxim by Novalis: 'The genuine philosophical deed is self-obliteration. This is the beginning of all true philosophy ... Only this kind of deed provides the condition (for all philosophizing) and exhibits the mark of a transcendental action.'.[5] For the *Frühromantiker* no real opposition obtained between these two positions for, ontologically considered, both represented but different and equally valid points of departure towards apprehending the Infinite or Whole. One approached it through the subject, the other through something above and beyond the subject.

Of course the Romantics could merrily play both tunes at once. Frequently they refused to acknowledge any difference between them whatsoever which usually came about in the wake of mystic raptures. Thus Shelley's famous celebration of 'reverie' made light of any epistemological distinctions. 'Those who are subject to the

state called reverie feel as if their nature were dissolved into the surrounding universe, or as if the surrounding universe were absorbed into their being. They are conscious of no distinction.'⁶ During his pantheistic period up to 1804, Wordsworth similarly dismissed any boundaries dividing the inner from the outer. 'All things shall live in us and we shall live / In all things that surround us.' Novalis again confounded his critics by passing from one position to another in quick succession. While urging man to commit 'egocide' he could also, and far more frequently, look to inwardness as the gospel of salvation. And this gospel decreed that man's greatest task was to take 'possession of one's transcendental ego, to be, as it were, the quintessential ego of one's ego.'⁷ It could be argued that both demands do not exclude each other: indeed they may well represent a metaphysical version of the familiar Biblical injunction according to which man must first lose his self in order to gain it. Nonetheless, the emphasis on the transcendental ego in Novalis's last example clearly points to a 'subjective' appropriation of the Whole.

The Romantics' procedure as pointed out in Chapter IV was partly inspired by the *modus operandi* characteristic of Fichte's and Schelling's metaphysical Idealism. Presupposing an Absolute in whom all contradictions disappeared, Fichte defined it as a primordial transpersonal Ego which was to be discovered only in and through the reflections of the personal ego. Hence Fichte's famous exhortation:

> Attend to thyself: turn thy glance away from all that surrounds thee and upon thine own innermost self. Such is the first demand which philosophy makes of its disciples. We speak of nothing that is without thee, but wholly of thyself.⁸

Schelling in turn approached the Absolute by way of both the ego and the non-ego. Unlike Fichte who firmly believed that this twin procedure was destined to fail — one proceeded either 'subjectively', or 'objectively', but never both — Schelling just as firmly insisted that these two modes of reflection were not only possible but vitally necessary in order to grasp the 'identity' of the subject and object which was implicit in knowledge and in the Absolute itself.

Thus, and similar to Fichte, we see Schelling extolling the all-

explanatory function of the ego: 'Everything is only in and for the Ego. In the Ego philosophy has found its "*Ευ και παϖ*", that is, the immanent union of all realities whose totality was synonymous with God.[9] Yet this 'speculative Egotism', as Jacobi called it, was preceded by a speculative physics, a philosophy of nature which looked to the object, to the universe as the key to the Whole. For Schelling both approaches were and had to be strictly complementary. The one revealed the Absolute as 'subjectivity', as spirit or intelligence and its conformity with the 'objective'; the other disclosed the Absolute as 'objectivity', as nature and its pre-ordained harmony with the 'subjective'. The philosopher's final task was to show their mutual inclusion in a higher unity, in a supreme 'absoluteness' which reconciled both.

While the *Frühromantiker* drew on Schelling for reasoned support of their convictions, their contemporaries in England could always turn to Neoplatonism, to Berkeley and Spinoza — to any monistic philosophy in fact which affirmed the identity of the One and the Many. And this included the thoughts of Erasmus Darwin, of Joseph Priestley and even the otherwise despised systems of the French materialists whose Monism influenced the younger Shelley. It also included the far more ancient notion of the human microcosm being a faithful mirror of the macrocosmic whole.

Yet in the last analysis no metaphysical deduction, nor any intuitively acquired certainty could ever wholly conceal, let alone erase, the basic disparity between a 'subjective' and an 'objective' mode of apprehension. Nor again did any reason offered account for the feeling of emotional and logical rightness that the individual Romantic professed for one or the other mode of reflection. While in their poetry and painting they could indeed move with no sense of contradiction from the self to things and from things to the self — when, like Byron, each could confidently claim that mountains, waves and skies were part of him as he of them — the dialectic mediating between the subject and the object was by no means smooth and certain of its reconciling end. It could just as often grind to a sudden, sometimes tragic, halt with the self confronting the strange otherness of things whose incomprehensible multiplicity frustrated any attempt at unity. 'I would make a pilgrimage to the Deserts of Arabia,' Coleridge sighed more than once 'to find the man who could make understand how the *one can*

be many', how the many can be one, how the self explained the universe and the universe the self.[10]

Hence the Romantic's unease which no visionary fervour could conceal. Hence also his being torn between an 'all-consuming' egotism and a self-less cosmism wholly satisfied with neither. Thus from the chill solitude of the transcendental ego he could escape into the warm immediacy of an oceanic oneness. From the horror of total absorption threatened by the latter he might again take refuge in a sovereign consciousness of self. And if neither escape offered any lasting solace there was always the 'Trinitarian resolution' which, known only to God, resolved all disparities and contradictions. Yet even then the question still arose which was the cross to be endured. Was it the world or the self, or did both require crucifixion for salvation?

Schleiermacher psychologized the Romantic's existential dilemma as he strove to comprehend the Whole both through the 'subject' and the 'object':

> Each human soul ... has its existence chiefly in two opposing drives. Following the one it strives to establish itself as an individual. For increase, no less than sustenance, it draws everything around it into itself, weaving it into its own life and absorbing it into its innermost being. The other drive is the dread fear to stand alone over and against the Whole, the yearning to surrender oneself and be absorbed in the greater, to be taken hold of and contained.[11]

Admittedly, Schleiermacher gives us a crudely simplified psychology, one moreover based on the typically Romantic infatuation with polarities which was especially marked among the philosophers of nature. Nonetheless, the fact remains that during the Romantic age egotism and cosmism, a hugely developed sense for the self and a hugely developed sense for the non-self met only in brief moments of vision and then entered into a relationship of conflict or indifference. Alternatively, the expansion of one sense could bring about the contraction of the other, or — an ever present possibility — cause their mutual inflation to a point when both senses began to float unattached to any earthly and spiritual object. Friedrich Schlegel's *freischwebender Geist* — an unfettered free-ranging spirit — was a typical example of the latter. Within this

broad spectrum of possibilities, there were probably as many personal variations in the give-and-take between the inner and the outer sense as there were individual Romantics. Just how each oscillated between them or opted in favour of one or the other, would require an immensely detailed study, one not unlike Professor McFarland's impressive *Coleridge And The Pantheist Tradition.*

However and arguing in terms of 'epochal' shifts or tendencies, it is not difficult to discern which of these two senses proved the more enduring. Thus when all qualifications have been duly weighed and measured, when possible exceptions such as Keats's concern for the concrete are readily conceded, when comparatively balanced attitudes like those of Wordsworth are freely acknowledged, who can deny that *collectively* the Romantic spirit was, by and large, a centripetal or self-related spirit. Sadly, we lack a term more descriptive of this spirit, for while being self-related it was therefore not self-obsessed and if it did 'egotize' the universe it also 'universalized' the ego. To label it 'subjectivist' — the usual predication — is probably more confusing than revealing for the Romantics always recognized something transcending the finite self. Their so-called subjectivism invariably strove for union and fusion with the One and All. It was precisely this monistic inclination which rescued the Romantics from the snares of solipsism.

At the same time their Monism was quite unlike any other monistic philosophy known then to the history of thought. It never lost sight of the self even where it taught its surrender to an 'absolute object'. The latter, in any case, not merely depended for its recognition on a contemplating subject, but being something *ideal* or spiritual throughout, it coalesced with the spirit of man. Put in a somewhat simplified way, if the Romantic's Monism surged from the inside outward to the circumference of all things, to the outermost limit of Creation and beyond, his Idealism returned the encompassed to the centre of the spiritual self in whose 'world-weaving' depths was to be found what is ultimately most real and true. Hegel's Delphic saying that the Absolute must be considered not simply as substance but as subject as well is appropriate in this context. It is even more appropriate in the case of the Germans for whom the 'subject' not only denoted the mind and soul of man, but

the mind and soul of the world, an evolving, dynamic spirit which advanced in and through the human spirit.

Of course this Idealist Monism was anything but consistent. It could and did create an unbearable tension between the subject and the object, the ideal and the real, the immanent and the transcendent. Nor was it successful in resolving the dread dilemma of human freedom in a universe subject to necessity and law. On all these issues the Romantics' commitment varied widely to the extent of frequently entertaining incompatible positions. Indeed we marvel at their ability to be so many different things at once. Thus next to being Monists and Idealists, they embraced a form of transcendental Theism, a religious creed which their avowed *poetic* Pantheism explicitly denied. And what the latter rhapsodically affirmed, namely the immanence and interdependence of all things was put in question again by their fierce insistence on the autonomy of the creative self. The same autonomy, in turn, was both affirmed and denied in the moral sphere where one was either a defiant Dualist defending man's freedom against the blind necessity moving matter, or, like Wordsworth, a Stoic moralist who urged man to submit quietly to nature's norms and teaching. In addition, the Romantics could be the staunchest Realists if the occasion so required. They could even, and rather refreshingly, poke fun at their holiest convictions as Schlegel's fragment with its biting wit reveals: 'There are writers in Germany who drink the Absolute like water; and books in which the very dogs are in tune with the Infinite.'[12]

The Romantics were by no means unaware of their ambiguous position. Yet unlike most of us they were prepared to endure the cross of contradictions. Some even thrived on it if only to mock the hollow claims of man's rational pretensions. Hence Keats's sagacious quip: 'What shocks the virtuous philosopher, delights the cameleon poet.' More important, the Romantics realized that seeming contraries may represent but varying aspects of a far wider and more inclusive truth. Their famous recourse to 'irony' was not least the obstinate refusal to be tied to any one particular truth however demonstratively valid and certain. All such acquired truth was hopelessly one-sided. Worse, it nearly always suffered from an exaggerated sense of its importance mistaking the partial for the complete. The truth of the Whole defied man's barren

understanding whose calculations Blake dismissed as the serpent of the finite. The Infinite called for a different mode of comprehension, one soaring beyond the paralytic Either / Or of logic towards a Both-And affirming spirit, a spirit which fired by premonitions of oneness, progressed by contraries, by the active interplay of oppositions. If that spirit offended the laws of thought so much the worse for reason. No reason could ever be admitted unless it aided intuition in perceiving that 'dark / Inscrutable workmanship' which throughout Creation 'reconciles / Discordant elements, and makes them cling together / In one society.'[13]

Admittedly, Man was but given a fleeting glimpse of this 'inscrutable workmanship' and then only by an act of Grace, but any lesser vision spelled inexorable estrangement and despair, a life-unto-death as preached by those who insisted on the discontinuity of man and his world, on the divorce of mind from matter, of the soul from things.

> Eternal universal mystery! It seems as if it were impossible; yet it *is* — and it is everywhere! — It is indeed a contradiction *in Terms* : and only in terms.[14]

If only in terms, then the abiding mystery of oneness was best proclaimed by poetry and art whose non-discursive language transcended all rational restrictions and in transcending revealed the unity of all.

Thus everything in Romanticism was destined to deify the aesthetic realm for it alone seemed capable of healing the rift between the subjective and the objective, the real and the ideal. It alone promised 'to end this eternal conflict between ourselves and the world' which Hoelderlin saw as the greatest task of his generation.

The Plates

*All measurements are in
centimetres; heights first.*

PLATE 1. C.D. Friedrich: *The Monk by the Sea* (1809–10)

> Oil on Canvas, 110 x 171.5
> Staatliche Museen Preussischer Kulturbesitz,
> Nationalgalerie, Berlin

While there is 'no great paradigmatic Romantic masterpiece' as Hugh Honour rightly points out,[1] Friedrich's *The Monk by the Sea* nonetheless occupies an indisputed place of eminence. Few paintings of this period have received as much attention and critical acclaim than this famous composition. A major work of Friedrich's early period, the painting is distinguished by its unprecedented boldness and uncompromising rigour of conception. Reality has been reduced to the original elements of *earth* — an arid stretch of sandy beach — *water* — a dark expanse of troubled sea — and *air* — a cloudy overpowering sky which virtually occupies four-fifths of the total picture space. It is nature 'dematerialized', purged of all particulars to permit unimpeded contemplation of the magnitude and mystery of Creation. The tiny forlorn figure in the foreground — probably a self-portrait — is clad in the robes of a monk to symbolize man's religious feeling for the vastness of the All.

The 'dehumanization' of Western art which we wrongly attribute to the Moderns begins with the Romantic's contemplation of nature, his longing to fuse with the Whole. The image of Man retreats as the artist advances to a vision of the universe and its pro-creative forces. Friedrich expresses it not only by dramatically reducing the size and significance of human figures, but also by divesting them of any individual identity. Turned either sideways or with their backs to the beholder, their desire is to become one with the source whence they come. In Friedrich's words: 'Man is not the unconditioned measure of himself. The Infinite, the Divine is his aim.'[2]

Predictably, the painting provoked controversy, for never before was the notion of an over-arching Allness presented in the form of a pregnant emptiness. Von Kleist's much-quoted remarks express something of the horror and the fascination Friedrich's painting evoked at the time. 'Nothing could be more mournful and fraught with unease than this position in the world, the only spark of life in

the wide realm of death, a lonely centre in a lonely circle. With its
two or three mysterious objects the painting appears like the
apocalypse . . . and since in its uniformity and boundlessness it
has no other foreground than the frame, when one looks at it, it
feels as if one's eyelids had been cut away' — as if, paraphrasing
Blake, the doors of perception had suddenly become unhinged to
let in the awesome spaces of Infinitude.[3]

Whatever Friedrich's intentions, a haunting ambiguity pervades
the painting. Its moody majesty at once attracts and repells. While
on one plane it signifies Man's pious dependence on the Infinite,
its frightful magnitude seems to mock and silence all human
aspirations. The projected vastness at the same time communicates
a feeling of dreadfulness, a form of metaphysical disquiet which
man experiences confronting the overpowering oppressiveness of
an unilluminated inexplicable universe. Like Wordsworth's
solitaries, Friedrich's figure is pushed to the 'very edge of
vacancy', to the 'brink of the abyss' in the words of Robert
Rosenblum who looks to *The Monk by the Sea* as the prototype of
a Northern Romanticism which finds its fulfilment in the luminous
voids of Mark Rothko.[4]

PLATE 2. C.D. Friedrich: *The Large Enclosure near Dresden*
(c. 1832)

Oil on Canvas, 73.5 x 102.5
Gemäldegalerie Neue Meister Staatliche
Kunstsammlungen, Dresden.

Painted during the last creative period of his life — three years
before a crippling stroke — Friedrich's art of 'infinitizing'
landscape reaches its peak in this superb composition. Although
more elaborate in structure than many of his preceding paintings,
the overwhelming effect is of a monumental simplicity based on
sweeping horizontals and complementing diagonals and parabolic

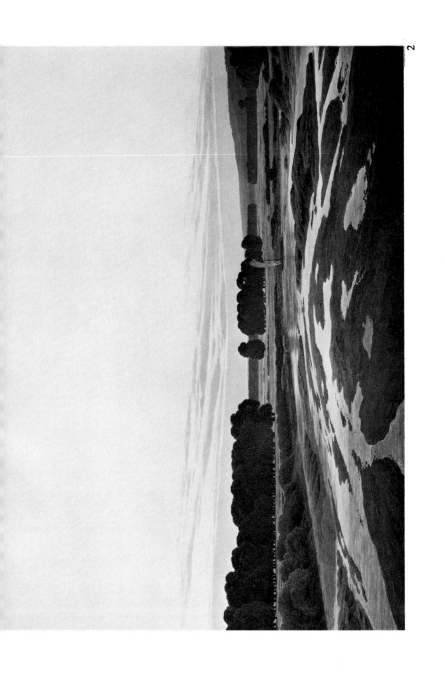

curves. The sky looms large, ascending from a pale purple to a golden sunset yellow which shades off into a pearly grey. As a colourist Friedrich rarely achieved anything more subtle and accomplished. He catches that most precious sight when nature at dusk seems to hold her breath before the shadows of night creep in upon the dimming lights. 'Never before', writes William Vaughan, did Friedrich capture 'a moment so precise — that instant when the sun has sunk and yet the earth is still half lit by the diffused illumination of the sky.'[5]

In the painting, the calm and lightness of this sky stands in striking contrast with the darkness of the trees and the perforated surface of the flooded meadows in the foreground. Yet there is no jarring note, for the conflict is resolved by the translucent quality of light which is reflected in the pools of stagnant water — Friedrich's way of saying that the infinite is mirrored in the finite, that eternity is present in the meanest object, even in so humble and transient a thing as a puddle.

The seeming naturalism of the painting is misleading. While it depicts a familiar locality — the Large Ostra-Enclosure to the north-west of Dresden — the mood evoked is the result of the painter's solitary communion with nature, one which made for the fusion of the felt and the seen. The communion was solitary indeed! As Friedrich once told his Russian patron and admirer Vasili Andreyevich Zhukovsky: 'I must be entirely by myself, and know that I am alone, in order to see and perceive nature completely. Nothing should stand between her and myself. I must give myself to my surroundings, must merge with my clouds and cliffs, in order to become what I am.'[6]

For Friedrich's visionary awareness, the inner and the outer, appearance and reality, invariably met in the notion of a transcendental unity, a divine presence which, glowing in and through the visible, drew the soul to the Beyond. In the present composition the eye, led by the gentle curves of earth and sky, finally alights on the sailing barge quietly floating towards an unseen destination.

PLATE 3. J.M.W. Turner: *Sun Setting over Lake* (1840–45)

Oil on Canvas, 91 x 122.5
Tate Gallery, London.

PLATE 4. J.M.W. Turner: *Waves Breaking on a Lee Shore*
(c.1835)

Oil on Canvas, 60 x 95
Tate Gallery, London.

Turner's burning sunset and unbounded sea are typical of his later paintings. All stand under the sign of fusion. While the range of his subjects continuously expands in the 1830s and 1840s, Turner's work then frequently oscillates between images celebrating elemental violence and paintings of profound lyrical repose with often paradisiac connotations. A warm enveloping luminosity characterises the latter compositions. What they

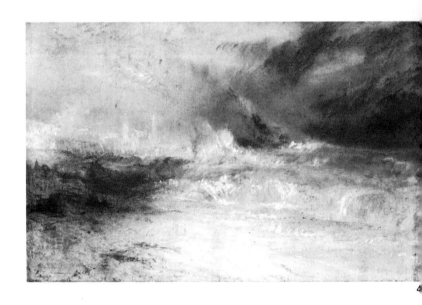

4

demonstrate in the words of Turner's favoured poet Thomson is 'the magic art of colours melting into colours' which creates 'one embracing mass of light and shade, that settles round the whole' — a whole enfolding sea and sky, earth and heaven locked in perpetual cohabitation.

This 'world-marriage' of the elements is clearly shown in the present two examples. In the more monochromatic ocean picture, immense wastes of water are washed upon a featureless shore. Winds and waves, spray and sky, are drawn with barely any lines of demarcation. The same is true of Turner's sunset painting in which a deeply glowing dusk dissolves all boundaries into a luminous whole.

It was Turner's two Italian visits (1819–20 and 1828–9) that acted as a catalyst for his Northern pantheistic visions. The lasting memory of the dazzling Southern light at once freed his imagination and released him from any neo-classic inhibitions. While the effect of the first visit was immediately visible in the

spontaneity and freshness of Turner's numerous watercolours, notably the Venetian series, the experience of the second visit nearly ten years later translates itself into richly glowing oils. Their tonality subsequently drives to ever greater heights of lightness. Colours become bolder, freer, brighter. Nature and art — the former never forgotten but assiduously studied — join in an unprecedented harmony which transfigures both.

PLATE 5. J. Constable: *The Coast at Brighton, Stormy Evening* (c. 1828)

Oil on Paper laid on Canvas, 16.6 x 26.7
Yale Center for British Art,
Paul Mellon Collection, New Haven.

While Constable has become justly famous for his fond picturing of rural England, he could range at times beyond such rustic scenes to truly magnificent visions of vastness. He clearly does so in the Brighton seascape. Its low horizon is overpowered by a huge sky whose heavy, shadowy clouds merge almost imperceptibly with the restless movement of the sea.

Here as elsewhere in his art Constable paints as much to the imagination as to the eye. While the eye faithfully records the time, place and circumstances of the composition — the painting is inscribed on the back of the paper: 'Brighton, Sunday Evening, July 20, 1828' — the mind moulds the scene into an imposing image of grandeur. As Constable wrote in *English Landscape Scenery*, he intended to give the fleeting moment snatched from time 'a lasting and sober existence, and to render permanent many of those splendid and evanescent Exhibitions, which are ever occurring in the changes of external Nature'.[7]

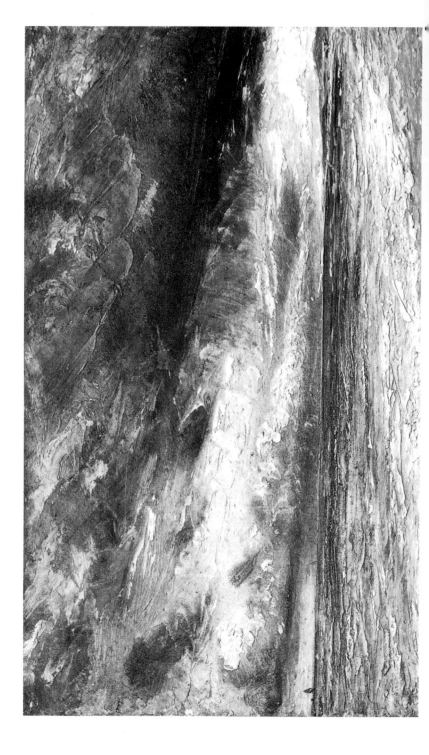

According to Constable no landscape could create a lasting impression without a large and dominating sky. The sky should be '*the keynote*, the *standard of Scale*, and the chief *Organ of sentiment*'. The landscapist 'who does not make his skies a very material part of his composition, neglects to avail himself of one of his greatest aids'.[8]

Although a painter of plains, dales, millstreams and meadows — especially those he associated with his beloved native Suffolk — Constable was deeply touched by the mystery and magnitude of the sea. 'Of all the works of the Creation none is so imposing as the Ocean; nor does Nature anywhere present a scene that is more exhilarating . . .'.[9]

PLATE 6. J. Constable: *Weymouth Bay* (c. 1817)

Oil on Canvas, 53 x 75
National Gallery, London.

Weymouth Bay at the National Gallery reveals Constable's way of blending closely observed particulars into a vast imposing generalization. He proceeds similarly to Wordsworth, with whom he is frequently compared, by rendering parts 'As parts but with a feeling for the whole'. Although Constable had good cause to remember this particular place — he honeymooned near Weymouth Bay, the same bay in which his cousin and Wordsworth's brother perished with their respective ships — the work itself transcends the biographical and local. It soars beyond its specific English setting towards something far more universal. As Carlos Peacock rightly observes in his monograph on Constable: 'the very Englishness of his art has tended to blind us to its element of universality'[10] — to the common theme underlying Romantic art: its feeling for the immanent unity of all things.

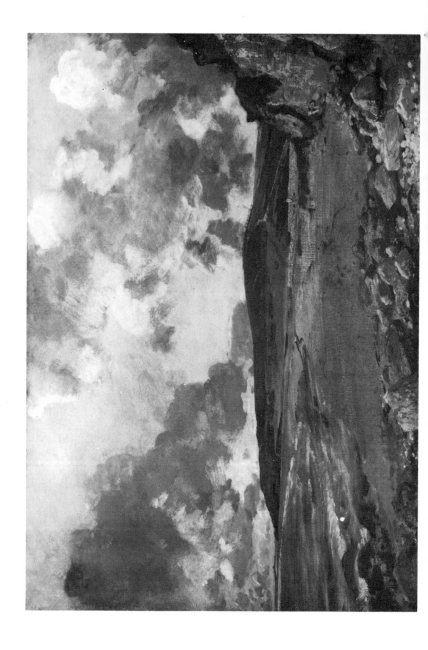

As Basil Taylor has cogently argued, too much is made of Constable the naturalist, the cool and studious observer of nature who looked upon his paintings as explorations into the realms of physics. He is not altogether blameless for fostering this image. Thus in 1802 he wrote 'there is room enough for a natural painture' (*sic*) and more than three decades later Constable told his audience at the Royal Institution that the art of landscape should be considered 'a branch of natural philosophy, of which pictures are but the experiments'.[11] These much quoted statements are not only highly ambiguous but outright misleading for Constable had no intention to excel in naturalism *per se*. He understood very early that a direct 'scientific' approach to nature aiming at visual accuracy was quite meaningless without imaginative generalizations. Hence his far less quoted remark: 'It is the business of a painter not to contend with nature and put this scene (a valley filled with imagery fifty miles long) on a canvas of a few inches, but to make something out of nothing, in attempting which he must almost of necessity become poetical.'[12] This plea for poetry or 'sentiment' in art explains Constable's terse phrase: 'Painting is but another word for feeling.'

Constable's feeling about nature was predominantly religious which gained in strength the deeper he looked into phenomena. With other Romantics, he believed in the revelatory significance of nature which was disclosed to him possessing an intimate knowledge of her inner workings. Such knowledge enabled the painter not to compete with nature but to create something as lawful, as autonomous and existing in its own right as anything found in the Creation.

PLATE 7. J.M.W. Turner: *Snowstorm: Steamboat off a Harbour's Mouth* (1842)

Oil on Canvas, 91.5 x 122
Tate Gallery, London.

The closest kinship between dynamics and Romanticism comes to the fore in Turner. Of all Romantic painters he succeeded most in embodying the dynamically Sublime. Unlike Friedrich who merely implies movement through stable forms and figures, Turner renders the essence of motion itself which he compresses into networks of tensions, trajectories of force, whirlpools of circling and contending energies.

The *Snowstorm* is a supreme example of Turner's energizing of the elements. The rolling, heavy sea, the cascading streams of steam, smoke and vapours, create a vortex of destructive fury which tosses the helpless vessel to and fro. No stabilizing verticals and horizontals arrest the gyrating movement. Even the horizon pitches forward to emphasize the surge and suction of a ferocious sea. Turner possessed the keenest eye for nature as a process of perpetual change and flux. Eternal transformation was for him the law of all Creation.

The painting appears to be based on Turner's personal recollection of a savage wintry sea which he endured on a steamer out of Harwich. He reacted fiercely when someone claimed they understood the picture: 'I did not paint it to be understood, but I wished to show what such a scene was like; I got the sailors to lash me to the mast to observe it; I was lashed for four hours and I did not expect to escape, but I felt bound to record it if I did. But no one had any business to like the picture.'[13] In other words, before the stupendous grandeur of the dynamically Sublime, the torrents of a raging storm, our feelings ought to be of awe and terror, of the puniness of man.

Turner's fierce reaction was born of his 'primordial' relationship to the sea. All-embracing, all-destructive, forever changing and forever the same, at once demonic and divine, the sea was for him a mysterious *magna mater*.

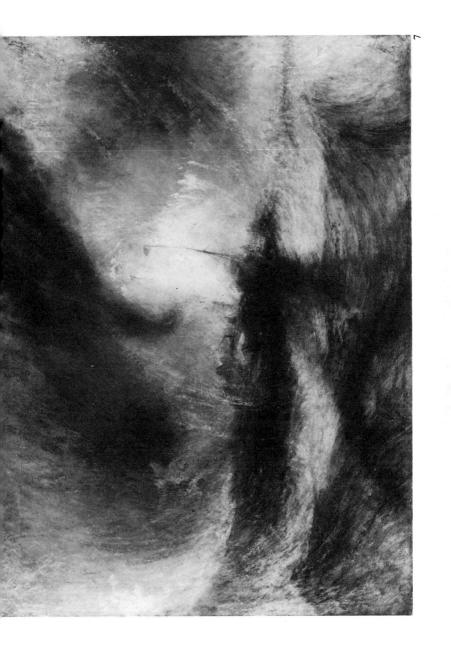

PLATE 8. C.D. Friedrich: *Arctic Sea* (1823–24)

Oil on Canvas, 96.7 x 126.9
Hamburg, Kunsthalle.

The painting reveals Friedrich's fascination with the forbidding forces of nature. Interpreted at times as a confession of personal despair but far more often as a political allegory, portraying his countrymen's growing sense of resignation after the Wars of Liberation, the painting in the end transcends any one of these specific meanings. As other pictures and studies show, Friedrich then was much preoccupied with catching the austere grandeur of ice, rocks, cliffs, sea and sky. His preoccupation with these elements was most likely influenced at first by Kosegarten's Ossianic celebrations of Nordic nature and Teutonic myths and heroes, whose alleged burial places known as Giant-graves (Hünengräber) Friedrich repeatedly painted. It was just this love of things Nordic, native and primeval of which Friedrich's patriotism was but its political expression, that prevented him from planning a trip to Rome which was the customary destination of every aspiring German painter. The stark and sombre landscapes of the North, Friedrich more than once implied, were far better suited to express profound religious feelings than the sensuous beauty of the South. As to Friedrich's intended journey to Iceland, this much-repeated story cannot be corroborated.[14]

Friedrich was that rarest of phenomenon: a stern-minded Romantic in whom the pantheistic revelry of his fellow Germans was tempered by a strict self-discipline which reflected his steadfast Lutheran faith. Something of Friedrich's character and the Spartan spirit of his art can be glimpsed from the reply he gave to his brother musing over the artist's handwriting: 'You call my script angular and you are right! Yet know this: he who wants to carve in stone must use hardened steel'.[15] The present composition looks as though it had indeed been quarried of some ancient ice and stone in a land that time forgot. Its immediate inspiration may well have been the catastrophic shipwreck of a polar expedition which occupied public imagination some years previously.

In its formal organisation, the painting is a masterful construction. Powerful diagonals, abruptly changing dynamic

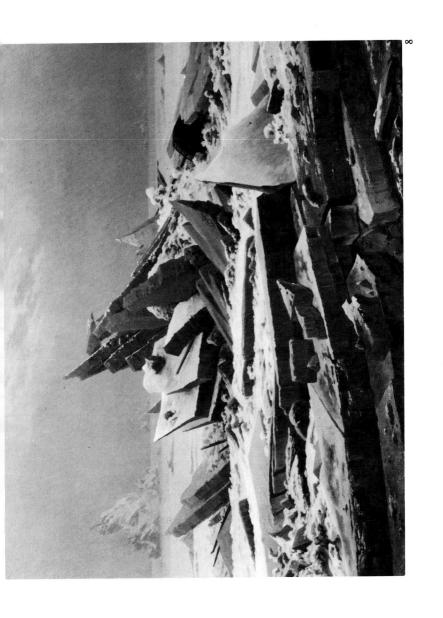

planes of force mount to a rough-hewn grisly pyramid of death which dominates the painting. The nearly upright triangular plate on the right forms a grim memorial for the crushed hull of the ship almost wholly buried under heavy sheets of ice.

This carefully constructed composition seems to confirm what one critic calls the 'frequent paradox of German Romantic art': its almost classical sense of organising forms symmetrically.[16] Yet Friedrich was no slave to it as the unresolved spatial tensions in the painting clearly show. By employing dramatically shifting viewpoints — the foreground is seen partly from below and sideways; the pyramidal centre slightly from above — Friedrich pulls the viewer in different directions at once, thereby 'internalizing' the dynamically Sublime. The frozen immobility of the image on canvas gives rise to a tense perceptual activity that looks in vain for any place of rest or resolution.

In its focus on the hostile elements of nature which defeat and mock man's aspirations, Friedrich's painting was of course defiantly anti-classical and in outright competition with the idyllic or idealized 'heroic' landscapes fashionable at the time among German–Roman painters.

Although the emphasis in Friedrich's composition is on death and dissolution, on the transience of all things human, there is an intimation of transcendence. Thus the horizontal floes of ice in the foreground form enormous steps leading to nature's pyramidal 'temple' which proclaims the awesome majesty and mystery of God. 'Foundering' man ascends on the calamities of earthly life towards the clear blue light of eternity to which the pyramid's apex points.

PLATE 9. S. Palmer: *Early Morning* (1825)

Sepia mixed with Gum, 18.8 x 23.2
Ashmolean Museum, Oxford.

PLATE 10. S. Palmer: *A Rustic Scene* (1825)

Sepia mixed with Gum, 17.9 x 23.5
Ashmolean Museum, Oxford.

Palmer's Shoreham pictures are arguably some of the greatest
visionary landscapes painted by an English artist during the
Romantic age. Unlike Constable's poetic naturalism, Palmer,
following his master Blake, imposes his own heavenly vision upon
the world of things. It is a Biblical vision which transplants the
fertile pastures of Sharon and Gilead to a rural corner in Kent. To
Palmer's ecstatic sense, nature at Shoreham appeared 'sprinkled
and showered with a thousand pretty eyes, and buds, and spires
and blossoms gemm'd with dew, and . . . clad in living green'.[17]

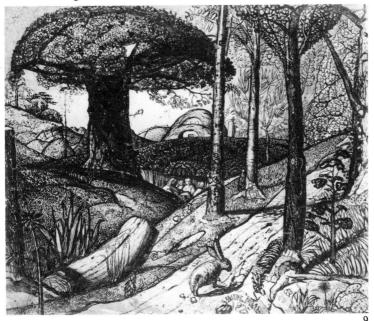

9

The soft pastoral ring of these words belies the sheer virility of his compositions, especially the series of six highly accomplished sepias, two of which are represented here. In each, a spiritualised pan-vitalism meditates upon the providential plenitude of God which is present in the humblest blade of grass. The driving forces of the earth push everything upward and outward in mutual embrace.

In *Early Morning* a maternal tree arches over rolling hills, fields and meadows crowned by the curved roofs of thatched country cottages. Near its massive trunk a group of silent peasants appear to pay homage to the rich bounty of the earth. Even the seemingly lifeless log in the foreground participates in nature's wedding feast of which the rabbit on the right is but an ancient symbol.

The *Rustic Scene* reveals the same intoxication with a blessed land glowing under a mystic sun, the bearer of a magic fullness. More dynamically arranged in composition, its swelling, breast-like hills and interlocking planes and curves enclose a half-reaped field of corn whose bushy heads stretch into a veritable forest. Although the rustic and his docile beast owe much to Blake, all is

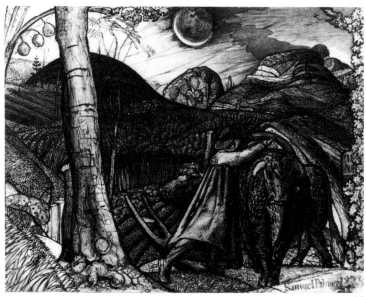

10

blended into a touchingly convincing image of benevolent abundance.

Palmer seems to confirm A.W. Schlegel's belief that the deeper the artist penetrates to an awareness of nature's 'fullness and totality' the greater will be his artistic genius to 'form a world within the world'. His Biblical pastorals come close to what he hoped to achieve: 'hymns sung among the hills of Paradise at eventide'.

PLATE 11. C.D. Friedrich: *Moonrise over the Sea* (1822)

> Oil on Canvas, 55 x 71
> Staatliche Museen Preussischer
> Kulturbesitz,
> Nationalgalerie, Berlin.

Ships figure prominently in Friedrich's art. Floating on the high sea, anchored in port, or moored along deserted riverbanks and beaches, they become 'soul-enchanted boats' — symbols of Man's deepest urges.

The painting shows Friedrich's subtle sense for interlocking forms which blend near and far, light and dark in a manner characteristic of this painter. Stones, rocks, sails, sea and sky melt into a 'boundless Whole' illuminated by a rising moon whose light turns into a silvery streak on the silent sea. The radiance of the cloud-framed sky boldly silhouettes the figures seated on a giant boulder. Their attention is turned towards the arriving ships and the nocturnal scene of sea and sky. The contemplative repose of these figures recalls F. Schlegel's notion that only in longing does man find stability and peace.

Not much is gained by viewing this painting and, beyond that, Friedrich's art generally, in terms of a highly codified set of

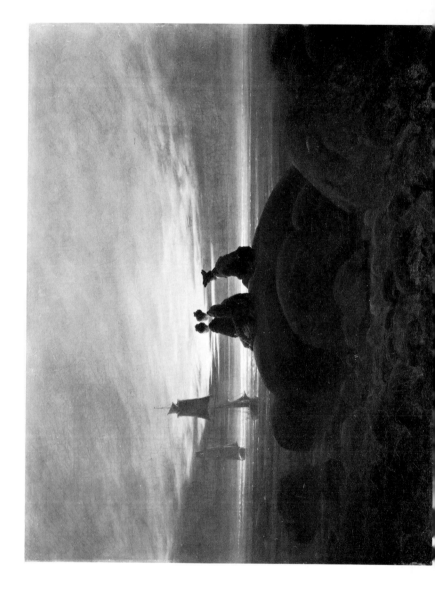

symbols which is the procedure of Börsch-Supan for whom the rising moon stands for Christ and the foreground rocks for the steadfastness of faith. Such single-minded interpretations not only diminish the multiple meanings of Friedrich's symbols, they also tend to impoverish the expressiveness of the painting as a whole. While Friedrich's art is indeed 'a symbolic representation of the Infinite' in A.W. Schlegel's well-known definition, it requires the latter's additional reflection concerning the nature and function of symbols: 'To begin with, each thing represents itself ... its essence being revealed in its appearance. (Hence it is a symbol of itself). Subsequently, it represents that to which it is related and by which it is affected. Lastly, it is a mirror of the universe'.[18] This comes far closer to Friedrich's actual practice with the proviso that his use of symbols serves first and foremost to establish a dominant, all-pervasive mood — in this case the mood of quiet yearning, what Jens Christian Jensen in a related context calls 'the longing for infinity, for coming home to God's eternal Kingdom'.[19]

PLATE 12. C.D. Friedrich: *Drifting Clouds* (1821)

Oil on Canvas, 18.3 x 24.5
Hamburg, Kunsthalle.

'Nature at its flattest and most monotonous is the best teacher of a landscape painter', A.W. Schlegel noted in one of his fragments. This monotonous impoverished nature, according to Schlegel, makes for 'a sense of frugality' in the artist which knows how to please the mind with but 'the slightest hint of higher life' in the landscape.[20] While Schlegel's observations touch on the heart of Friedrich's art, there is no hint of higher life at all in the present painting. No vivacious succession of images, no startling variety of contrasts meets the eye in this vacant landscape, one of the smallest Friedrich ever painted. Unencroached, the view glides

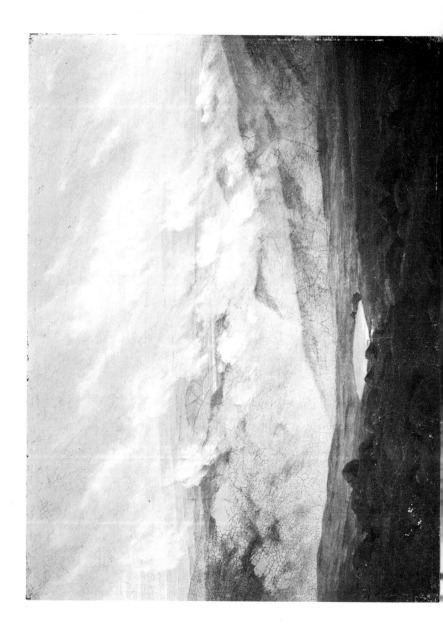

from a bleak boulder-strewn hill into the distant reaches of drifting mists and cloud-enveloped mountains. It is a Wordsworthian vision of nature. Friedrich shared a deep religious feeling for the austerity and frequently oppressive grandeur of landscape with the poet of the Lake District. Like the latter, he communicates the power of inward-looking solitude which holds unremitting intercourse with the primary forms of nature, a solitude which evokes 'Ye Presences . . . in the sky / And on the earth! Ye Visions of the hills! And Souls of lonely places'.[21]

The mood manifest in the painting is indeed of melancholic places which in turn hint at the loneliness of the human spirit, a spirit not quite at home in this world. It is not least this premonition of man's homelessness that gives to such paintings their enduring tension. The silence that broods over this almost unfeatured land conveys a vision not only of infinitude but also of man's "otherness" and isolation. Tieck, describing Friedrich's art, referred to its 'solemn sadness'.[22] It is the sadness of unconsumated yearnings. While being confronted with an image of the infinite, we are never made to feel part of it. Alternatively, our awareness of boundlessness dissolves into drifting, meandering moods which defy concretion and containment. As Hazlitt once observed of Wordsworth, the image becomes 'lost in the sentiment . . . in an endless continuity of feeling'.[23] What remains is a 'floating' subjectivity unattached to any object.

PLATE 13. C.D. Friedrich: *The Evening Star (View of Dresden)*
(1830–35)

Oil on Canvas, 32.2 x 45
Frankfurt, Freies Deutsches Hochstift
Frankfurter Goethemuseum

A strangely haunting quality pervades this composition in which a
deeply glowing evening sky plunges the earth into dark-green and
purple shadows. As in so many of his paintings, Friedrich leaves
the foreground unadorned. No introductory motifs lead into the
barren gently rising hill on which a group of three figures ascend
towards the summit. The figures, it has been suggested, represent
Friedrich's wife, Caroline, one of his two daughters and the
painter's only son Gustav Adolf (b. 1824). They are returning
from an evening stroll to their home town Dresden which lies
behind and below the hill. The boy, eager to catch the last sight of
a disappearing view, has run impatiently ahead. With arms
outstretched, holding a cap in his right hand, he greets the evening
star beckoning brightly in a cloud-ridden sky. His exuberance and
joy contrasts sharply with the dignified withdrawn attitude of his
companions. Deep in their own thoughts, mother and daughter are
oblivious of the sublime spectacle around them.

A row of mournful poplar trees on either side gives an
impression that these figures were taking part in a solemn
procession. The trees on the left appear to move with the ascending
figures, while those on the right seem to advance towards them.
The skeletal spires of churches thrusting towards the pale gold of
the sky form the connecting link between the trees and central
group of figures.

If the row of poplars introduce a sombre note — their ghostly
shapes suggest the presence of departed souls — the conspicuous
stretch of darkened sky lies oppressively upon the earth. This
oppressiveness is heightened by the even darker clefts cutting
diagonally across the barren hill.

The painting combines a host of moods: joy and acquiescence,
piety and resignation, faith conscious of dread and fate yet tinged
with premonitions of transcendence. All this may well be implied
already in the title of the painting: *The Evening Star*. The latter
(Venus) is, of course, the star as well of the morning thus
combining the dying away of light with its rebirth — death and
Resurrection!

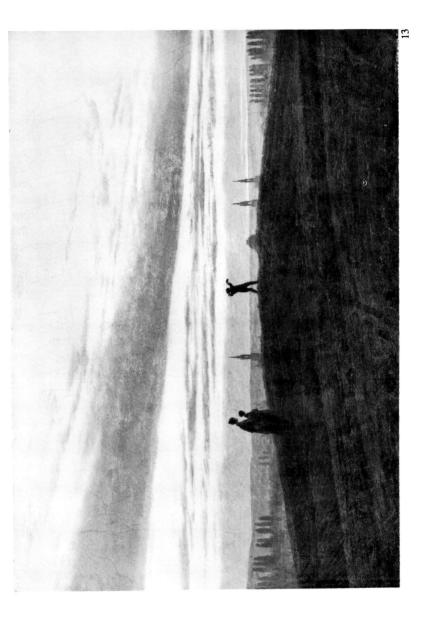

PLATE 14. J.M.W. Turner: *Snow Storm: Hannibal and his Army Crossing the Alps* (1812)

Oil on Canvas, 145 x 236.5
Tate Gallery, London.

Turner's pessimism found dramatic voice in numerous paintings of cataclysms, of elemental upheavals that overpower man. *Hannibal* — his first fully developed whirlpool composition and a milestone in the development of his art — depicts the dreadful power of an Alpine storm engulfing the Carthaginian army. Looting and marauding it is pictured as another blind potency of destruction, calling forth the inevitable counterforce of hostile native mountaineers. In the painting Man's savagery provides the grim foil to nature's elemental violence which sweeps all things before it, material and moral.

Hannibal is also the first picture accompanied by a verse tag from Turner's 'Fallacies of Hope', his projected, though never completed, epic poem which was meant to 'correct' the unreasonable optimism of the age as expressed in Campbell's well-intentioned but one-sided 'The Pleasures of Hope'.

The verse line attached to the painting yield some vital clues about its allegorical meaning. They preach a bleak historical pessimism — the ultimate defeat of Man's greatest deeds. Hannibal, the hero of the mountain heights, will come to grief on 'Campagnia's fertile plains', his victorious army corrupted by 'Capua's joys', that is, by the enervating luxury of the vanquished Romans. The painting clearly marks the beginning of Turner's life-long 'obsession' as Leslie Parris called it with the Carthaginian empire, the fate of which to Turner's dark forebodings pointed to 'the possible fate of Britain'.

As John Gage and Graham Reynolds have remarked, Turner is using ancient history to pass implicit judgement on the self-destructive rivalry between Napoleonic France and imperial Britain. Influenced by his close friend Fawkes, who at the time was fighting for the restoration of the Constitution, touched by Thomson's *Liberty* and more immediately by Byron's *Childe Harold*, the first two cantos of which appeared in March 1812, Turner became deeply pessimistic about the state and future of his

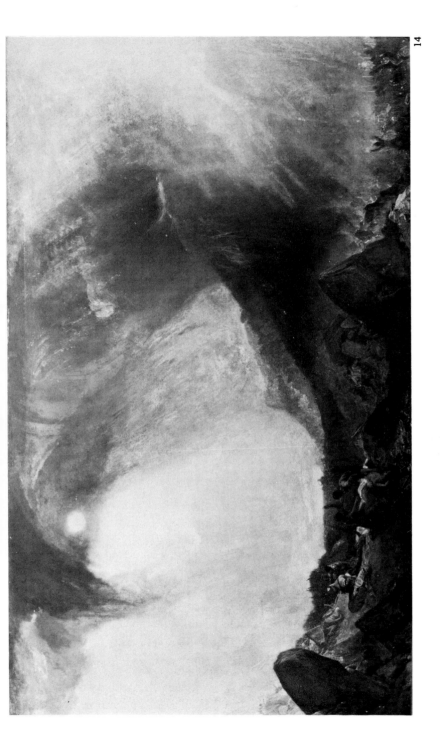

native country threatened, he believed, by corruption from within, its strength as a mercantile nation being eroded through the amassing of prodigious wealth. As he was to show with devastating effects much later in the horrendous 'Slavetrader', England's virtue was sold on the market-place for inhuman commercial gains.

Yet Turner's pessimism cut far deeper, to an almost atavistic sense of fate which everywhere perceived the vanity of human labour: for in a universe ruled by perpetual change and transformation all things decay, nothing endures. Ruskin writes of Turner's persistent 'sadness' which came to conquer him: 'He was without hope' and wherever he looked 'he saw ruin and twilight', the 'Faint breathing of the sorrow of night'. Other painters drew decay and ruin, but none so consistently and persuasively as Turner who in 'the midst of all the power and beauty of nature still saw this death-worm writhing among the weeds'. He, and he alone, painted the 'loveliness of nature with the worm at its root: Rose and cankerworm ... the one *never* separate from the other'.[24] Ruskin's rhetoric rings utterly convincingly despite, or rather because of, his own inveterate pessimism which, as Andrew Wilton claims, greatly coloured his view of Turner's work.[25] In this case, it took one perceptive pessimist to recognize its subtle and often concealed manifestations in another.

PLATE 15. J. Constable: *Hadleigh Castle (full-scale sketch)*
(1828–9)

Oil on Canvas, 122.5 x 167
Tate Gallery, London.

The popular view of Constable as the keen and confident observer of England's green and pleasant fields whose bloom and freshness he happily held fast on canvas is somewhat misleading to say the least. It ignores the darker, sombre aspect of his art which was clearly recognized by those around him. Thus his maternal uncle

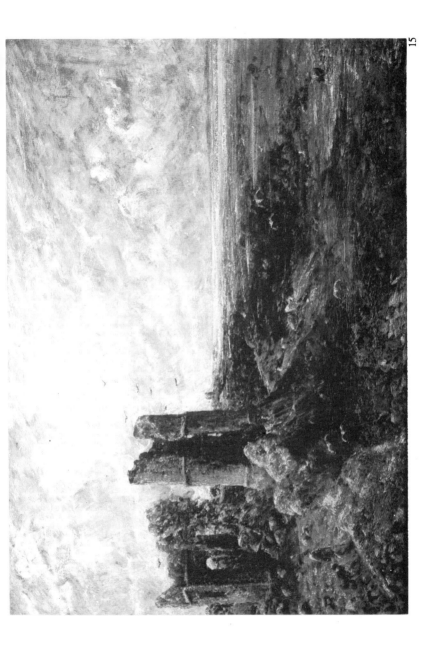

reproached him for lacking 'cheerfulness' in his landscapes. 'They are tinctured with a sombre darkness.'[26] Constable himself was well aware of a melancholic trait in his nature. There is a 'great anxiety that ought not to be with me' he wrote more than once. This note of inner torment runs repeatedly through his voluminous correspondence. As he told his friend the Archdeacon Fisher who implored him to cast off his crippling anxious disposition: 'I live by shadows, to me shadows are a reality.'[27]

Constable's anxiety intensified with the illness and premature death of his wife in 1828 when, full of despair, he turned to nature for refuge, investing her with a sense of desolation he so deeply felt in himself. While the 'darker side' of landscape, as Leslie Parris points out, attracted Constable some years before Maria died, after her death images of ruins and sadness, of melancholy and desolation appeared far more frequently in his art.[28]

The sketch of Hadleigh Castle, one of Constable's greatest and most expressive pictures, reveals this sense of desolation and despair. It is painted in sombre shades of blue, grey and darkish green which together produce a near monochromatic tonality. The turbulent oppressive sky, the bleak sea and gloomy shore, the derelict castle around which hover birds in black, express at once the artist's torment, loneliness and isolation. What Graham Reynolds writes of the finished version of *Hadleigh Castle*, now in the Paul Mellon Collection at the Yale Center for British Art, applies still more to the present full-scale sketch at the Tate: 'Constable has extracted the last vestige of expression by the stormy sky and the cold sinister light'. By focusing on a ruined castle we get the impression the painter was indeed portraying his 'own ruin'.[29]

It is not difficult to detect this 'lowering mood of pessimism' in Constable's later compositions of clouds, storms, skies, seas and rainbows.[30] Even in his more guarded public remarks on *Old Sarum* in *English Landscape Scenery* Constable cannot entirely suppress a melancholic note. He refers to the barren and deserted air of the place which recalled to him the poet's words: 'Paint me a desolation'.[31] David Lucas' mezzotint with its pronounced black shadows conveys Constable's melancholic mood of *Old Sarum* particularly well.

PLATE 16. C.D. Friedrich: *Sea Piece by Moonlight* (1830–35)

Oil on Canvas, 25 x 31
Leipzig, Museum für bildende Künste.

Although Friedrich painted a number of impressive funeral scenes, (see *Plate* 21) his notion of life as an unquenchable longing for death and salvation does find more compelling expression in his various paintings of ships. Some of them display a prominently placed anchor in the foreground which in other pictures is paired with an even more commanding cross. All such paintings express Friedrich's deep awareness of human infirmity which craves for anchorage in God, his profound conviction that man's highest yearning cannot and must not be met while still being yoked to a mortal frame.

The scene in nearly all these paintings is either nocturnal or shrouded in the deep shadows of dusk. Both night and dusk are associated with man's troubled existence reaching its final destination, the harbour where his frail boat finds its last rest.

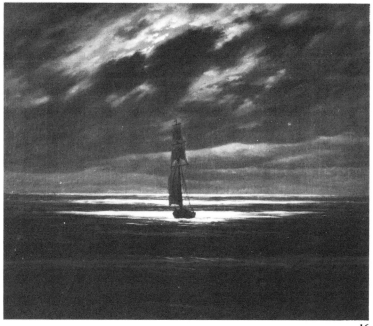

16

In the present composition, a nocturnal moon-illuminated sea and sky conveys a mood of utter stillness. The moon, though concealed behind clouds, casts brilliant beams of light around the solitary vessel. The light may well be that of reassuring faith which guides the lonely traveller through the adversities of life symbolized in this view by the windswept gathering clouds. The boat seems to be approaching that final darkness through which man must pass to a diviner light which redeems the grief and gloom that mars terrestrial existence.

PLATE 17. J.M.W. Turner: *Yacht approaching Coast*
(c.1835–40)

Oil on Canvas, 102 x 142
Tate Gallery, London.

Not unlike Friedrich's solitary vessel, Turner's *Yacht* weaves its own enchanting measure. Reminiscent of Shelley, it sails that 'sea profound of ever-spreading sound' towards a radiating fount of light, an over-arching, all-dissolving luminous round. It is Turner's most glowing and colourful sea picture which makes use of daring reds. Although Turner wisely refrained from subscribing to any specific colour symbolism, he associated yellow and grey with morning and red with matter, darkness and 'departing rays'. Red also had a more ominous significance for Turner. It conjured up 'fire and blood' and a 'sea of blood'. Thus the painting strangely unites sunset and sunrise, dusk and dawn — dissolution and transfiguration. The cycloid of radiating light becomes the beckoning sheltering womb of peace towards which the red-tinged sailor floats to meet his own transcendence.

Ruskin has pointed to Turner's obsessesive preoccupation with death and dissolution, his continuous involvement with *Atropos* which he painted as 'under some strange fascination or captivity'.[32] Yet nowhere does Ruskin explicitly link death with Turner's

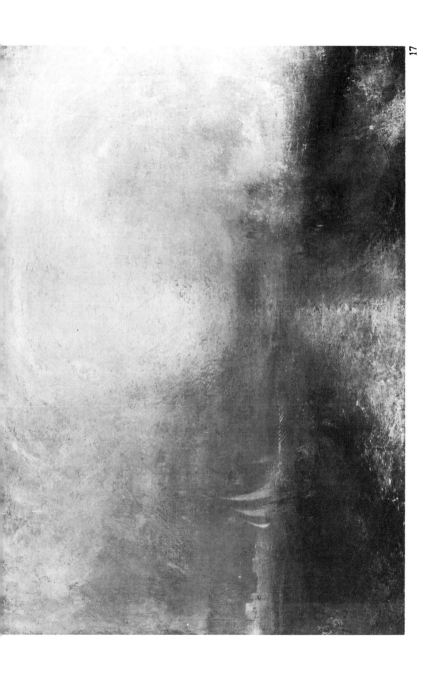

persistent use of vortex and gyre which are simply seen as the artist's particular truth to nature's force and energy. While the vortex serves indeed that purpose in Turner's painting, his creative compulsion to depict gyrating shapes over and over again even in his calmest pictures points to a more fundamental and largely unconscious emotional need.

From mythology we know that spiralling, vortexing configurations possess a cosmic meaning symbolizing 'the wheel of life', the rotating sphere of space and time, or the 'great maternal round'. Alternatively, and this is especially true of older cosmological theories, the vortex signifies the dawn state of the beginning when chaos, redeemed by light, becomes transformed into a cosmos. Psychologically, it evokes that blessed still *undifferentiated* oneness out of which all things emerge and into which all things crave to return.

Whatever else Turner's art may signify, it certainly reveals a marked tendency towards 'blissful' dissolution, towards a pleromatic unity experienced as all-embracing — a state of utter containment and contentment. Turner is indeed the painter of the 'void' which yet contains all things in their original purity and freshness. His luminous dusks and dawns are more than just dramatically distilled impressions from nature. In a deeper sense they are symbols of cosmic return and transformation.

PLATE 18. J.M.W. Turner: *Interior at Petworth* (c. 1837)

Oil on Canvas, 91 x 122
Tate Gallery, London.

The unity of light and colour ranks as Turner's greatest art–historical achievement. This unity, having gradually ripened, bursts into sudden prominence and brilliance with the series of Petworth pictures and Venetian oils. Subsequent compositions exhibit at times an even greater brilliance and brightness. It is the

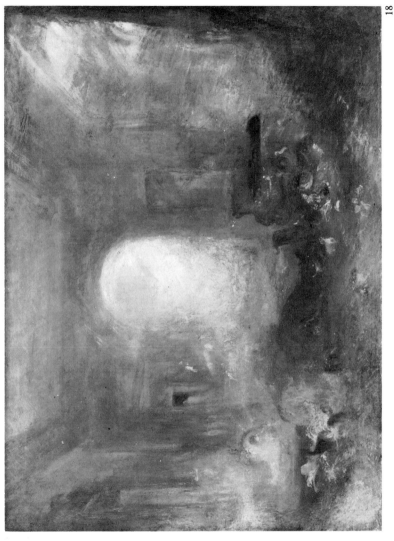

poetry of light and colour, intensely lyrical or dramatically expressive that emanates from all these paintings, the appeal of which is intimately linked to the affective values of liberated colours.

While the present composition still depicts some recognizable scene, the pictorial means employed serve expressive rather than descriptive ends, ends which may well have included Turner's reaction to the death of Lord Egremont, his friend and patron. As in other pictures associated with Petworth, colour, in Martin Butlin's words 'is used emotively and even sometimes in an almost abstract way'.[33] The luminous reds, greens and yellows breathe a life independent of the painting's subject.

Turner's relationship to modern painting has become the subject of heated controversial speculations. Thus he has been hailed as the precursor — indeed the father — of both Impressionism and Abstract Expressionism, while to others he is firmly tied to and conditioned by then prevailing art–historical traditions.

On first sight, Turner's alleged proto-Impressionism seems particularly striking in view of his atmospheric gradations broken down into combinations of coloured specks and patches. In an observation which was to touch on the very core of Impressionist art, Turner himself appealed to 'the ruling principles of diurnal variations', the 'pure combinations of Aerial colours' as manifest in 'the grey dawn, the yellow morning, and red departing ray, in ever changing combination ...' More than three-quarters of a century later Monet was to embody just such aerial colours in his series of 'Haystacks' which in turn shocked Kandinsky into the realization that painting need not represent objects to achieve an emotional effect.

Yet Turner was not a *plein-air* painter intent to record the ever changing effect of light upon objects. While passionately committed to nature's truth as thousands of commemorative studies show, the truth he sought surged beyond mere appearances. Nor does Turner systematically employ the Impressionist technique of juxtaposing coloured dots in order to create a purely 'retinal art'. His own painting serves different ends. It celebrates 'the vast, the stable, the sublime' in the words of his beloved Akenside, the poet Turner fondly quotes in his lecture on light and colour. Turner is essentially a visionary painter who breathed into his atmospheric

hues a glow and fire uniquely Romantic. This visionary conception of light and colour points forward to the exploding suns of van Gogh as well as to the brilliant seascapes of Nolde's so-called 'unfinished pictures'.

While extremely sensitive to colour as an embodiment of light, Turner at the same time proved unusually perceptive of the inherent expressive quality of colour as paint. His numerous water colours and freely painted oils, notably those he concealed from the public, reveal a sensitivity to colour which is distinctly modern. With these pictures we reach the borderland of abstraction and representation. Is Turner then a precursor of Abstract Expressionism? He is in the restricted sense of having recognized the independent value of colour which requires no object to produce an emotional effect. However Turner never aimed at abstraction for its own sake. Even his most spontaneous studies still retain a sense of 'subject'. Where abstraction does occur in his art, it is invariably the by-product of a pantheistic vision which looked to light and colour as emanations from the deity. As Turner's pantheistic vision grew more all-embracing, his pictures gradually dissolved all separate objects into bursts and streams of light and colour. In short, the abstractness of all these paintings is not an operative principle but a consequence of Turner's synoptic and holistic vision.

PLATE 19. C.D. Friedrich: *Morning in the Riesengebirge* (1811)

Oil on Canvas, 108 x 170
Staatliche Museen Preussischer
Kulturbesitz,
Nationalgalerie, Berlin

In a deeper sense, all of Friedrich's landscapes are religious for he perceived the presence of God in everything. Yet he painted a number of pictures with the specific aim of creating a new kind of sacred art which, he hoped, would occupy its rightful place on the altars of a symbolically impoverished Protestant religion. By his

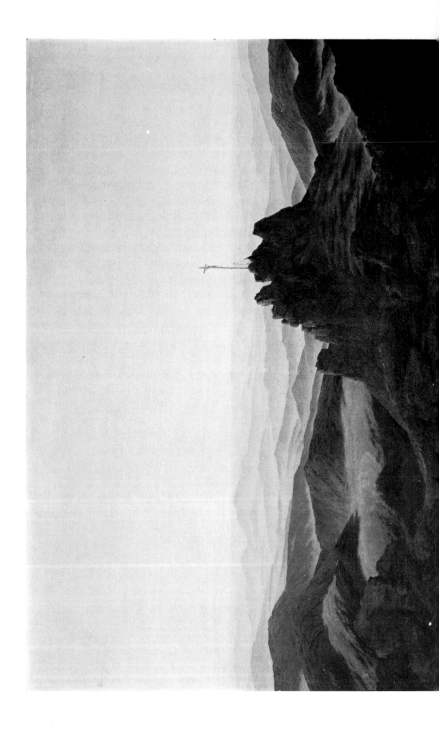

own standards, *The Morning in the Riesengebirge* should be seen as a devotional picture.

In conception, it continues the more dramatic *Cross in the Mountains* (1808), Friedrich's controversial altarpiece which marks his first major attempt to sacralize nature in the light of an increasingly inward-looking Protestant faith. This attempt met with opposition, notably that of Ramdohr, the conservative critic, who accused Friedrich of being party to a mysticism of nature which like 'narcotic vapour' crept into everything: art, science, philosophy and religion.[34] An essentially neo-classic critic, Ramdohr's sustained objections were directed against Romanticism itself which, inspired by Schleiermacher, the foremost Protestant theologian, sought indeed to 'cosmicize' a largely a-cosmic Christian creed.

Morning in the Riesengebirge presents a bi-partite composition with the sky and distant mountains hinting at heavenly existence, while the rocky foreground and the deep valley between the brown rocks — the valley of shadows? — relate to earthly life. On the far left the rays of the rising sun cast a redeeming light on the receding mountain ranges so reminiscent of Friedrich's ocean paintings. The luminous is clearly meant to indicate the numinous. The same rays fall on the prominent rock in front crowned by the Cross which intersects and simultaneously unites foreground and background. Evidently, Christ is seen as the intermediary between heaven and earth and those who follow him on the difficult path of faith, like the two miniscule figures climbing towards the Cross, will enjoy the unbroken peace of God. Friedrich may even hint at the transfiguration of nature herself with Christ redeeming not only Man but the whole of his Creation.

Deficient in drawing the human form, Friedrich had his close friend, the painter Georg Friedrich Kersting sketch in the tiny male and female figure. The latter, lightly clad, pulls the former — meant to be Friedrich himself — towards the base of the Cross. The feminine appears as the active force and mediator of Salvation.

Although an imagined landscape, its individual sections derive from diverse and detailed studies of nature. This corresponds with Friedrich's customary way of working. He builds up a compound or composite picture to suit his inner visions. His method might be called a form of visionary naturalism.

PLATE 20. J.M.W. Turner: *The Angel Standing in the Sun*

Oil on Canvas, 78.5 x 78.5
Tate Gallery, London.

Turner's *Angel* is one of three major apocalyptic compositions painted in the last decade of his life. Three years earlier he exhibited the famous pendants of deluge pictures whose chromatic values derived in part from Goethe's *Farbenlehre*. Like *The Morning after the Deluge*, the *Angel* is painted in 'plus' or warm colours — luminous shades of red and yellow. The picture was accompanied by two verse passages, the longer one being borrowed from the *Book of Revelation* (XIX, 17–18). It portrays an 'angel standing in the sun', summoning all the fowls flying in heaven to partake of God's great feast by feeding on the flesh of kings and captains, of men both free and slave. The other caption, whose meaning remains obscure, was culled by Turner from Samuel Roger's *Voyage of Columbus* which carries the sub-title 'The Flight of an Angel of Darkness':

> The morning-march that flashes to the sun;
> The feast of vultures when the day is done.

According to recent interpretations, the *Angel* is not the heavenly host announcing a new Creation but the implacable 'Cherubim with the flaming sword' barring Man's entrance into paradise. Thus John Gage has suggested that the painting — together with other compositions of the time — presents Turner's final renunciation of 'the possibility of redemption'. The *Angel* is said to embody 'a terrible and avenging God' in keeping with Turner's 'growing pessimism which expressed itself not alone in darkness but also in the more awful sublimity of light'.[35] This conclusion is difficult to sustain in view of the painting's iconography which freely interprets the relevant passages in chapters XIX and XX of *Revelation*. While Turner's pessimism was indeed profound, his longing for a better and purer world delivered from discord and division was just as pronounced. And it is just this kind of pristine world that he repeatedly evokes in airy, luminous visions, in pictures, for instance, like *Norham castle, Sunrise* (c. 1835–40) and *Sunrise, with a Boat between Headlands* (c. 1835–40).

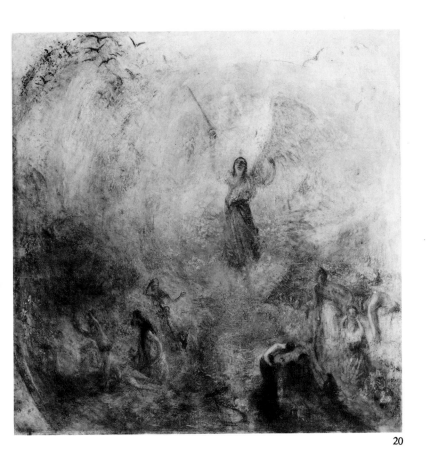

20

PLATE 21. C.D. Friedrich: *Abbey in the Oakwood* (1809-10)

Oil on Canvas, 110.4 x 171
Staatliche Museen Preussischer
Kulturbesitz, Nationalgalerie, Berlin.

Exhibited as the companion piece to *The Monk by the Sea*, Friedrich's snow-bound abbey belongs to a series of wintry landscapes which relate to death and transformation. Historically, its various motifs can be traced back to a mid-eighteenth century tradition with its fascination for graveyards and Gothic ruins. The painting's spectral appearance recalls Young's 'Night Thoughts' and Thomas Gray's 'Elegy written in a Country Churchyard'. Both pre-Romantic English poets enjoyed great popularity in Germany where they found many disciples, foremost among them G.L.T. Kosegarten, the poet, parson and Protestant theologian, who greatly influenced both Friedrich and Runge.

Although Friedrich makes use of traditional, even fashionable motifs, he blends them into something uncanny and compelling. The speckled snow and barren trees, the ghostly ruin and tilted crosses, the freshly dug grave in the foreground past which moves a procession of monks carrying a coffin — all these component elements create an awesome image of desolation, a landscape of death. Viewed next to *The Monk by the Sea* it is not difficult to imagine that the coffin contains the same monk — Friedrich himself — who has departed from this dark and troubled sphere.

The ruined abbey, writes Friedrich's recent biographer, 'is an emblem of the Church as an institution, which, like the heathen oaks, is waning before the morning of Resurrection'.[36] For all its bleakness the painting does indeed contain the promise of Salvation. The light of the Cross, clearly visible in the abbey's central doorway, assures man's untroubled life beyond the grave.

While the painting testifies to Friedrich's sometimes obsessive preoccupation with death and personal salvation, subsequent compositions are charged with more impersonal millennial meanings. Thus *Vision of the Christian Church* and, above all, *The Cathedral* (c. 1818) depict a restored, that is, a 'resurrected Church'. Such paintings at once express the longing for the rebirth of religion and for the realization of God's Kingdom on earth.

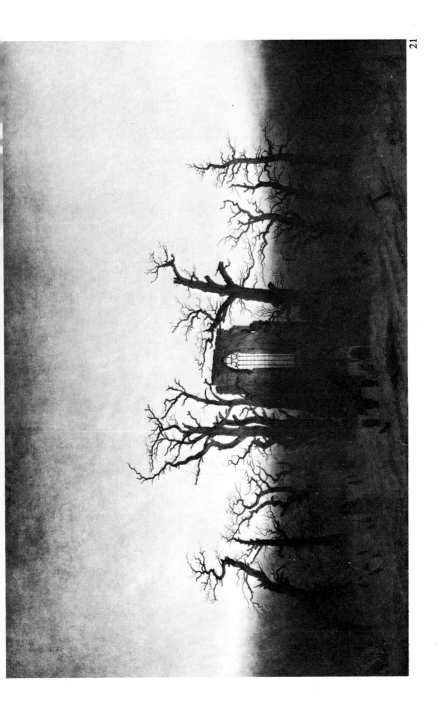

Footnotes

Chapter I

1. Michel Le Bris *Romantics and Romanticism* (Skira New York 1981) p.80
2. Hugh Honour *Romanticism* (London 1979) p.21 ff. See *'Romantic' and its Cognates: The European History of a Word* ed. Hans Eichner
3. *Childe Harold* III, LXXXIX
4. To John Thelwall, 14. Oct. 1797 *Letters* I, p.349, *Religious Musings*, 126-28
5. 'Hyperion' *Sämtliche Werke* ed. N. von Hellingrath *et. al.* II, p.91
6. *Monologen* ed. F.M. Schiele, p.73
7. Poem 'Eins and Alles'
8. *Ausgewählte Werke* ed. Wolfgang Frühwald I, 139
9. *Schriften* ed. P. Kluckhohn and R. Samuel I, p.319
10. 'Lines composed . . . above Tintern Abbey', 100-01
11. 'Queen Mab' IV, 139-45
12. 'Religious Musings', 105
13. *Schriften* II, p.650
14. *Ibid.* I, p.347
15. *Romantic Art* p.23
16. 'The Tables Turned', 27
17. To A.v. Werdeck 29. July. 1801 in *Werke und Briefe* ed. S. Streller (Berlin 1978) IV, p.251
18. Hymnen an die Nacht *Schriften* I, p.145
19. *Sämtliche Werke* XXIV, p.53-4
20. 'Conclusion' *Aids to Reflection* (London 1893) pp.268-9
21. 'Die Christenheit oder Europa' *Schriften* III, p.515
22. *Lamia* Pt II, 234-5
23. 'To the Rainbow' 13-16 in *Poetical Works* ed. W.M. Rossetti p.257

24. 'The Tables Turned', 26; *The Prelude* II, 216-18
25. *Ibid.* II, 220-21
26. To A.W. Schlegel *Werke und Briefe* ed. E. Wasmuth IV, p.229
27. *Defence of Poetry* in *Shelley's Literary and Philosophical Criticism* ed. John Shawcross, p.152
28. 'Lehrlinge zu Sais' *Schriften I*, p.96
29. To O.A.R. von Lilienstern, 31. Aug. 1806 in *Werke und Briefe* IV, p.355 V, p.328
30. Kritische Fragmente 115 in *Kritische Ausgabe* II, p.161
31. 'The Tables Turned', 21-24
32. To Benjamin Bailey 22. Nov. 1817 *The Letters of John Keats* ed. M.B. Forman p.68
33. *Biographia Literaria* II, p.19
34. 'Lebenskunst' 16 in *Gedichte der deutschen Romantik* ed. Karl Otto Conrady p.90
35. *Romantic Roots in Modern Art*, p.15
36. *Kritische Schriften und Briefe* ed. Edgar Lohner VI, p.112
37. 'Preface to Lyrical Ballads' *Poetical Works*, p.735
38. *Romantische Naturphilosophie* ed. W. Rössle p.XVI
39. Novalis *Schriften* II, p.537
40. To George and Thomas Keats, 21. Dec. 1817 *Letters* p.72
41. *Schriften* II, p.545
42. *The Discovery of the Unconscious* (New York 1970) p.205
43. *Ibid.* pp.205-08
44. *Ibid.* p.78
45. Hazlitt, 'The Plain Speaker' in *Complete Works* ed. P.P. Howe (London 1931) XII, p.118, Coleridge 'On Poesy or Art' in *Biog. Lit.* II, p.258
46. Jean Paul (Richter) *Vorschule der Ästhetik* ed. J. Müller, p.53

Chapter II

1. *Hinterlassene Schriften* ed. Daniel Runge I, p.77. See Jorg Traeger *Philipp Otto Runge und sein Werk* chapters III and VII
2. *Kritische Schriften und Briefe* II, p.92
3. *Ibid*
4. 'On Poesy or Art' in *Biogr. Lit.* II, p.262
5. Athenäum Fragmente 116 *Kritische Ausgabe* II, p.182

6. *Kritische Schriften und Briefe* VI, p.112
7. To Thomas Poole 16. Oct. 1797 *Letters* I, p.354
8. *Biogr. Lit.* II, p.12
9. *The Prelude* VII, 735-6
10. 'The Marriage of Heaven and Hell' Plate 14
11. *Childe Harold* IV, CLVII
12. *Home at Grasmere* MS.D 574-7 '*The Excursion*' I, 227-30
13. 'Essay, Supplementary to the Preface' *Poetical Works* p.748
14. *Childe Harold* III, LXXII
15. *Ibid.* IV, CLXXIX
16. *Endymion* I, 795-7
17. 'Lines composed ... above Tintern Abbey' 96-99
18. *Notebooks* I Text 132
19. *Biogr. Lit.* II, p.101
20. *The Life and Letters of Samuel Palmer* ed. A.H. Palmer, p.79
21. *Biogr. Lit.* II, p.309
22. *Critique of Judgement* transl. J.C. Meredith pp.90-115
23. Longinus *On the Sublime* transl. William Smith (London 1739) p.3
24. See Thomas Burnet *The Sacred Theory of the Earth* 1690; (rpr. London 1965); Angela Leighton *Shelley and the Sublime* (Cambridge Un. Pr. 1984) pp.1-25; Thomas Weiskel *The Romantic Sublime* ... (John Hopkins Un. Pr. 1976); Andrew Wilton *Turner and the Sublime* (British Museum London 1980)
25. On Turner's 'indistinctness' see Adele M. Holcomb 'Indistinctness is my fault': A letter about Turner from C.R. Leslie to James Lenox' *Burlington Magazine* CXIV 1972 p.555. John Gage 'The Distinctness of Turner' Journal of the R.S.A. July 1975 pp.448-57
26. See James Sellars *Samuel Palmer* pp.18-19; George Grigson *Samuel Palmer's Valley of Vision* (London 1960); Raymond Lister *Samuel Palmer and his Etchings* (London 1969)
27. 'Die Gemählde' *Athenaeum* 1798-1800 ed. A.W. Schlegel and Friedrich Schlegel II, p.50
28. *Godwi, Werke* ed. Friedhelm Kemp II, p.263
29. *Hinterlassene Schriften* II, p.202
30. *Biogr. Lit.* II, p.103
31. Athenäum Ideen *Kritische Ausgabe* II, p.262
32. 'The Destiny of Nations' 23; 'Ode on the Departing Year' 18
33. *The Prelude* XIV, 168-70
34. *Epipsychidion*, 128-9

35. Poem 'Melancholie' 21
36. *Vom Wärmestoff* p.39
37. Ricarda Huch *Blütezeit der Romantik* (Leipzig 1908) pp.248-9
38. *Hymnen an die Nacht* VI, 58-60
39. *The Prelude* I, 229; *Excursion* IX, 608
40. *Kritische Schriften und Briefe* V, p.25
41. *Lucinde* in *Kritische Ausgabe* V, p.78
42. *Ein Apokalyptisches Fragment* ed. Herbert Blank p.9
43. *Prometheus Unbound* Act II Scene V, 72-79
44. Gillian Rodger 'The Lyric' in *The Romantic Period in Germany* ed. Siegbert Prawer (London 1970) p.154
45. *The Prelude* VI, 604-5
46. *Childe Harold* III, LXX. See T. McFarland *Romanticism and the Forms of Ruin* pp.3-20
47. *Flegeljahre in Werke* ed. N. Miller II, p.858
48. Alan Menhennet *The Romantic Movement* (London 1981) p.86
49. 'Stimme des Volks' 2. Version, 17
50. 'Die Bergwerke zu Falun'
51. Goethes Gespräche ed. W.V. Biedermann III, p.8
52. Wordsworth 'Resolution and Independence' IV, 24-5
53. F. Schleiermacher *On Religion* transl. John Oman (New York 1958) p.245
54. *Constable's Correspondence* VI, p.211
55. To George Richmond 19. Aug. 1835 in *The Life and Letters of Samuel Palmer* pp.188-9
56. 'The Dilemma of a Century: The Four Stages of Romanticism' in *The Triumph of Romanticism* p.91
57. 'Blütenstaub' 1 *Schriften* II, p.413
58. 'The Zucca' III, 17-21
59. 'The World is too much with us' *Miscellaneous Sonnets* XXXIII
60. *The Borderers* III, 1543-4
61. *The Ruined Cottage* MS.D, 350-1
62. *The White Doe of Rylstone* I, 177; VII, 159
63. *The Prelude* I, 393-401
64. 'Lines written at Shurton Bars . . .' 17-18, 21
65. 'Limbo'. See also 'The Pains of Sleep'
66. *Dejection: An Ode* II, 21-2, 30
67. 'Coleridge's Anxiety' in *Coleridge's Variety* ed. J. Beer pp.134-65
68. *Hymnen an die Nacht* VI, second stanza

69. I have slightly altered Charles E. Passage's translation of *Hymns to the Night* (1960) pp.14-15
70. S.S. Prawer *German Lyric Poetry* (London 1952) p.119. For all his perceptiveness Prawer's hostile view of the 'essentially corrupt nature' of Novalis' 'love-death cult' (Ibid.) betrays a curious insensitivity towards the deeper meaning of the 6th Hymn.
71. *Hymnen an die Nacht* IV
72. *Caspar David Friedrich in Briefen und Bekenntnissen* ed. S. Hinz (Berlin 1968) p.82 subsequently cited as Hinz 1968
73. *Ansichten von der Nachtseite der Naturwissenschaft* (1808, rpr. Darmstadt 1967) pp.306-7 Engl. transl. in *Caspar David Friedrich* (exh. cat., Tate Gallery London 1972) p.106. This fine catalogue is an excellent introduction to Friedrich.
74. *Modern Painters* I, p.378
75. Hazlitt's critique appeared in the *Examiner* (1816)
76. 'Ode to a Nightingale' VI
77. Else Lasker-Schüler poem 'Weltende'
78. 'Work without Hope' (last line)
79. *The Excursion* V, 998-1001
80. 'Ode to a Nightingale' VIII, 79-80

Chapter III

1. 'Die Romantische Kunstform' *Vorlesungen über die Ästhetik* in *Sämtliche Werke* ed. H. Glockner XIII, pp.130-3
2. 'Preface to Lyrical Ballads' in *Poetical Works* p.735; *Constable's Correspondence* VI, p.78
3. *Ibid.* VI p.157
4. To Benjamin Bailey 22. Nov. 1817 in *Letters* p.67
5. To Thomas Moore 5. July. 1821 in *Works, Letters and Journals* ed. R.E. Prothero (London 1901) V, p.318; A. Rutherford *Byron A Critical Study* (1962) pp.15 ff
6. Wackenroder and Tieck *Herzensergiessungen eines Kunstliebenden Klosterbruders* and *Phantasien über die Kunst für Freunde der Kunst* ed. A. Gillies (Blackwell Oxford 1966)
7. *Schriften* III, p.650
8. *Biogr. Lit.* II, p.120
9. 'Essay, Supplementary to the Preface' in *Poetical Works* p.750

10. Athenäums-Fragmente 139, 197; Kritische Fragmente 98 in *Kritische Ausgabe* II pp.187, 196, 158 Crit. Fragm 98: 'The following are universally valid and fundamental laws of written communication: (1) one should have something to communicate; (2) one should have somebody to whom one wants to communicate it; (3) one should really be able to communicate it and share it with somebody, not simply express oneself. Otherwise it would be wiser to keep silent.' (Engl. transl. P. Firchow)
11. Hinz 1968, p.86
12. *Ibid.* p.92
13. 'A Descriptive Catalogue' in *Complete Writings* ed. G. Keynes p.576
14. *The Life and Letters of Samuel Palmer* p.16
15. *The Prelude* III, 589-90
16. 'On Poesy or Art' in *Biogr. Lit.* II, p.256
17. *Defence of Poetry* in Shawcross p.155
18. 'What is Romanticism?' in *Art in Paris 1845-1862* transl. and ed. J. Mayne, p.46
19. *Modern Painting and the Northern Romantic Tradition* (1975) A.K. Wiedmann *Romantic Roots in Modern Art* (1979)
20. *Franz Sternbalds Wanderungen* in *Werke* ed. M. Thalmann I p.894
21. *Ibid.* p.810
22. *Ibid.* p.907
23. *The Painter of Modern Life* transl. and ed. J. Mayne p.62
24. *The Green Henry* transl. A.M. Holt (London 1960) pp.498-502
25. *Gedenkausgabe* ed. E. Beutler (Zürich and Stuttgart 1950-71) XIII, p.732
26. *Franz Sternbald* in *Werke* I, p.928
27. *Ibid.* p.1008; quoted in the *Nachwort* by M. Thalmann
28. *Schriften* III, p.572
29. *Ibid.* II p.672. The same was true of pure lines, forms and colours: 'Black chalk, colours, strokes, words are *genuine* elements like mathematical lines and planes.'; *Ibid.* III p.244
30. *Schriften* ed. J. Minor III, p.176
31. *Flight out of Time* (New York 1974) p.71
32. *Sämtliche Werke* ed. E. Böcking XII, p.34
33. Quoted in John Neubauer *Novalis* (Boston 1980) p.36. Ironically Karl Jaspers was to charge Schelling with the same shortcomings. (*Schelling*, 1955, pp.247-59)

34. 'A Vision of the Last Judgment' in *Complete Writings* p.617
35. *Modern Painting and the ... Romantic Tradition* p.45
36. 'Annotations to ... Wordsworth' *op. cit.* 783
37. 'The Transformations of Ariel' *T.L.S.* 9. Aug. 1974 pp.845-7
38. *Sternbald* in *Werke* I pp.741-2 Engl. transl. M. Brown, *The Shape of German Romanticism* (1979) p.105
39. *Vorlesungen über die Ästhetik Sämtliche Werke* XIII, pp.130-33
40. See Thomas McFarland *Coleridge and the Pantheist Tradition* (1968) pp.54 ff
41. *Modern Painters* III, p.276
42. 'Über das Verhältnis der bildenden Künste zu der Natur' in *Werke, Ergänzungsband* 3, p.427
43. *Herzensergiessungen* ... (Gillies) pp.38-42
44. F. Schlegel Athenäum-Fragmente 116
45. L. Furst *Romanticism in Perspective* p.82
46. Athenäum-Fragmente 116
47. K. F. Burdach *Romantische Naturphilosophie* ed. W. Rössle p.216
48. *German Romantic Painting* p.57
49. *Literary Notebooks* 1797-1801 ed. H. Eichner No. 977 p.107. For stimulating and thoughtful discussions of the arabesque see Peter Conrad *Shandyism. The Character of Romantic Irony* (1978) ch. 5 and Marshall Brown *The Shape of German Romanticism* pp.90-104
50. Godwi in *Werke* II, p.259
51. *Kritische Schriften und Briefe* V, p.22
52. *Godwi* op. cit. p.259
53. See W.E. Suida, *Kunst und Geschichte* (Köln 1969) p.105
54. *Hinterlassene Schriften* I, p.17
55. W. Vaughan, *German Romantic Painting* p.52
56. 'Zur Begleitung der Tageszeiten' in *Hinterlassene Schriften* I pp.52-54
57. 'Alte und Neue Kirchenmusik' in *Schriften zur Musik* (Winkler Verl. München 1977) p.212. Engl. Transl. R. Taylor. See note 66.
58. 'On Poesy or Art' in *Biogr. Lit.* II, p.261
59. *Schriften* II, p.574
60. *Herzensergiessungen* ... (Gillies) p.148
61. *On the Aesthetic Education of Man* ed. and transl. E.M. Wilkinson and L.A. Willoughby (Oxford 1967) p.155
62. Über Naive und Sentimentalische Dichtung' in *Werke* ed. L. Bellermann VIII p.356

63. To Marie v. Kleist, Summer 1811 in *Werke und Briefe* IV, p.481
64. See John F. Fetzer *Romantic Orpheus* (Un. Cal. Pr. 1974) pp.179-260
65. Letter Dec. 1814 *Letters of W. and D. Wordsworth* (Selincourt) II, p.617. Allan G. Hill gives a slightly different date and wording of this letter in *Letters of William Wordsworth* (Oxford 1984) p.171
66. 'Germany and the Germans' in *Thomas Mann's Addresses* (Library of Congress, Wash. 1963) p.52; See Ronald Taylor 'Romantic Music' in *The Romantic Period in Germany* ed. S. Prawer pp.282-304
67. *Lucinde in Kritische Ausgabe* V p.46

Chapter IV

1. See M.H. Abrams, *The Mirror and the Lamp* pp.47-69
2. To Baggesen Apr. 1795 in *J.G. Fichte Briefwechsel* ed. Hans Schulz 2 Vols. (Leipzig 1925) I, p.449-50
3. *Schriften* II, p.524
4. Eichendorff, *Werke und Schriften* ed. Gerhart Baumann 4 Vols (Stuttgart 1958) IV, pp.407, 485, 397
5. *Werke* I and II. See also Alan White *Schelling: An Introduction to the System of Freedom* (New Haven 1983); Joseph L. Esposito *Schelling's Idealism and Philosophy of Nature* 1977
6. *Schriften* II, pp.417-8; p.541
7. Radical subjectivism and self-aggrandizement are the charges usually hurled against the *Frühromantiker*. Thus Lilian Furst writes of the 'arrogant, well-nigh megalomaniac self-assertiveness' which is said to characterize the individualism of the German Romantics. (*Romanticism in Perspective* p.69). This rather ungenerous view wilfully ignores the metaphysical context and complexities of the Germans' subjectivism which cannot be reduced to egotism and individualism in the narrow sense. As Novalis and Friedrich Schlegel pointed out repeatedly the innermost self, the 'transcendental ego', has nothing in common with the personal ego. (*Kritische Ausgabe* XVIII p.31). More important, charges of this kind tend to minimise the 'subjectivism' rampant in English Romanticism, the presence of the 'egotistical sublime' which Keats diagnosed in the poetry of Wordsworth. Furst's claim that this poetry produced a 'happy

realism' was not at all shared by Wordsworth's contemporaries. Similarly to Keats, Hazlitt observed in the Lake poet an 'intense intellectual egotism' which swallowed everything. 'He sees all things in himself' an observation which coincides with Wordsworth's confession to Miss Fenwick about the 'abyss of idealism' he found in himself. 'I was often unable to think of external things as having external existence, and I communed with all that I saw as something not apart from, but inherent in my own immaterial nature'. (*The Poetical Works* ed. E. de Selincourt ... 1947, IV, p.463). As Henry Crabb Robinson once remarked there was indeed a 'German bent' in Wordsworth's mind, (*diary* 9. May. 1815).

Coleridge's 'For all we see, hear, feel and touch the substance is and must be in ourselves', (*B.L.* II, p.259) was of course as much part of this epistemological and metaphysical subjectivism as was Shelley's suspension of empirical reality discussed by Pottle, Fogle, Bloom and others long ago. As to Blake's belief that everything without is to be found deep within man's imagination this, as Lilian Furst remarks, comes close — uncannily close to Novalis' formulations. Of all English Romantics only Keats succeeded in more or less safeguarding what he called the 'identity' of things.' — Miss Furst's disparaging attitude towards the German Romantics mars her otherwise admirable thesis. Chapter 9 of the present study returns to the problem of Romantic subjectivism.

8. *Poetical Works* p.738
9. *The Prelude* XIV, 192, 71-5
10. 'Vision of the Last Judgement' *Complete Writings* p.604
11. *Biogr. Lit.* I, p.202
12. To Richard Sharp 15. Jan. 1804 *Letters* II, p.1034
13. 'On Poesy or Art' *Biogr. Lit.* II, pp.257-8
14. See Norman Fruman *Coleridge The Damaged Archangel* p.168
15. *Defence of Poetry* Shawcross pp.124, 148
16. *Ibid.* p.155
17. *Endymion* II, 438
18. To Benjamin Bailey 22. Nov. 1817 *The Letters of John Keats* p.67
19. *Werke* II, pp.628-9
20. F. Schlegel *Kritische Ausgabe* VI, p.282
21. *Schriften* II, p.533; *Werke und Briefe* ed. Alfred Kelletat (Winkler Verl. München) p.423

22. *Kritische Ausgabe* II, p.266
23. Etienne Gilson *Painting and Reality* (New York 1957) p.267
24. Wackenroder and Tieck *Herzensergiessungen* ... (Gillies) p.146
25. 'Gemäldebeschreibungen ...' *Kritische Ausgabe* IV, pp.3-116
26. *Hinterlassene Schriften* I, pp.9, 15, 16, 24; II, p.257
27. A.W. Schlegel *Kritische Schriften und Briefe* VI, p.112
28. 21. Jan. 1824, *The Letters of William and Dorothy Wordsworth, The Later Years 1821-1828* Part 1 ed. Alan G. Hill (Oxford 1978)
29. *Jerusalem* Plate 5: 18-19
30. *Everlasting Gospel* d: 75-6
31. Quoted in Harold Bloom *Shelley's Mythmaking* p.67
32. *Concepts of Criticism* p.188
33. 'The Statesman's Manual' *Collected Works* VI *Lay Sermons* ed. R.J. White (Princeton 1972) p.30
34. 'Preface ... 1815' *Poetical Works* p.753. See R. Wellek *Concepts of Criticism* pp.189-98; M.H. Abrams *The Mirror and the Lamp* pp.290-97; Northrop Fry *A Study of English Romanticism* 1968; Harold Bloom *Shelley's Mythmaking*; Douglas Bush *Mythology and the Romantic Tradition* ... 1937
35. *The Excursion* I, 205; *The River Duddon* XXXIII, 13-4
36. *Colour in Turner* pp.141-45; chapters 8 and 11 contain many useful observations on Turner's use of mythology.
37. Lawrence Gowing *Turner: Imagination and Reality* p.27
38. *Songs of Experience*. Intro. 1-5
39. *Defence of Poetry* Shawcross p.159
40. *Schriften* III, p.686 *Ibid.* 'Divinity reveals itself through art'
41. *Defence of Poetry* Shawcross p.124
42. *Schriften* I, p.347
43. *Kritische Ausgabe* XVIII, p.398
44. *Schriften* II, p.426
45. Francois Hemsterhuis *Alexis ou de l'âge d'or* 1787
46. H.W. Piper *The Active Universe* pp.193, 164-5
47. 'Die Christenheit oder Europa' *Schriften* III, p.523
48. *Hinterlassene Schriften* II, p.202
49. Hinz 1968, p.103
50. *Natural Supernaturalism* pp.334, 339
51. *Fichte's Popular Works*, transl. (William Smith London 1898) I, p.442
52. Godwi *Werke* II, p.267
53. *Modern Painting and the ... Romantic Tradition* chs. 1 and 8

Chapter V

1. M.H. Abrams, *The Mirror and the Lamp* p.168
2. 'Über Naive and Sentimentalische Dichtung' in *Werke* VIII, p.310
3. *Conjectures on Original Composition* 1759 (rpr. Scholar Pr. Leeds 1966) p.12
4. *Coleridge Shakespearean Criticism* ed. T.M. Raysor I, p.198; A.W. Schlegel *Kritische Schriften und Briefe* VI, p.109
5. *Ibid.* II, p.91
6. To Zelter 29 Jan. 1830 in *Briefwechsel zwischen Goethe und Zelter* ed. M. Hecker (Leipzig 1918) III, p.249. For Kant see *Critique of Judgement* (Meredith) pp.166-70, 176, 181-3
7. *Biogr. Lit.* I, p.202, II, p.65
8. *System des Transzendentalen Idealismus in Werke* II, p.349
9. Goethe 'Über Wahrheit und Wahrscheinlichkeit der Kunstwerke' in *Sämtliche Werke* XXXIII, p.90 and 'Einleitung in die Propylaen' *Ibid.* p.108
10. *Shakespearean Criticism* I, pp.197-8. See A.W. Schlegel *Kritische Schriften und Briefe* VI pp.109-10
11. 'Italienische Reise' *Sämtliche Werke* XXVII p.108
12. Philosophie der Kunst in *Werke Ergänzungsband* 3, p.282
13. K.C.F. Krause *Das Urbild der Menschheit* eds. P. Hohlfeld and A. Wünsche p.43
14. Shaftesbury *Characteristics of Men, Manners* etc ed. John M. Robertson I, p.36
15. See M.H. Abrams *The Mirror and the Lamp* pp.272-85
16. 'Kritische Schriften' in *Nachgelassene Schriften* ed. R. Köpke IV, p.12; *Sternbald* in *Werke* I, p.889
17. Krause *op. cit.* p.44
18. *Hinterlassene Schriften* I, p.84
19. 'On Poesy or Art' in *Biogr. Lit.* II, p.257
20. 'Über das Verhältnis der bildenden Künste zu der Natur' in *Werke, Ergänzungsb.* 3, p.401. For an English translation of this essay see M. Bullock in H. Read *The True Voice of Feeling* (London 1968) pp.323-58; large sections of it appear in *German Aesthetics ... Kant, Fichte, Schelling* etc. ed. D. Simpson (1984) pp.149-58
21. 'H.v. Offerdingen' *Schriften* I, p.286
22. 'Fragmente II' *Literary Notebooks* No. 1760, p.176
23. *Kritische Schriften und Briefe* VI, p.112

Chapter VI

1. 'Preface' to the 1814 Edition of *The Excursion Poetical Works* p.590 lines 62-8
2. *Schriften* III, p.382
3. *The Prelude* VI, 636-37
4. *Kritische Ausgabe* II, p.262
5. *Werke und Briefe* p.432
6. *Shelley's Prose* ed. D.L. Clark 1966, p.197
7. 'Blütenstaub' 28 *Schriften* II, p.424
8. *Sämtliche Werke* I, p.422
9. *Werke* I, p.117
10. *Notebooks* I Text, 1561, 556
11. *On Religion* p.4
12. *Kritische Ausgabe* II, p.154
13. Wordsworth *The Prelude* I, 341-44
14. Coleridge *Notebooks* I Text, 1561

Plates

1. *Romanticism,* p.15
2. Hinz 1968, p.83
3. *Ibid.* p.222
4. *Modern Painting and the Northern Romantic Tradition* chs. 1 and 8
5. *German Romantic Painting* p.112
6. Hinz 1968, p.235. English translation in *Friedrich* (exh. cat.) 1972 p.108
7. *John Constable's Discourses* ed. R.B. Beckett, 1970 pp.9-10
8. *John Constable's Correspondence* ed. R.B. Beckett 6 Vols (Suffolk Record Society), 1962-1968 VI, p.77
9. *Constable's Discourses* p.19
10. Carlos Peacock *John Constable the Man and his Work* London, 1965 p.41
11. *Constable's Discourses* p.69
12. *Constable's Correspondence* VI, p.172
13. Martin Butlin and Evelyn Joll *The Paintings of J.M.W. Turner,* Yale Univ. Press, New Haven and London, 1977 Text, p.224

14. See Jens Christian Jensen *Caspar David Friedrich, Life and Work,* Woodbury, New York, London, 1980 pp.136-37
15. Hinz 1968, p.32
16. W. D. Robson-Scott 'German Romanticism and the Visual Arts' in *The Romantic Period in Germany* p.271
17. To John Linnel 21. Dec. 1828, A.H. Palmer *The Life and Letters of Samuel Palmer* p.173
18. *Kritische Schriften und Briefe* II, p.83
19. Jens Christian Jensen *Caspar David Friedrich* p.147
20. *Athenaeum* I, p.225
21. Wordsworth *The Prelude* I, 464-66
22. Hinz 1968, p.237
23. Hazlitt Review of *The Excursion, Examiner* 21, 28. Aug.; 2 Oct. 1814 reprinted in *William Wordsworth, A Critical Anthology,* ed. Graham McMaster, Peng. Bks 1972, pp.115-16
24. Ruskin *Modern Painters* V, p.328
25. Andrew Wilton *Turner and the Sublime* p.186
26. *Constable's Correspondence* IV, pp.28-9
27. *Ibid.* VI p.211
28. Leslie Parris *The Tate Gallery Constable Collection* Catalogue, The Tate Gallery 1981, p.132
29. Graham Reynolds *Constable The Natural Painter* London 1965, p.111
30. Andrew Wilton *Constable's 'English Landscape Scenery',* British Museum 1979 p.8
31. *Ibid.* p.44; *Constable's Discourses* p.24
32. Ruskin *Modern Painters* V, pp.340 incl. note 1, 328
33. *Turner at the Tate* The Tate Gallery 1980 p.11
34. Hinz 1968, pp.138-45
35. *Colour in Turner* pp.187, 145
36. Jens Christian Jensen *Caspar David Friedrich* p.153

Select Bibliography

The bibliography below lists sources cited in the text, together with a representative collection of studies consulted in the preparation of the present work. Elaborate titles have been shortened; subtitles for the most part omitted without loss of essential information. Any other abbreviations are readily understood in context.

I. Primary Sources

Athenaeum 1798-1800 ed. A.W. Schlegel and F. Schlegel, rpr. Stuttgart 1960

Baader, Franz von *Schriften* ... sel. and ed. M. Pulver, Leipzig 1921

Baudelaire, Charles
 Art in Paris 1845-1862 trans. and ed. Jonathan Mayne, London 1965
 The Painter of Modern Life transl. and ed. Jonathan Mayne, London 1964

Blake, William *The Complete Writings* ed. Geoffrey Keynes, London 1966

Bonaventura, *Die Nachtwachen* (1804), Stuttgart, Reclam 1964

Brentano, Clemens *Werke* ed. Friedhelm Kemp 4 vols, Munich 1966

Byron, George Gordon
 The Complete Poetical Works ed. Jerome J. McGann 4 vols, Oxford 1980-86
 The Works of Lord Byron. Letters and Journals ed. R.E. Prothero 6 vols, London 1898-1901

Campbell, Thomas *The Poetical Works* ed. W.M. Rossetti, London n.d.

Carus, Carl Gustav
 Lebenserinnerungen und Denkwürdigkeiten, Leipzig 1865-66
 Neun Briefe über Landschaftsmalerei, Leipzig 1831

Coleridge, Samuel Taylor
 Aids to Reflection, London 1893
 Biographia Literaria 2 vols ed. J. Shawcross, Oxford 1979
 The Collected Letters ed. E.L. Griggs 6 vols, Oxford 1956-71
 The Collected Works gen. ed. K. Coburn 9 vols (incompl.), Princeton and London 1971-81
 The Notebooks ed. K. Coburn 3 vols, London 1957-73
 Shakespearean Criticism ed. T.M. Raysor, 1960

Constable, John
 John Constable's Correspondence ed. R.B. Beckett 6 vols, Ipswich
 (Suffolk Records Society) 1962-70
 John Constable's Discourses ed. R.B. Beckett, Ipswich 1970
 Further Documents and Correspondence ed. L. Parris *et al*, (Suff. Rec.
 Soc.) 1975
 C.R. Leslie *Memoirs of the Life of John Constable* (1845) ed. J.
 Mayne, London 1951
Fichte, Johann Gottlieb
 Sämtliche Werke Vols I and II ed. J.H. Fichte, Leipzig 1844
 Fichte's Popular Works transl. W. Smith 2 vols, London 1889
 J. G. Fichte Briefwechsel ed. H. Schulz 2 vols, Leipzig 1925
Friedrich, Caspar David *Caspar David Friedrich in Briefen und
 Bekenntnissen* ed. S. Hinz, Berlin 1968
Görres, Joseph *Ausgewählte Werke* ed. W. Frühwald 2 vols, Freiburg
 1978
Goethe, Johann Wolfgang *Sämtliche Werke*, Jubiläumsausgabe 1902-07
Günderode, Karoline von *Ein Apokalyptisches Fragment* ed. H. Blank,
 Stuttgart 1960
Hazlitt, William *The Complete Works of William Hazlitt* ed. P.P. Howe,
 London 1930-34
Hegel, G.W.F. *Vorlesungen über die Aesthetik* 3 vols in *Sämtliche Werke*
 ed. H. Glockner, Stuttgart 1927-39
Heine, Heinrich *Werke und Briefe* ed. H. Kaufmann 10 vols, Berlin and
 Weimar 1972
Herder, J.G. von *Sämtliche Werke* ed. B. Suphan, Berlin 1877-99
Hoelderlin, Friedrich *Sämtliche Werke* ed. N. von Helllingrath, Berlin
 1923
Hoffmann, E.T.A. *(Werke)* 5 vols, Winkler Verlag, München 1969-71
Kant, Immanuel
 The Critique of Judgement transl. and ed. J.C. Meredith, Oxford 1957
 The Critique of Pure Reason trans. N. Kemp Smith, London 1933
Keats, John
 Poetical Works ed. H.W. Garrod, Oxford 1939
 The Letters of John Keats ed. M.B. Forman, London 1947
Keller, Gottfried *The Green Henry* transl. A.M. Holt, London 1960
Kerner, Justinus
 Ausgewählte Werke ed. G. Grimm, Stuttgart 1981
 Die Seherin von Prevorst ed. J. Bodamer, Stuttgart 1973
Kleist, Heinrich von *Werke und Briefe* ed. S. Streller 4 vols, Berlin 1978

Krause, K.C.S. *Das Urbild der Menschheit* ed. P. Hohlfeld, Leipzig, 1903
Novalis
 Schriften eds. P. Kluckhohn and R. Samuel 4 vols, Stuttgart 1960-1975
 Werke und Briefe ed. A. Kelletat, München 1953
Palmer, Samuel *The Life and Letters of S.P.* ed. A.H. Palmer, London 1892
Richter, Jean Paul
 Vorschule der Ästhetik ed. J. Müller, Leipzig 1923
 Werke ed. N. Miller 4 vols 3 ed., München 1971
Robinson, Henry Crabb *The Diary of H.C. Robinson* ed. D. Hudson, London 1967
Runge, Philipp Otto *Hinterlassene Schriften* ed. D. Runge 2 vols, Hamburg 1840-1
Ruskin, John
 The Art Criticism of John Ruskin ed. Robert L. Herbert, New York 1964
 Modern Painters 5 vols, London 1856-60
Schelling, F.W.J. von *Werke* ed. M. Schröter, München 1927-54
Schiller, J.C. Friedrich von
 Werke ed. L. Bellermann, Leipzig und Wien. Meyers Klassiker, n.d.
 On the Aesthetic Education of Man ed. and transl. E.M. Wilkinson and L.A. Willoughby, Oxford 1967
Schlegel, August Wilhelm
 Kritische Schriften und Briefe ed. E. Lohner 7 vols, Stuttgart 1962-74
 Sämtliche Werke ed. E. Böcking, Leipzig 1846-7
Schlegel, Friedrich
 Kritische Ausgabe gen. ed. Ernst Behler and Hans Eichner, München 1958
 Kritische Schriften ed. W. Rasch, München 1956
 Literary Notebooks 1797-1801 ed. H. Eichner, London 1957
 Lucinde and the Fragments transl. and introd. Peter Firchow, Minneap. 1971
Schleiermacher, Friedrich
 Monologen ed. F.M. Schiele, Leipzig 1902
 On Religion transl. John Oman, New York 1958
Schubert, Gotthilf, Heinrich von
 Ansichten von der Nachtseite der Naturwissenschaft (1808), Darmstadt 1967
 Die Symbolik des Traumes, Heidelberg 1968

Shaftesbury Anthony Earl of, *Characteristics of Men, Manners, Opinions, Times* etc ed. J.M. Robertson, London 1900

Shelley, Percy Bysshe
The Complete Poetical Works ed. T. Hutchinson, Oxford 1960
Shelley's Literary and Philosophical Criticism ed. J. Shawcross, London 1909

Tieck, Ludwig *Werke* ed. M. Thalmann 4 vols, München 1963-6

Turner, J.M.W. *Collected Correspondence of J.M.W. Turner* ed. J. Gage, Oxford 1980

Wackenroder, Wilhelm
Sämtliche Schriften ed. C. Grützmacher, Rowohlt 1968
Wackenroder and Tieck *Herzensergiessungen ... and Phantasien über die Kunst* etc ed. A. Gillies, Oxford 1966
Confessions and Fantasies transl. ann. and intr. M.H. Schubert, Penn. State U.P. 1971

Wordsworth, William
The Letters of William and Dorothy Wordsworth ed. E. de Selincourt 6 vols, Oxford 1967
The Letters of William and Dorothy Wordsworth ed. Alan G. Hill 3 vols, Oxford 1978-82
Letters of William Wordsworth. A New Selection ed. Alan G. Hill, Oxford 1984
The Poetical Works ed. T. Hutchinson, London 1959
Home at Grasmere ed. B. Darlington, Ithaca, N.Y. 1977
The Ruined Cottage and The Pedlar ed. J. Butler, Ithaca, N.Y. 1979

Young, Edward *Conjectures on Original Composition* (1759) Scholar Pr. Leeds, 1966

II. Documents and Anthologies

Caspar David Friedrich (exh. cat.), Tate Gallery, London 1972
A Documentary History of Art ed. E.G. Holt Vol III, New York 1966
European Romanticism comp. Lilian R. Furst, London 1980
German Aesthetic ... Kant to Hegel ed. D. Simpson, Cambr. 1984
German Aesthetic ... The Romantic Ironists and Goethe ed. K. Wheeler, Cambr. 1984
Neo-classicism and Romanticism ed. and intr. L. Eitner 2 vols, New Jersey 1970
Romantische Naturphilosophie ed. C. Bernoulli and H. Kern, Jena 1926
Romantische Naturphilosophie ed. W. Rössle, Jena 1926

III. Comparative and General

Abrams, M.H.
The Mirror and the Lamp, New York 1958
Natural Supernaturalism, New York 1971
Antal, F. *Classicism and Romanticism,* London 1966
Appleyard, J.A. *Coleridge's Philosophy of Literature,* Cambr. Mass. 1965
Arendt, D. *Der 'poetische Nihilismus' in der Romantik* 2 vols, Tübingen 1972
Babbitt,I.
The New Laokoon, London 1910
Rousseau and Romanticism, New York 1959
Barrell, J. *The Dark Side of Landscape,* Cambridge 1980
Barzun, J. *Classic, Romantic and Modern,* London 1961
Beer, J. *Coleridge's Poetic Intelligence,* London 1977
Beer, J. (ed.) *Coleridge's Variety,* London 1974
Benz, R. *Deutsche Romantik,* Reclam 1956
Benz, R. and A. von Schneider *Die Kunst der deutschen Romantik,* München 1939
Bindmann, D.
Blake as an Artist, Oxford 1977
The Complete Graphic Works of W. Blake, London 1978
Bisanz, M. *German Romanticism and Ph.O. Runge,* N. Illinois U.P. 1970
Bloom, H.
Shelley's Mythmaking, New Haven 1959
The Visionary Company, New York 1961
Blunt, A. *The Art of William Blake,* London 1959
Börsch-Supan, H. and K.W. Jähnig *Caspar David Friedrich* (Werkkatalog) München 1973
Börsch-Supan, H. *Caspar David Friedrich,* London 1974
Bowra, C.M. *The Romantic Imagination,* Oxford 1961
Bradley, A.C. *Oxford Lectures on Poetry,* London 1926
Brieger, L. *Die Romantische Malerei,* Berlin 1926
Brion, M. *Art of the Romantic Era,* London 1966
Brown, M. *The Shape of German Romanticism,* Ithaca and London 1979
Brown, R.F. *The Later Philosophy of Schelling. The Influence of Boehme . . .,* Lewisburg and London 1977
Burke, E. *A Philosophical Enquiry into ... the Sublime and the Beautiful,* London 1925

Butlin, M. and E. Joll *The Paintings of J.M.W. Turner* 2 vols, New Haven and London 1977

Butlin, M.
'Art and Content' in *Turner* (exh. cat. Royal Academy), London 1974
Turner at the Tate, London 1980
The Paintings and Drawings of W. Blake 2 vols, New Haven 1981

Cardinal, R. *German Romantics in Context*, London 1974

Caspar David Friedrich (exh. cat. Kunsthalle), Hamburg 1974

Cassirer, E. *Rousseau, Kant, Goethe*, Princeton 1945

Clark, K. *The Romantic Rebellion*, London 1973

Coburn, K. (ed.) *Coleridge A Collection of Critical Essays*, New Jersey 1967

Conrad, P.
Shandyism. *The Character of Romantic Irony*, Oxford 1978
The Victorian Treasure House, London 1973

Cooke, M.G. *Acts of Inclusion*, New Haven and London 1979

Cormack, M. *Constable*, Oxford 1986.

Dobai, J. *Die Kunstliteratur des Klassizismus und der Romantik in England*, Bern 1977

Eichner, H. ed. *'Romantic' and its Cognates: The European History of a Word*, Toronto 1972

Eichner, H.
'F. Schlegel's Theory of Romantic Poetry', *Publ. of the Mod. Lang. Ass.* LXXI, 1956, pp.1018-41
F. Schlegel, New York 1970

Ellenberger, H.F. *The Discovery of the Unconscious*, New York 1970

Emmerich, I. *Caspar David Friedrich*, Weimar 1964

Esposito, J.L. *Schelling's Idealism and Philosphy of Nature*, 1977

Ewton, R.W. *The Literary Theory of A. W. Schlegel*, The Hague 1972

Fackenheim, E. 'Schelling's Philosophy of the Literary Arts' *Philosophical Quarterly* 4 (1954) pp.310-26

Fetzer, J.F. *Romantic Orpheus, Profiles of C. Brentano*, Berkeley 1974

Finke, U. *German Painting from Romanticism to Expressionism*, London 1975

Frank, M. *Das Problem Zeit in der deutschen Romantik*, München 1972

Franke, C. *Ph.O. Runge und die Kunstansichten Wackenroders und Tiecks*, Marburg 1974

Fruman, N. *Coleridge The Damaged Archangel*, London 1972

Frye, N.
In Fearful Symmetry: A Study of W. Blake, Princeton 1947

A Study of English Romanticism, Harvester Pr. 1983
Fry, N. (ed.) *Romanticism Reconsidered*, New York, London 1963
Furst, L.R. *Romanticism in Perspective*, London 1969
Gage, J.
 Colour in Turner, London 1969
 Goethe on Art, London 1980
Gilbert, K. and H. Kuhn *History of Aesthetics*, New York, London 1956
Gower, B. 'Speculation in Physics: The History and Practice of *Naturphilosophie' Studies in the History and Philosophy of Science* 3 (1972-3) pp. 301-56
Gowing, L. Turner: *Imagination and Reality*, New York 1966
Grigson, G. *Samuel Palmer's Valley of Vision*, London 1960
Grundy, J.B.C. *Tieck and Runge*, Strassburg 1930
Grützmacher, C. *Novalis und Runge*, München 1964
Halsted, J. (ed.) *Romanticism: Problems of Definition . . .*, Boston 1965
Hamburger, M.
 Reason and Energy, London 1957
 Contraries. Studies in German Literature, New York 1970
Hartmann, N. *Die Philosophie des deutschen Idealismus* (1923), Berlin 1960
Haym, R. *Die Romantische Schule*, Berlin 1870
Haywood, B. *Novalis: The Veil of Imagery*, The Hague 1959
Heinisch, K.J. *Deutsche Romantik. Interpretationen*, Paderborn 1966
Heller, E. *The Artist's Journey into the Interior*, London 1966
Herrmann, L. *Turner*, Oxford 1975
Hirsch, E.D. *Wordsworth and Schelling*, New Haven 1960
Hofmann, W. *The Earthly Paradise*, New York 1961
Honour, H. *Romanticism*, London 1979
Huch, R. *Die Romantik*, 2 vols, Leipzig 1908
Hughes, Glyn Tegai *Romantic German Literature*, London 1979
Jenisch, E. *Die Entfaltung des Subjektivismus*, Königsberg 1929
Jensen, J.Ch.
 Caspar David Friedrich, Barron's, Woodbury, N.Y. 1981
 Philipp Otto Runge, Du Mont 1978
Joel, K. *Wandlungen der Weltanschauung*, Tübingen 1934
Jones, W.T. *The Romantic Syndrome*, The Hague 1961
Kermode, F. *Romantic Image*, London 1961
Kluckhohn, P. *Das Ideengut der deutschen Romantik*, Tübingen 1953
Knox, I. *The Aesthetic Theories of Kant, Hegel and Schopenhauer*, New York 1936

Krober, K. *Romantic Landscape Vision: Constable and Wordsworth*, Mad. Wisc. 1975

Lankheit, K. *Revolution und Restauration*, Baden-Baden 1965

Le Bris, Michel *Romantics and Romanticism*, New York 1981

Leighton, A. *Shelley and the Sublime*, Cambridge 1984

Lindsay, J.
 Turner His Life and Work, 1966
 Turner The Man and His Art, Granada 1985

Lippuner, H. *Wackenroder, Tieck und die bildende Kunst*, Zürich 1965

Lister, R. *Samuel Palmer and his Etchings*, London 1969

Lister, R. (sel. and cat.) *Samuel Palmer and the 'Ancients'*, Cambridge 1984

Lovejoy, A.O.
 The Great Chain of Being, Cambr. Mass. 1936
 'On the Discrimination of Romanticism' in *Essays in the History of Ideas*, Baltim. 1948

McFarland, T.
 Coleridge and the Pantheist Tradition, Oxford 1969
 Romanticism and the Forms of Ruin, Princeton 1981

McMaster, G. (ed.) *William Wordsworth. A Critical Anthology*, Penguin 1972

Mason, Eudo C. *Deutsche und englische Romantik* (1959), Göttingen 1966

Mayer, H. *Zur deutschen Klassik und Romantik*, Pfullingen 1963

Menhennet, A. *The Romantic Movement*, London 1981

Müller, A. *Landschaftserlebnis und Landschaftsbild*, Stuttgart 1955

Nemitz, F. *Caspar David Friedrich*, München 1949

Neubauer, J. *Novalis*, Boston 1980

Newton, E. *The Romantic Rebellion*, London 1962

Orsini, G.N.G. *Coleridge and German Idealism*, London 1969

Parris, L.
 Landscape in Britain c. 1750-1850 (exh. cat.), Tate Gallery, London 1973
 The Tate Gallery Constable Collection, London 1981

Paulson, R. *Literary Landscape: Turner and Constable*, New Haven and London 1982

Peacock, C. *John Constable the Man and his Work*, London 1965

Peckham, M.
 Beyond the Tragic Vision, New York 1962
 The Triumph of Romanticism, Columbia, S. Car. 1971

Romanticism and Behavior, Columbia, S. Car. 1976

Pelles, G. *Art, Artists and Society*, New Jersey 1963

Piper, H.W. *The Active Universe*, London 1962

Podro, M. *The Manifold in Perception*, Oxford 1972

Prawer, S.S. (ed.) *The Romantic Period in Germany*, London 1970

Prawer, S.S. *German Lyric Poetry*, London 1952

Praz, M. *The Romantic Agony* (1933) rev. ed., London 1960

Rasch, W. *Bildende Kunst und Literatur*, Frankfurt 1970

Read, H. *The True Voice of Feeling*, London (1953) 1968

Rehder, H. *Die Philosophie der unendlichen Landschaft*, Halle/Saale 1932

Reiff, P.F. *Die Ästhetik der deutschen Frühromantik*, Urbana, Ill. 1946

Reynolds, G.

 Constable the Natural Painter, London 1965

 Turner, London 1969

 The Later Paintings and Drawings of J. Constable, New Haven 1984

Richards, I.A. *Coleridge on Imagination*, London 1962

Ridenour, G.M. (ed.) *Shelley. A Collection of Critical Essays*, New Jersey 1965

Robson-Scott, W.D. 'German Romanticism and the Visual Arts' in *The Romantic Period in Germany* ed. S. Prawer, London 1970

Romantic Art in Britain (exh. cat.), Detroit Institute of Arts and Philadelphia Museum of Art 1968

Rosen, C. and H. Zerner *Romanticism and Realism*, London 1984

Rosenblum, R.

 Transformations in Late Eighteenth Century Art, Princeton 1967

 Modern Painting and the Northern Romantic Tradition, London 1975

Rosenthal, M.

 British Landscape Painting, Oxford 1982

 Constable, The Painter and his Landscape, New Haven and London 1983

Rutherford, A. *Byron. A Critical Study*, Edinburgh and London 1962

Schenk, H.G. *The Mind of the European Romantics*, London 1966

Schmidt, P.F. *Deutsche Landschaftsmalerei*, München 1922

Schrade, H. *German Romantic Painting*, New York 1978

Sellars, J. *Samuel Palmer*, London 1974

Shaper, E. *Studies in Kant's Aesthetic*, Edinburgh 1979

Simpson, D. *Wordsworth and the Figurings of the Real*, London 1982

Steffen, H. (ed.) *Die Deutsche Romantik*, Göttingen 1967

Steinbüchel, T. (ed.) *Romantik Ein Zyklus Tübinger Vorlesungen*, Tübingen 1948

Strich, F. *Deutsche Klassik und Romantik*, Bern 1949

Sumowski, W. *Caspar David Friedrich Studien*, Wiesbaden 1970

Taylor, B. *Constable*, London 1973

The Romantic Movement (Council of Europe, Tate Gallery), London 1959

Thorlby, A. (ed.) *The Romantic Movement*, London 1966

Traeger, J. *Philipp Otto Runge und sein Werk*, München 1975

Turner Studies Bi-annual publ. (Tate Gallery) London Vol. 1 No. 1 (1981) — Vol. 5 No. 2

Tuveson, E. *Imagination as a Means of Grace*, Berkeley 1960

Tymms, R. *German Romantic Literature*, London 1955

Vaughan, W.
'Caspar David Friedrich' in *Caspar David Friedrich* (exh. cat.), Tate Gallery, London pp.9-44
William Blake, London 1977
Romantic Art, London 1978
German Romanticism and English Art, New Haven and London 1979
German Romantic Painting, New Haven and London 1980

Walzel, O *German Romanticism*, New York 1966

Watson, J.R. *Picturesque Landscape and English Romantic Poetry*, London 1970

Weiskel, I. *The Romantic Sublime*, Baltimore and London 1976

Wellek, R.
A History of Modern Criticism: The Romantic Age, London 1955
Concepts of Criticism, New Haven and London 1963
Confrontations, Princeton 1965

Wiedmann, A. *Romantic Roots in Modern Art*, Gresham Books, Old Woking 1979

Wilkinson, G. *Turner on Landscape*, London 1982

Willoughby, L.A. *The Romantic Movement in Germany*, Oxford 1930

Wilton, A.
Constable's 'English Landscape Scenery', Brit. Mus. Publ., London 1979
The Life and Work of J.M.W. Turner, London 1979
Turner and the Sublime, Brit. Mus. Publ., London 1980

Index